FLORIDA'S HEALING WATERS

RICK KILBY

GILDED AGE MINERAL SPRINGS, SEASIDE RESORTS & HEALTH SPAS

UNIVERSITY PRESS OF FLORIDA

Florida A&M University, Tallahassee
Florida Atlantic University, Boca Raton
Florida Gulf Coast University, Ft. Myers
Florida International University, Miami
Florida State University, Tallahassee
New College of Florida, Sarasota
University of Central Florida, Orlando
University of Florida, Gainesville
University of North Florida, Jacksonville
University of South Florida, Tampa
University of West Florida, Pensacola

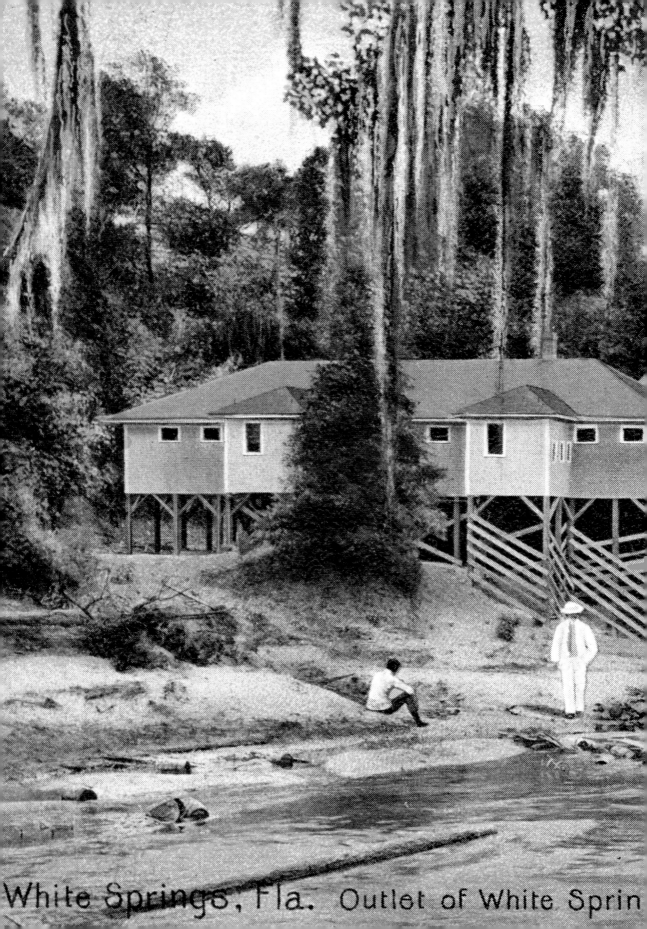

White Springs, Fla. Outlet of White Sprin

FLORIDA'S HEALING WATERS

RICK KILBY

GILDED AGE MINERAL SPRINGS, SEASIDE RESORTS & HEALTH SPAS

University Press of Florida

Gainesville · Tallahassee · Tampa · Boca Raton · Pensacola · Orlando · Miami · Jacksonville · Ft. Myers · Sarasota

on The Suwanee River.

Page i, Green Cove Springs; *pages ii–iii*, Springhouse, White Springs.

25 24 23 22 21 20 6 5 4 3 2 1

Library of Congress Control Number: 2019954697
ISBN 978-0-8130-6653-0

The University Press of Florida is the scholarly publishing agency for the State University System
of Florida, comprising Florida A&M University, Florida Atlantic University, Florida Gulf Coast
University, Florida International University, Florida State University, New College of Florida,
University of Central Florida, University of Florida, University of North Florida, University of South
Florida, and University of West Florida.

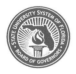
University Press of Florida
2046 NE Waldo Road
Suite 2100
Gainesville, FL 32609
http://upress.ufl.edu

Bathers at White Sulphur Springs, July 1919.

CONTENTS

PREFACE

In my first book, *Finding the Fountain of Youth: Ponce de León and Florida's Magical Waters,* I explored how myth had been used to help promote the state and examined the springs that were touted as the authentic location of the Spanish explorer's quest for immortality. After the book was published in 2013 I continued to investigate the one area that intrigued me the most: Florida's Victorian-era watering places that drew large numbers of health seekers from faraway places. The splendid health spas and elaborate bathing facilities that once proliferated in the state are now merely memories. I wanted to know more. As I researched these fascinating destinations, I grew to understand their place in a larger context of reverence for water, once seen as sacred and a source of healing power in cultures across the globe.

Myths and legends connected to water can be found in every civilization from the indigenous populations of North America to the classical customs of Europe, and it's from Old World traditions that most of the healing practices in Florida origi-nate—soaking in and drinking mineral water from springs, bathing in sea water, and using cold tap water for therapeutic treatment (hydrotherapy).

I sought out historical places where water was used for healing, from Hot Springs, Arkansas, to Bath, England, in an attempt to understand better the culture and practices of water therapies. I visited as many of these places as I could in person and wrote about my experiences to encourage readers to do their own exploring. As I discovered, while many water treatments are seen as alternative medicine today, they still hold the universal truth of water's power and necessity in supporting life on this planet. I also found a fundamental paradigm shift in the way water has been perceived—transforming from a sacred element into a capitalistic commodity.

Some of Florida's most ephemeral developments were built at springs—only ves-tiges remain from this once stately era—and it seemed important to document as many of these properties as possible. Many spectacular seaside resorts from the same time period, where guests breathed the salt air and gingerly waded into the cold surf, have been lost, too. While sea bathing in Florida is an important aspect of the state's medical-tourism history, these beachside hotels were focused mostly on promoting leisure pursuits and could not be considered to have been health resorts exclusively. Sanitariums practicing hydrotherapy have vanished as well, but surpris-ingly, a few morphed into contemporary health facilities that still exist.

Ironically, the state's once pristine waters, long used to promote Florida, helped inspire millions to move to the Sunshine State, inevitably putting stress on its water resources. The need for understanding the water stories from our past has never been greater, and I believe there is much we can learn from Florida's historical wa-tering places.

Top left: Bathers in Pinellas County, circa 1890s. *Bottom left:* Recreational swimmers at Gilchrist Blue Springs, 2014.

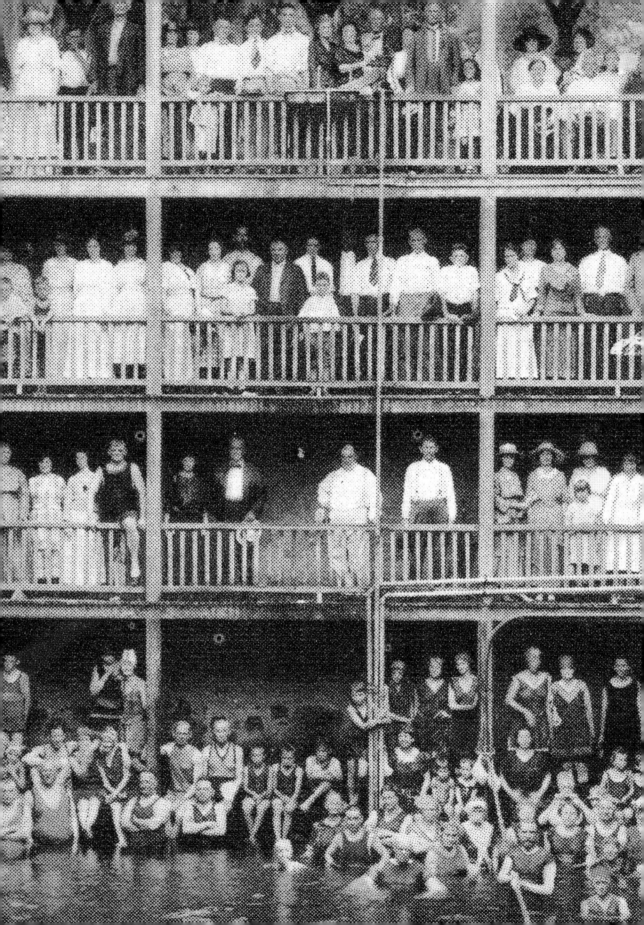

INTRODUCTION

Contemporary Florida's economy is based on tourism—people coming from other places to enjoy our world-famous attractions, sunny beaches, and glorious warm winters. The roots of the tourist industry stretch back to a time when significant numbers of people first started to travel to what was then the last frontier of the eastern United States. Much of the interior of the state was perceived as exotic and wild, in an untamed condition that sparked the imaginations of Victorian travelers. Florida's balmy climate and temperate waters were a tonic for relief from the cold winters of the increasingly industrial North.

This spike in visitation couldn't happen until people were able to travel to Florida conveniently because of advances in transportation technology. When steamboats ruled the state's waterways, Florida's springs were its major attraction—cerulean jewels that glowed from beneath the earth. As railroad travel advanced down the peninsula and across the Panhandle, Florida's beaches became accessible to visitors, and enormous, lavish resorts appeared by the sea. Finally, in the age of the automobile, much more of the state's interior opened up, and health-conscious folks in search of fresh air, sunshine, and restoration were welcomed at sanitariums, early versions of today's health spas. Both invalids and those simply seeking rejuvenation were drawn to the waters of Florida—spring water laced with minerals, salt water at boundless beaches, and water piped from the aquifer.

Ambitious visitors and Floridians alike saw opportunities in the natural, pristine state of Florida, and its ubiquitous water was like gold—a vital resource that could be used to draw tourists like a siren's call to lusty sailors. They carved up the wilderness, exploiting their Eden and destroying much of its flora and fauna along the way. They used mass media as a force for promotion, and many of the tales of Florida's watering places can be found in the printed record of that time. Newspaper accounts, advertising materials, and travel guides are often the best method for understanding the extent of the popularity of these health resorts, some of which started out as merely wet spots in the woods. The visual evidence can be found in postcards and stereograph cards reproduced in large numbers. The inexpensive souvenirs of another age, they are vital tools for understanding the scale of these locations.

The story of these places helps us develop a better picture of how today's Florida came to be, with a thousand new residents arriving daily and millions more visiting every year. The tension between the pressures of carving up the natural areas for development and marketing the state as paradise continues today, and the consequences have never been greater. It is important that the history of Florida's Victorian-era spas, sanitariums, and mineral springs is not forgotten and that we understand how they fit into the larger context of human history and our relationship to water.

Opposite page: Interior of springhouse, White Sulphur Springs. *Following pages:* Breakers Hotel, Palm Beach.

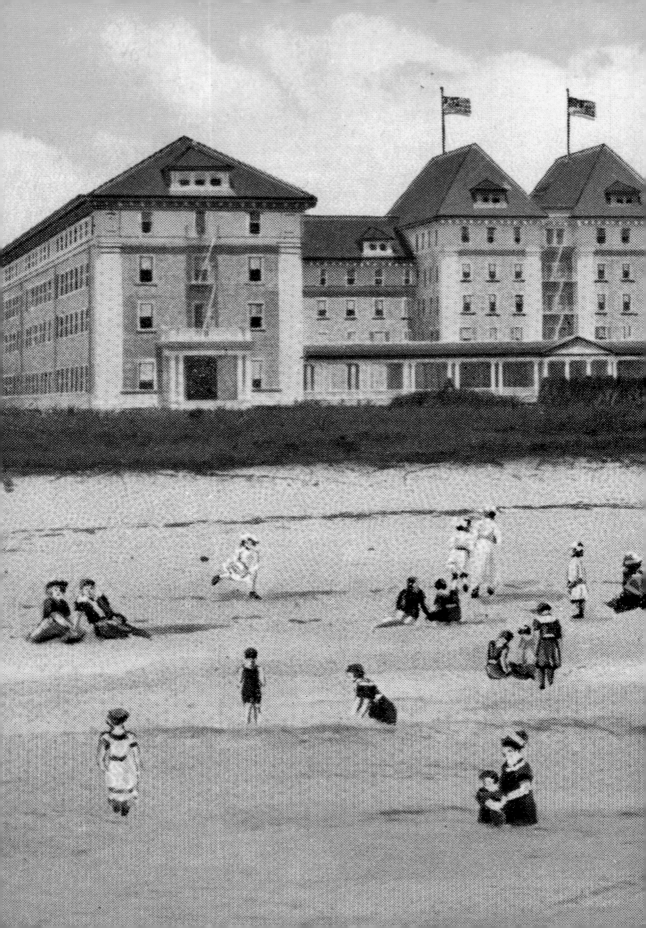

Florida's
Healing Waters

Rick Kilby

Gilded Age Mineral Springs,
Seaside Resorts & Health Spas

THE HEALING POWER OF WATER

Connections to Ancient Sacred Tradition

The waters come from places we cannot venture, are transported by forces we cannot see, and cure through means we cannot understand. How did these waters become sacred? Even today, with medical discoveries seemingly an everyday event, many people still attribute special powers to holy waters.

—*James Salzman,* Drinking Water: A History

In 2015 Florida reached the high-water mark of 100 million annual visitors, and the volume of tourists flowing into the state has increased each year since. Many of them, seduced by the fantasy of a place where dreams become reality, leave behind their normal lives for a quick fix of make-believe. In addition to slick corporate theme parks and countless second-tier attractions, tourists flock to the beaches, spend hours floating in swimming pools and water parks, and dive into freshwater springs.

In seeking out the waters of the state, these visitors continue a fascination that reaches back thousands of years. Ancient people were both awed by the life-giving power of water and frightened by its destructive aspects. They connected water to gods and goddesses, and in many cultures throughout history, important religious sites were centered around sacred waters. When the spiritual entities associated with these waters were credited with miraculous cures, the sites often evolved into pilgrimage destinations for people seeking better health. That was certainly true in Florida, where the natural geographic features were ideally suited for attracting visitors to take the waters.

Opposite page: A bather at Suwannee Springs, 1989. *Right:* Detail of Wekiwa Springs Water label.

❀ SACRED ORIGINS: WATER IS LIFE

For civilizations going back to the beginning of recorded time, water meant life, as it surely did for the first people to inhabit Florida. They arrived during the Pleistocene epoch—the Ice Age—at least twelve thousand years ago, when the peninsula had a much larger land mass and the climate was cooler and drier than it is today. Archaeologist Jerald Milanich has described how these Paleoindians found fresh drinking water at watering holes, limestone catchment basins, and sinkholes fed by springs during periods of high rainfall. The havens of fresh water also attracted game, and early Floridians hunted and ate the prey found near springs. Today bones from ancient meals as well as the tools used for hunting provide evidence of Florida's first people living near these watery places.

Around 8000 BC the climate of Florida began to change. Rainfall increased, and water sources became more abundant. As glaciers melted, the state's familiar coastline began to emerge as well as its lakes, rivers, and springs. Some of the people living during this era, dubbed the Archaic period, conducted ritualistic burials of their dead in ponds and springs. Little Salt Springs in Sarasota County and the Windover Pond site in Brevard County are two examples of sacred sites where formal burials took place. The bodies of the departed were shrouded in handwoven material made of plant fibers and were carefully placed in shelters with "effigy poles" over the bodies. As Milanich notes, these pond burials suggest that water, "so important to life," may have had special significance for these people.

Windover Pond facing north-northeast. Photographed in 1985; the Brevard County site was discovered by accident in 1982.

Artesian springs may have been holy sites for the living during this period as well. Archaeologist Jason O'Donoughue notes that springs embody many qualities that would have filled ancient people with awe and wonder. In addition to the mysterious emergence of crystal-clear water bubbling up from the earth, springs offered fascinating visions created by the refracted light that cast iridescent colors over objects beneath the surface of the water. Votive offerings and dugout canoes intentionally sunk in several Florida springs suggest that these long-ago

George King's painting of Indian Rocks Spring at the Indian Rocks Beach City Hall.

people believed springs were sacred. By the time visitors of European descent "discovered" the springs of Florida, these natural wonders had already been well used by people for thousands of years. The archaeological sites at Silver Glen Springs in the Ocala National Forest, for example, consist of shell ridges, mortuary mounds, and two huge U-shaped shell mounds that were developed over a period of years.

More recently, it is likely that relatively contemporary native peoples, such as the Seminoles, continued to think of springs as sacred locations. According to legend, the Seminole leader Coacoochee dreamed he was visited by his dead twin sister, who had returned from the land of souls to tell him that if he drank the spring water of the Great Spirit, he would return to her forever. Some accounts suggest the Seminoles' reverence for water led them to treat springs as conflict-free zones, where hostilities against other tribes were suspended. "Warring tribes set aside their differences, allowing each other to bathe and drink in the mineral water without fear of attack," according to an interpretive marker at White Springs.

Florida spring water had healing powers, according to Native American tradition. "The intersection of Indian trails at some of the springs and the location of ancient mounds nearby seem to point to a much older tradition of therapeutic use," writes Burke G. Vanderhill in his study of Florida's historic spas. An 1875 "Guide to Florida" noted that the peninsula's indigenous peoples, "from the earliest times, had resorted to these fountains for medicinal purposes, and knew well their beneficial effects." Early promoters of Florida spas often capitalized on legends of a connection between springs and Native American healers in an attempt to prove the efficacy of their waters.[1]

Florida's indigenous people were not unique in their belief that water was sacred. Four of the first ten verses in the biblical book of Genesis deal with the world's watery beginning, and similar creation stories are found in other Middle Eastern cultures. The ancient Greeks developed a sophisticated cosmology of benign and hostile deities associated with water; they considered springs to be so holy that they often built temples around them. Spring water was considered a conduit to the divine. The gods and goddesses of the springs made them sacred, and thus the water was believed to possess the power to heal. The Greeks created public baths for both healing and restorative purposes that also served as centers of social life and facilities for hygiene.

The ancient Romans took ritualized bathing to a whole new level, creating elaborate baths that became social and cultural hubs throughout their empire. The demand for baths grew so great that at one point Rome had eleven enormous imperial baths known as thermae—plus more than nine hundred public baths. The largest of the thermae was said to accommodate as many as ten thousand Romans. Architectural elements of these grand facilities included polished marble, detailed mosaics on the floors, gardens with grottoes, elaborate fountains, and beautiful sculpture. The baths were famously egalitarian, open to all Romans every day of the year.[2]

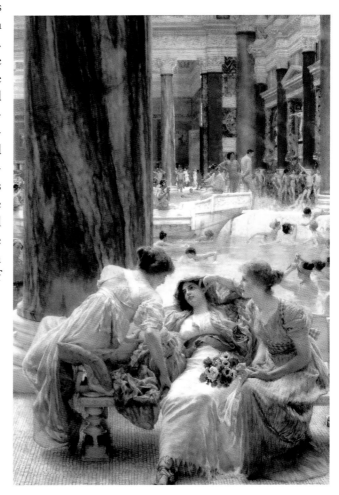

A romantic version of *The Baths of Caracalla* by the English painter Sir Lawrence Alma-Tadema, 1899.

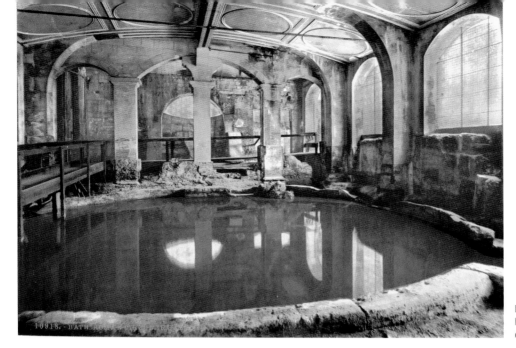

Roman Baths, Bath, England, circa 1900.

AQUAE SULIS: THE ANCIENT SPA OF BATH

Perhaps the best surviving example of a Roman thermae complex can be found to-day in Bath, England. The Celts used the hot springs there even before the arrival of the Romans in 43 AD. According to legend, the Celtic Prince Bladud, reduced to the lowly position of pig herder because he had leprosy, discovered the springs by accident when the swine under his care would not leave the mineral-rich mud surrounding the spring. The waters that percolated up through the limestone of the Mendip Hills supposedly healed the prince, and invalids have sought out these storied springs ever since.

The Romans appropriated the name of the local Celtic goddess Sulis for the sophisticated bath they constructed around the hot springs and completed about 75 AD. The town built around the springs was known as Aquae Sulis. The original complex consisted of a large entrance hall, steam rooms, and three swimming areas, including the Great Bath, an interior swimming pool lined with lead sheets. The lead, mined nearby, was also used for pipes that channeled surplus water into the River Avon.

The hot spring was considered sacred, and because of its reputation for healing, large bathing facilities were added to accommodate the many pilgrims who traveled to Aquae Sulis. Sacrifices were made, and gifts were offered at the adjacent temple in the name of Sulis Minerva, a mash-up of the local goddess Sulis and the Roman goddess of wisdom, Minerva. The Romans used the bath complex for three hundred years, but in the fourth century AD, invasions by barbarians and severe flooding by the River Avon led to its demise. A new era of bathing in Bath peaked in the eighteenth century, and the Roman baths were rediscovered by accident during the Victorian era. Today they are wonderfully preserved in a contemporary museum.[3]

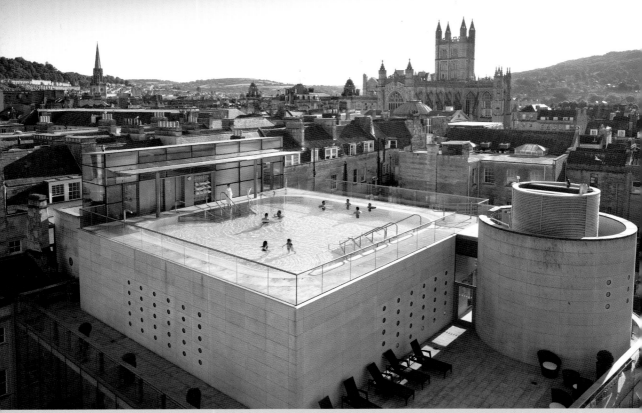

The New Royal Bath at Thermae Bath Spa in Bath, England, utilizes the famed mineral water in a contemporary setting.

MODERN SPA IN AN ANCIENT CITY

The city of Bath in England is a UNESCO World Heritage Site that preserves two thousand years of documented history associated with the manmade resources of the hot springs. The city's Roman Baths, carefully restored, serve as a focal point for interpreting the past, and the museum there is modern and accessible. Visitors can also explore the surviving architecture from the city's halcyon days as a hub of British society during the Georgian Period, and free walking tours offer a glimpse into the era made famous by Jane Austen. After soaking up all that history during my own pilgrimage there, I was ready for a literal soak in the contemporary Thermae Bath Spa, seamlessly integrated into historic buildings near the Roman Baths. The spa's entrance is between the Grand Pump Room, an elegant restaurant

that was the heart of Bath's social scene during the Georgian era, and the King and Queens Baths, one of the three baths from that period.

My wife, Julie, and I chose to take the waters at the end of the day in order to enjoy the spectacular late-afternoon views at the spa's open-air rooftop pool. It was a sunny evening, and we had plenty of company as we soaked in 92-degree waters while basking in the visual delights of the town of Bath painted in the golden light of summer. The pool was full of fellow tourists, floating on foam "noodles," hovering over whirlpool jets, and reveling in a two-thousand-year-old tradition. The water felt warm but not hot, and I thought I smelled a slight hint of chlorine. The hot spring water at the ancient Roman Baths next door turns green when exposed to sunlight, as dis-

solved nutrients in the water feed the growth of algae, but the water on the rooftop was crystal clear.

The views were spectacular, although a cool breeze made it a bit chilly for a warm-blooded Floridian like me, despite the transparent wall surrounding the pool. After a bit of rooftop relaxation, I left to explore the rest of the spa. On the ground floor I found another large pool called the Minerva Bath, named after the goddess to whom the ancient Romans dedicated their Bath temple. The spacious ceiling over the pool is supported by toadstool-shaped columns reminiscent of those at Frank Lloyd Wright's iconic Johnson Wax Headquarters in Wisconsin (or Victor Lundy's Warm Mineral Springs Motel in Florida).

I soon discovered that the curved shape of the pool had a circular flow, and I floated around on an unseen "lazy river," reminiscent of those at water parks in Florida. In the middle of the

pool the jets of a hot-tub area would turn off automatically after several minutes, perhaps to encourage bathers to keep circulating. Large wall clocks near both pools offered reminders that the tranquility created by this bathing session was constrained by the limitations of time.

I also touched in at the Wellness Suite, described by the spa's website as offering a "range of state-of-the-art" experiences. Those included two steam rooms, an ice chamber, an infrared room, and a "Celestial Relaxation Room," which featured a video monitor playing a montage of images of outer space accompanied by new age music, creating a mellow ambiance for spa users resting on mosaic-covered chaise lounges. The entire space was engulfed in a floral fragrance, described as an homage to the ancient Romans and their use of herbs and flowers for healing and in everyday life.

Our experience in Bath mixed elements from ancient water traditions with familiar modern spa therapies. Its high-end resort amenities were laced with a hint of new-age flavor. I was surprised to find it reminded me a whole lot of hanging out poolside in Florida. But the scenery from the rooftop in Bath was unlike anything in the Sunshine State. I was glad I had brought my swim trunks to England.

THERMAE
BATH SPA

Top: The Minerva Bath at Thermae Bath Spa. *Left:* The Thermae Bath Spa is surrounded by Bath's eighteenth-century Georgian architecture.

The hedonism and decadence that came to be associated with baths of Rome led to a significant decrease in bathing practices when Christianity rose throughout Europe. In contrast, some ancient Roman baths, such as the mineral spring at Spa, Belgium, were associated with Christians saints, and the faithful believed these holy waters possessed the power to heal. Spa, associated with St. Remaclus, attracted so many pilgrims during the Middle Ages that a "cure tax" was imposed. Despite admonishment from the early Christian church, social bathing in the Roman tradition persisted at bathhouses south of London known as "stews," which were actually brothels. During the plagues of the Middle Ages, such bathhouses were perceived as centers of infection (and sources of syphilis), and many were permanently shuttered. When the Crusaders returned to Europe after being exposed to the bathing culture of the Middle East, public bathhouses regained popularity.

The use of water for spiritual and healing rituals was not exclusive to Western cultures. Japan has a rich tradition of communal bathing; ritual purification and a deep respect for water as one of the natural elements are essential aspects of the Shinto religion. Buddhism, which originated in India but is widely practiced in Japan, also incorporates ritual water offerings for purification, and water is said to represent calmness and clarity in Buddhist practice. The primary religion of India, Hinduism, is deeply connected to sacred waters and rituals. The very word *Hindu* is derived from the "Sindu," the name given to the Indus River in ancient Persian. The philosophy of Taoism, attributed to the mythical Lao Tzu, which originated in China around the fourth or third century BC, used water as a metaphor for the flow of life.[4]

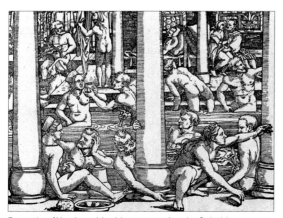

Fountain of Youth and bathhouse woodcut by Sebald Beham, 1536.

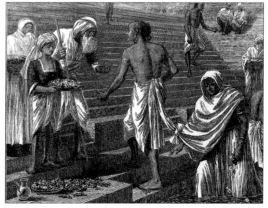

Nineteenth-century bathing scene at Benares, India.

As Western civilization emerged from the Middle Ages, the widespread belief in the sacredness of water diminished as a more modern perspective emerged. In the era of the Enlightenment, scientific reason became a new lens through which to see the world, and the source of the magic of healing waters was no longer seen as divine. Philosophers and scientists believed that the mysteries of nature could be unlocked if carefully observed and studied. Water's healing powers were attributed to its chemical composition, especially the minerals dissolved in it. Desirable minerals that cured specific ailments, including magnesium sulfate (Epsom salts), iron salts, and sulfur, were often found in mineral springs where spas arose. By the eighteenth century, as the bathing practices of the ancient Romans returned in a refreshed form, a new spa culture for the upper classes spread across Europe.

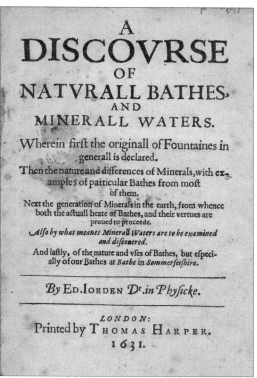

Cover of *A Discourse of Naturall Bathes, and Minerall Waters.*

Contemporary spas can trace their roots back to the early fourteenth-century rediscovery of the healing waters of Spa, Belgium, where the ancient spring had once been reviewed by Roman writer Pliny the Elder. Scholars have debated whether the word "spa" originates from a Roman acronym for the Latin *sanitas per aquas* (health through water) or the word *espa* (fountain) in the Walloon language of southern Belgium. Another source could be the Latin *spagere,* which means to sprinkle or spill. Whatever the derivation, taking the waters became so synonymous with the Belgian mountain town of the same name that the term *spa* is still used today for health resorts or businesses. Similar facilities sprang up at mineral springs throughout Europe.

By the 1700s, a great deal of scientific literature was being written about the healing powers of Europe's mineral springs. Taking the waters at such springs was called balneotherapy, from the Latin *balneum,* meaning bath. The aristocratic class insisted on elaborate facilities at mineral-spring spas, and an opulent culture of leisure arose around spa resorts, where the wealthy clientele took water cures for a wide variety of complaints by day and then spent their evenings entertaining themselves with dining, dancing, and gambling.[5]

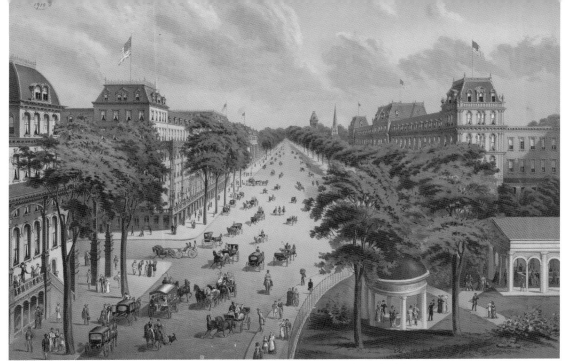

Saratoga Springs, New York, 1876; Columbian Springs is in the rotunda on the right.

✿ THE SPA CULTURE IN THE NEW WORLD

The advent of leisure travel in the United States is directly connected to the rise of a spa culture that emulated the watering places of Europe and, in particular, those of England. Many of the spas that developed at American springs traced their origins to storied sacred places that indigenous people visited for healing. Saratoga Springs—the standard by which all Victorian-era health resorts in the United States would be measured—was said to have been revealed to white men by the Iroquois. Much of the social activity that would become synonymous with American spa culture originated at Saratoga, a popular destination for the well-heeled for most of the nineteenth century.

Spas that developed at springs throughout the Appalachians were more rustic. A string of facilities erected around the mountain springs of Virginia and West Virginia claimed devoted patrons from Thomas Jefferson to Robert E. Lee. Eventually, as railroads opened up the nation, spas spilled across the continent from Hot Springs, Arkansas, to Calistoga, California. Some became famous for their bottled water, such as Indiana's Pluto Water and Maine's Poland Springs.

Initially only the wealthy escaped the increasingly polluted and disease-plagued cities for spas in the country. But as trains made travel more affordable, people with lesser means could seek health from the nation's mineral springs. As the popularity of taking the waters diminished in the twentieth century, two of the most popular bathing destinations in the United States—Hot Springs, Arkansas, and Saratoga Springs, New York—came under the control of federal and state governments, ensuring their preservation for future generations.[6]

VISITING AMERICA'S LEGENDARY WATERING PLACES

I've gone out of my way to soak up the history and culture at America's vintage spas whenever possible. One summer vacation, my wife and I visited Saratoga Springs in New York, the place where American spa culture reached its zenith during the Victorian era. The best-known springs there are in Congress Park and the High Rock Area near downtown, where elegant resorts once catered to wealthy health seekers; among the resorts were two of the world's largest hotels of the early 1800s.

Some of Saratoga's springs were "spouters" that dramatically sprayed water into the air like a geyser. The water maintains a constant cold temperature (55 degrees at Saratoga compared with the 72 degrees of most Florida springs), has a high mineral content, and is naturally carbonat-ed—which ultimately put the springs at risk from soda bottlers at the beginning of the twentieth century. The State of New York assumed control of 155 of Saratoga's springs in 1909 because bottlers extracting carbon dioxide gas from the water had led to depletion of their flow. Many of the springs were sealed, except the eighteen that one can still visit today.

During our visit we sampled the water from each spring (which, in some cases, tasted pretty awful) and witnessed locals filling plastic water jugs. At one spring a man used a small plastic footbath to soak his feet in the mineral-laden water. We also explored the New Deal–era facilities created by President Franklin Roosevelt at what is now Saratoga Spa State Park. The sprawling facility served veterans after World War II, and

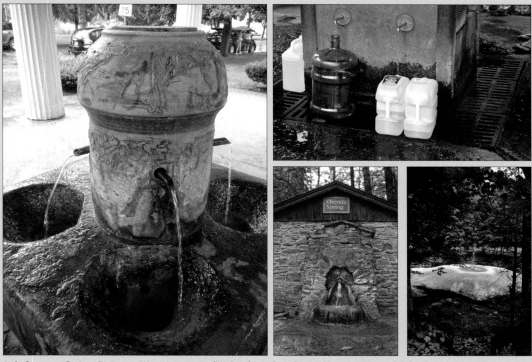

Left: Congress Spring. *Right top:* Water jugs being filled at State Seal Spring. *Center:* Orenda Spring. *Bottom right:* Geyser Island Spouter.

a spa still operates for those who wish to take the waters.

A few years ago we ventured to perhaps the oldest bathing structure in the United States: the Jefferson Pools in Warm Springs, Virginia. Thomas Jefferson is said to have spent three weeks soaking in the warm spring water in 1818—hence the name. When we visited in 2015 the pool was an amenity of the Omni Homestead Resort, and anyone could bathe there for nineteen dollars, regardless of whether one was staying at the luxury hotel. As I entered the water contained in an octagonal wooden springhouse, I was struck by its shimmering cyan hue, the same as Florida spring water. My wife, however, was concerned about the wear and tear on the wooden building—its centuries-old support beams tested by years of rising steam. A few years later this historic facility is closed, because it was determined that these colonial-age structures were in dire need of restoration.

We found more watering places in Arkansas, where other resort communities developed around therapeutic springs, in addition to the well-known bathing facilities in Hot Springs. One such community is the small mountain town of Eureka Springs, where Native Americans purportedly carved a tub-like depression into solid rock to collect spring water for healing purposes. In the nineteenth century this spring's reputation for curative powers caught the attention of Dr. Alvah Jackson, who set up a hospital in a cave and used spring water to treat wounded Civil War soldiers from both armies. The doctor's facility soon grew into a successful business, and when an associate was cured from a "crippling disease," the word soon spread. Founded in 1879, the town of Eureka Springs exploded with growth, and "visitors flocked to the original encampment of tents and hastily built shanties," according to eurekasprings.com.

A vintage travel brochure published by the Missouri and North Arkansas Railroad claimed that the "City of Healing Waters" boasted some fifty springs within the city limits. The Eureka Springs website now lists the total at sixty-three. Vestiges of America's "Golden Age of Bathing" like these can be found throughout the country, offering fascinating glimpses into our culture and, in some cases, also providing a relaxing soak.

Left: The Gentlemen's Pool House in Warm Springs, Virginia, was built in 1761. *Right:* Sweet Spring in Eureka Springs, Arkansas.

Rainbow Springs is a first-magnitude spring near Dunnellon, with a flow rate of 400 million gallons of water per day.

FROM SUBTERRANEAN CAVES COME BOWLS OF LIQUID LIGHT

Florida has more than a thousand springs, perhaps the largest concentration on the planet, so it's no coincidence that the spa culture originating at northern resorts such as Saratoga became established in the Sunshine State. When rain seeps into the porous limestone beneath most of the state, it gradually dissolves the rock due to trace amounts of acidic carbon dioxide in the raindrops. The water is contained in the karst terrain in a network of connected underground caverns made of limestone—a type of rock that can be visualized as Swiss cheese with its holes full of water. All water held underground is referred to as groundwater, and where groundwater breaks the surface it creates a spring. Florida environmental icon Marjory Stoneman Douglas would call the water that surges up from subterranean caverns "bowls of liquid light." Most of the groundwater feeding the largest springs in Florida comes from the immense Floridan Aquifer, which extends beneath five southeastern states. Today it is Florida's largest source of drinking water.

Springs are classified by the volume of water that flows up to the surface from underground. The largest, first-magnitude springs, have a flow of more than 64.6

million gallons a day. Florida has twenty-seven of this size, some of which are well-known recreational destinations such as Silver, Rainbow, and Wakulla springs. The majority of the state's springs, however, are of the smaller third-magnitude classification, a handful of which were developed into spa resources by confining the water in manmade bathing pools of wood or concrete. Springs with a distinctive rotten-egg smell, indicative of high amounts of hydrogen sulfide or the presence of sulfur, were considered desirable for health spas. According to noted scientist Robert L. Knight, the source of this sulfurous water is often an intermediate aquifer of shallower depth than the Floridan Aquifer.[7]

In several instances, if a natural spring wasn't available, opportunistic developers simply drilled wells into the aquifer to create pseudo "springs." In the nineteenth century, groundwater flow was so strong that pumps were often unnecessary to bring the water to the surface, and these artesian wells could be found throughout Florida.

The water temperature of Florida springs depends upon the depth from which the water originates, with a range between 68 and 76 degrees Fahrenheit, but most are around 72 degrees. Because the water temperature was considerably warmer than

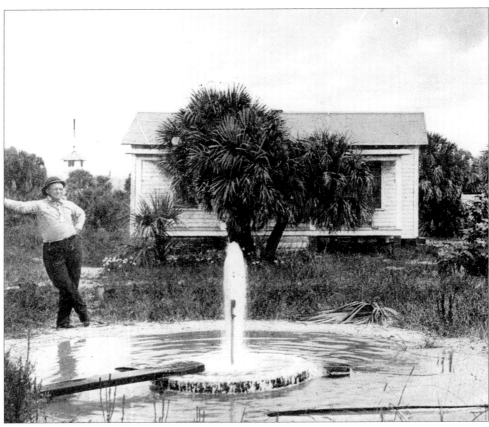

An artesian or free-flowing well is drilled into an aquifer where the underground pressure is sufficient for the groundwater to rise within the well; in some instances the water can flow to the surface without a pump.

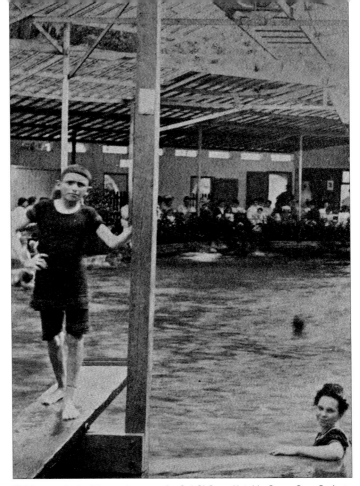
Children at the bathing casino near the Qui-Si-Sana Hotel in Green Cove Springs.

the air temperature in winter, Florida springs were often referred to as hot or warm springs in travel literature. But for year-round residents, springs were also a way to beat the heat of summer before the invention of air-conditioning. Many of the same springs described as warm in promotions to northerners were used by locals for cooling down in summer. During the nineteenth century few northern tourists braved Florida's heat and humidity during the warmer months.

But hot, soggy summers weren't the only obstacle facing the full-scale development of health spas at Florida's many pristine springs. The first Europeans to have domain over the land, the Spanish, did little to encourage civilian settlement of its territory, and the small population was mostly concentrated on the coasts. The interior was mostly left to native tribes, as lack of transportation infrastructure made inland travel almost impossible. When the British controlled Florida for two brief decades, the idea of encouraging immigration to the Land of Flowers gained traction, and a tradition of writing about the colony as an earthly paradise emerged, mostly thanks to the work of one man. Ultimately the narrative created by William Bartram and those he inspired would unleash a flood of visitors, many coming to find renewed health and vigor in this southern Eden.

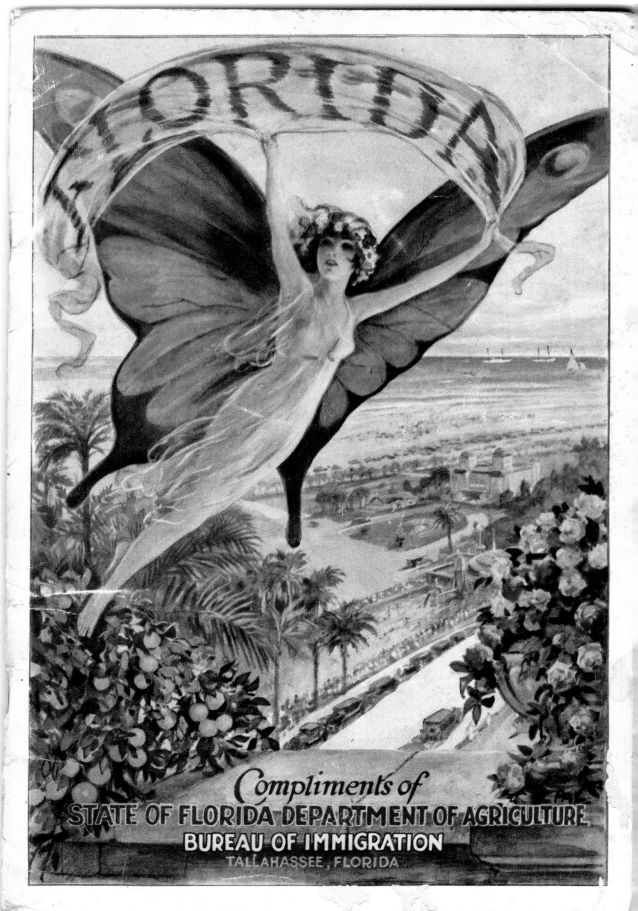

FLORIDA

Compliments of
STATE OF FLORIDA DEPARTMENT OF AGRICULTURE
BUREAU OF IMMIGRATION
TALLAHASSEE, FLORIDA

PROMOTING PARADISE

Natural Features Give Rise to Medical Tourism

Whether traveling by Spanish galleon or by auto-train, generation after generation has come to Florida with hopes of restoration or re-creation.

—*Maurice O'Sullivan and Jack C. Lane,* The Florida Reader

On the cover of a promotional brochure for Florida, a goddess-like figure floats on beautiful butterfly wings over a lush landscape. Below her feet an orange tree bears fruit near a highway that parallels the coast, lined by a row of automobiles, near what appears to be an oceanfront hotel. It's easy to imagine that this winged enchantress represents the state's metamorphosis from a sparsely populated swampland to a mythic paradise for visitors. The brochure, published in 1930 by Florida's Bureau of Immigration, concludes with a nod to the state's origins in its claims that "De Leon and De Soto sought in vain for water of youth restoring virtue and for gold—yet both are here today. . . . The tingle of our salt surf and the gold of our sunlight bring renewed health and vigor to age and supply to youth the best possible setting for the development of mind and body."

In some ways this pamphlet represents the success of the bureau, which was formed in 1868 to attract settlers to Florida. But it also shows how promoters of the state employed myth and a romanticized version of the promised land to help seduce visitors to its fertile realm. They were able simultaneously to market the state as a perfect utopia, undisturbed by the human hand, and also as a realm of untapped potential waiting to be unlocked and exploited.

We can see these two perspectives in the way both naturalists and promoters wrote about Florida from the late 1700s to the 1900s. Scholars Jack Lane and Maurice O'Sullivan, who assert that Florida has the oldest literary tradition in the nation, trace these two views to two versions of the Garden of Eden story in Genesis. Some writers, including Harriet Beecher Stowe and Sidney Lanier, portrayed Florida as an idyllic wonderland where one could find spiritual renewal and personal transformation. In the nineteenth century, when a popular notion that being outdoors—in nature—contributed to physical health, Florida became a desirable

Florida's 1868 Constitution established the Office of Commissioner of Immigration, which in 1885 was changed to the Department of Agriculture. Empowered to attract tourists, it created guides such as this 1930 brochure offering "authentic information."

destination for those in search of wellness. Its exotic flora and fauna helped to support a vision of an earthly paradise.

In the second theme, Florida was presented as a tabula rasa—a blank slate upon which one might create something new and perhaps make a fortune along the way. Colonial ideologies of "desire and possession" suggested that readers of Florida travelogues should not only visit Florida but "share in its possession," writes historian Deborah Craig Nester. Because Florida was sparsely populated and not ravaged by the Civil War like other southern states, it was ripe for development. Many of the state's earliest promoters were motivated simply by economic opportunity, seeing the unbounded potential in the state's vacant land and abundant waters. In this view Florida's natural features were resources to be exploited. The concept of Florida as paradise was also used to promote its development, at the same time that the notion of the state as heaven on earth gained traction.

The British, who controlled Florida for twenty years in the eighteenth century, were the first Europeans to promote immigration to the colony. In the next century, when innovative ideas and revolutionary technology swept over Europe and the United States, Florida remained a wild frontier, and it took an influx of travelers from the North after the Civil War to bring the state into the modern era. Tourism was an engine of the state's development, and from Florida's very beginnings, many of its visitors were invalids seeking health and restoration, enticed by a shared vision of the Land of Flowers as a utopia of rejuvenation.[1]

An 1888 image from *Frank Leslie's Illustrated Newspaper* shows a naturalist gathering specimens of rare birds and eggs in Florida.

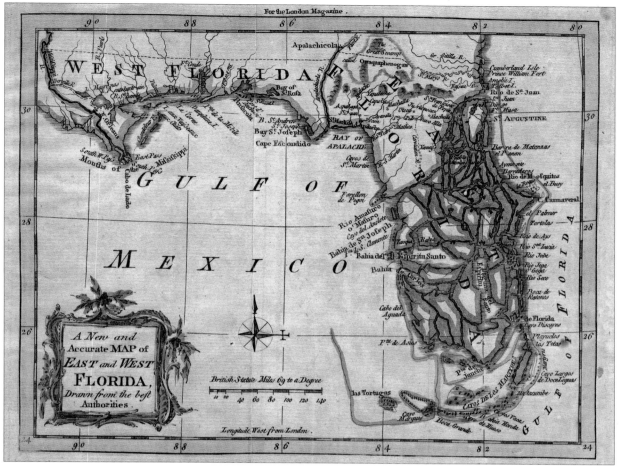

Map of East and West Florida, 1765, published by J. Prockter.

THE BRITISH PROMOTE SETTLEMENT OF FLORIDA

When the Spanish governed Florida for the first two centuries after Ponce de León's arrival, they used La Florida mostly to control the flow of resources from the New World to Spain. It wasn't until the British period, which began in 1763 at the end of the Seven Years' War, that Florida's rulers put substantial effort into encouraging settlement. Promotional writings aimed at encouraging immigration to the new British territory portrayed it as a health-giving, idyllic paradise. The British divided their new possession at the Apalachicola River into two colonies, East and West Florida, and soon the governor of East Florida, Scotsman James Grant, began touting Florida as ripe for development, boasting that the British troops stationed in St. Augustine "enjoyed an uninterrupted state of Good health" and observing that there was "something very extraordinary in the air."

The population of the Florida colonies at the beginning of British rule was minuscule. Pensacola, West Florida's capital, had fewer than eight hundred residents, and St. Augustine, East Florida's capital, was home to just over three thousand.

This 1904 postcard is labeled "ruins of an old fort," possibly showing remnants of Andrew Turnbull's ill-fated New Smyrna colony.

To entice settlers, the British offered sizable land grants to investors and smaller plots to individuals. According to historian Robin F. A. Fabel, "apocryphal testimony to the healthiness of the climate and optimistic forecasts of the commercial prospects in both Floridas appeared in papers on both sides of the Atlantic."

English settlers in Florida often fell victim to illness, despite the claims of a healthy climate. Yellow fever, a viral disease that would plague the development of Florida for the next century, was blamed for killing almost half of the four hundred troops from the British Thirty-first Infantry Regiment after they arrived at Pensacola in 1765. The British government's attempts to lure people to Florida with descriptions of healthy air and water, only to have them fall ill from tropical disease, were echoed in a reoccurring pattern that would befall settlers and visitors until the sources of disease were better understood in the twentieth century.[2]

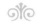 THE BARTRAM EFFECT

Perhaps the biggest impact on tourism during British occupation was made by William Bartram's account of his expeditions to Florida in a narrative known today as Bartram's *Travels*. The book made a significant impact on the way the colony was perceived by the rest of the English-speaking world, catching the imagination of readers and helping create the vision of Florida as an earthly paradise. Its descriptions of Florida's springs were among the first published in English.

Bartram's father, John, a self-taught botanist and farmer from Pennsylvania, was appointed royal botanist to King George shortly after England acquired Florida in 1763. One of the conditions of his royal appointment was that he explore England's new territories, so he recruited his twenty-eight-year-old son, who was working as

a trader in North Carolina, to join him on an expedition to Florida. John and Billy Bartram, as his father called him, ventured south in August 1765 and explored the St. Johns River for the next five months, venturing as far south as Puzzle Lake in central Florida. Then they followed the St. Johns all the way back to the sea before returning to St. Augustine for more explorations inland. At the end of their journey the son stayed in Florida and established a plantation southeast of Green Cove Springs; the father headed home to Pennsylvania.

The plantation wasn't a success, and by the fall of 1766 William Bartram had abandoned it. He eventually migrated back to Pennsylvania but returned to Florida in 1774 for a second expedition, sponsored by English naturalist Dr. John Fothergill. The account of Bartram's eight-month solo excursion surveying the wonders of Florida would not be published until seventeen years later, and initially, few of his contemporaries recognized the value of his influential narrative. But Bartram's writings were important: in addition to providing a snapshot of eighteenth-century life in Florida, his work inspired other writers and poets, including William Wordsworth, Samuel Taylor Coleridge, Percy Bysshe Shelley, and Alfred, Lord Tennyson. Bartram's descriptions of caves within Florida's artesian springs are even said to have prompted lines in Coleridge's celebrated poem "Kubla Khan": *"Where Alph, the sacred river, ran / Through caverns measureless to man / Down to a sunless sea."*

William Bartram's poetic *Travels* eventually caught the public's imagination, especially in Europe, and he unwittingly became the first English-speaking travel writer to espouse a romantic vision of Florida. His vivid accounts of the colony's pristine natural environment excited explorers, naturalists, and botanists, whose subsequent accounts added to the perception that Florida was a beautiful, untamed paradise.

Today one can follow Bartram's Trail throughout Florida, and his work is widely revered by environmentalists and Floridaphiles. His lyrical description of Salt Springs as the "blue ether of another world" succinctly sums up the mystical quality of the subaqueous realm of a Florida spring and is often quoted. Naturalist and artist John James Audubon, who traveled throughout Florida in 1831, used Bartram's *Travels* as his guide and was said to have accused Bartram of "causing a land boom in Florida."[3]

William Bartram's drawing "View of the Alligator Hole," from his *Travels,* 1791.

LOOKING FOR BILLY BARTRAM

Historical markers and signs trace the Bartram Trail throughout Florida, but the small city of Palatka seems to have cornered the Bartram market. Its annual St. Johns River Bartram Frolic features historical reenactors, art, music, hiking, biking, kayaking, and a symposium of Bartram presentations. My first foray to the Frolic was participating in a guided kayak trip to several springs visited by Bartram along the St. Johns River.

The river, swollen from a recent storm, looked like swirling black ink as my fellow kayakers and I retraced the route explored by John and William Bartram in December 1765. A short paddle upriver led us to our first stop—Satsuma Spring, described in John Bartram's journal but only

recently rediscovered. The spring is on private property, and the Bartram festival organizers had arranged our visit ahead of time with the owner.

Located in a small ravine, Satsuma Spring is confined within a semicircular basin lined with cement-filled sand bags to prevent erosion. The water reeks of sulfur—one of the clues that linked the spring to the Bartrams. John Bartram described it as smelling "like bilge-water, or the washings of a gun-barrel." Despite the odor, even on this gray overcast day, the water possessed the distinctive cerulean hue I've come to associate with Florida's most beautiful springs. After a few minutes of soaking up the history and natural beauty of this third-magnitude spring, we returned to our kayaks and continued our journey.

Our next stop was Welaka Spring, a third-magnitude spring I remember fondly from my adolescence, when I plunged into the spring from a rope swing tied to a tree branch. The freezing water was an oasis of clarity in the otherwise root-beer-colored cove. As we paddled down the spring run, I noticed that the spring was "browned out," meaning the water level of the surrounding river was so high that the brilliant blue hue, so noticeable at Satsuma Spring, was not evident here. There was, however, a significant boil on the surface, indicating good flow. While our tour leader related anecdotes about the spring's history, rain began to fall gently, and we paddled back downriver to our starting point, following the Bartrams' footprints left more than 250 years earlier.

View of Satsuma Spring, 2017.

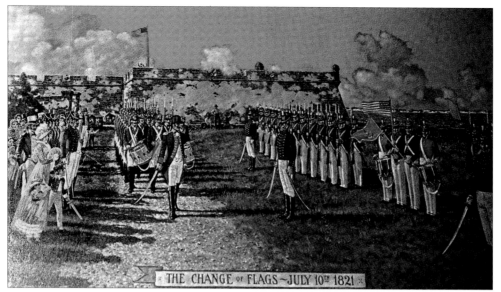

The 1821 change of flags at Castillo de San Marcos in St. Augustine marked the beginning of Florida's Territorial Period.

FLORIDA'S TERRITORIAL PERIOD: THE AMERICAN MIGRATION BEGINS

Florida's British period ended at the conclusion of the American Revolution, when Britain relinquished the land back to Spain in 1783 as part of the Treaty of Paris. Spain had a shaky hold on Florida during its second period of control. In West Florida, Americans poured in, asserting their independence and forcibly annexing much of the Gulf Coast west of the Perdido River. Americans swamped East Florida as well, an indication of Spain's inability to govern its territory. In 1821, in exchange for assuming $5 million of Spain's debt, the United States took possession of Florida. U.S. General Andrew Jackson had led raids into Spanish Florida twice, in 1814 and 1818, and the second raid marked the beginning of the First Seminole War—one of the primary reasons Spain relinquished Florida.

U.S. citizens were not the only people moving into Florida—native tribes, who once aligned themselves with the British against the Spanish in Florida, had begun to move south. At the beginning of the nineteenth century large portions of Florida's undeveloped interior became increasingly populated by Native Americans from outside the territory. They were not the first indigenous people to inhabit Florida. When Europeans landed in the sixteenth century, Florida's population may have been as high as 350,000. Ultimately these original Floridians remained somewhat autonomous and were able to coexist with the Spanish by pledging their loyalty. But they had no immunity to the diseases brought by the Europeans, and almost the entire indigenous population was decimated by the beginning of the 1700s.

Raids into Florida by English settlers from South Carolina and their Creek and Yamasee Indian allies had a detrimental effect on Florida's remaining indigenous people. After an uprising in 1715–16 known as the Yamasee War, in which various Native American groups attacked British settlers in South Carolina, Creeks and other tribes fled south into Florida, absorbing or eradicating what was left of the peninsula's original human population. The Spanish called these bands of displaced Native Americans who settled in Florida *cimarrónes,* meaning wild people or runaways, which translates in the Muskogee language as *simanó-li.* By the mid-1700s the term *Seminole* was common, and William Bartram visited several Seminole villages in north Florida.

When Florida became a U.S. possession in 1821, Seminole villages were seen as an obstacle to its settlement. American forces fought three wars against the Seminoles, who were eventually pushed into reservations in Oklahoma and south Florida. The Armed Occupation Act of 1842 encouraged settlers to usurp land Native Americans once occupied. But the threat of conflict with Seminoles remained throughout much of the nineteenth century, even as the population of Florida began to swell. The potential for hostilities with the Seminoles delayed the growth of tourism and helped determine which areas of the state would be developed first.[4]

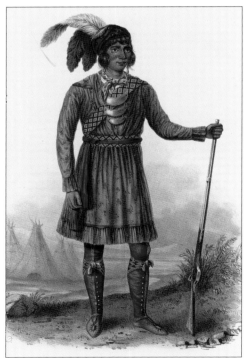 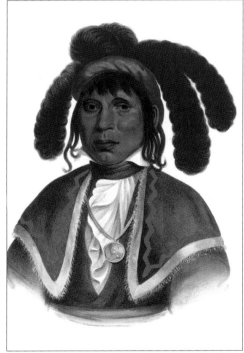

Left: An 1842 lithograph depicted the Seminole leader Osceola (in Creek, Asi-Yahola). *Right:* An 1838 lithograph portraying the Seminole chief Micanopy was based on a painting by Charles Bird King.

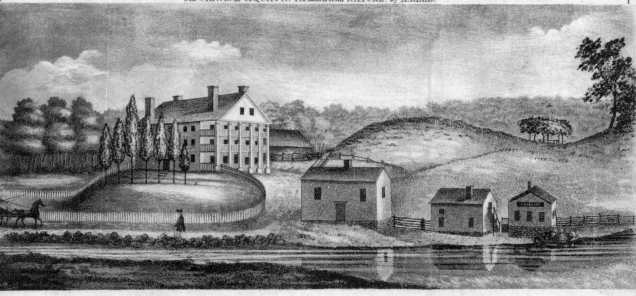

N. Western View of the HOTEL, and other Buildings, belonging to Dr. S. WILLARD, at the Mineral SPRINGS, in Stafford. (Con.)
Published by A. Reed, Engraver, Hartford.(Con.) June 1810.

An 1810 print shows the hotel and other buildings at the mineral springs in Stafford, Connecticut. John Adams visited the springs in 1771.

❀ NINETEENTH-CENTURY TRAVEL FOR LEISURE AND HEALTH

When much of Florida's population was composed of Seminoles and U.S. settlers living off the land, some well-to-do folks in the rest of the country found themselves with the money and time for leisure travel. Young aristocratic Europeans, especially the English, traditionally made a "grand tour" of the continent to visit the lands of the classical tradition, and those making the circuit were known as "tourists."

The whole notion of travel for pleasure in the United States, however, clashed with the Protestant work ethic that ran deep in the country's roots. According to author John P. Sears, for tourism to develop, a segment of the population must have enough free time and money to travel as well as a reliable means of transportation and a proper infrastructure to support travelers at their destinations. Significant tourism didn't develop in the United States until those requirements were met in the 1820s and 1830s, and popular watering places were among the first destinations for leisure travel in the United States. Those with means escaped to primitive facilities at mineral springs such as Stafford Springs in Connecticut, Ballston Spa in New York, and Bath Springs near Bristol, Pennsylvania. Eventually so many spas sprang up at the springs in western Virginia that it was nicknamed "America's Sanitarium."

Health was often the reason for travel, because as cities grew, they became havens for diseases such as yellow fever and cholera, and individuals who could afford to travel often escaped urban epidemics by fleeing to the country. Doctors frequently recommended that their patients partake of the salubrious air and healthful waters found at America's springs, seashores, and mountains as a cure for the illnesses

A 1912 image by Richard Tennant Cooper portrays an invalid visited by tuberculosis.

of the day. One of the major maladies of the nineteenth century and much of the twentieth was tuberculosis, at the time called consumption. Nicknamed the "white death" or "white plague" because of the pale complexions of its victims, the disease spread more rapidly as more people moved into cities during the Industrial Revolution. By 1851 one in four deaths in Europe and America was caused by tuberculosis. Strangely, the ghostly pallor exhibited by victims of the disease came into vogue among the fashion-conscious set.

The cause of tuberculosis would be discovered by Robert Koch in 1882, but effective treatment for the disease would not be found until the mid-twentieth century. In the 1800s, establishments stressing fresh air, exercise, healthy eating, and bathing in fresh water offered hope to tuberculosis patients in Europe. The first of these facilities, known as "sanatoriums" or "sanitariums" in the United States, opened in Saranac Lake, New York, in 1885, and soon American consumptives flocked to similar facilities, usually located in rural settings with fresh air, sunshine, and clean water. Consumptive travelers soon flocked to Florida.[5]

Dr. Edward Livingston Trudeau, a New York physician who suffered from tuberculosis, established the Adirondack Cottage Sanitarium in Saranac Lake, New York, in 1885.

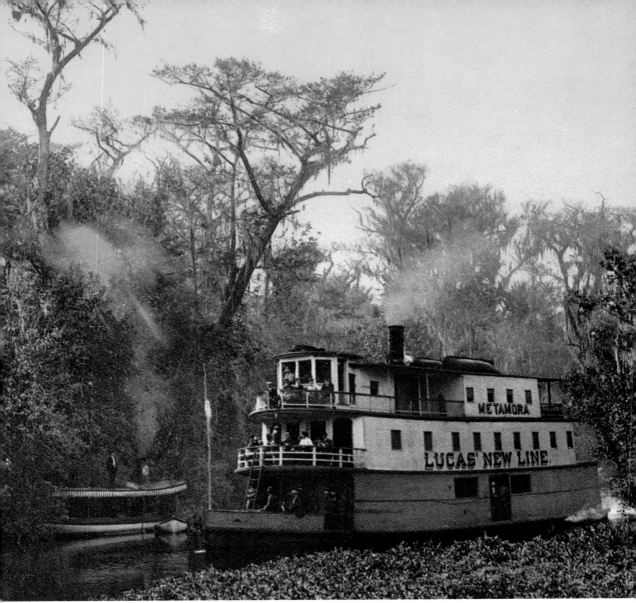

A 1902 photochrom print produced by the Detroit Publishing Company shows the steamer *Metamora* on the Ocklawaha River.

STEAMBOAT TRAVEL LAUNCHES FLORIDA TOURISM

The Seminole Wars limited the appeal of a journey into Florida's interior in the first half of the nineteenth century, and the lack of transportation and decent roads made it even less appealing. Settlers often used slow, single-axle oxcarts, and early travelers to the state were forced to rely upon uncomfortable stagecoach travel. Florida's ability to attract visitors on a large scale would not occur until transportation challenges were resolved. When the steamer *George Washington* traveled from Charleston to Jacksonville in 1827—the first steamboat to visit north Florida—it started a new era in Florida's history in which large portions of the state opened up to new visitors.

A steamboat at the busy wharf in Palatka during the height of the river city's popularity as a tourist destination.

The effects along the St. Johns River were almost immediate. Settlements such as Palatka, once a center of logging and agriculture, saw the their economy transformed as residents began to cater to out-of-state travelers arriving by steamboat. St. Johns travel between Jacksonville and Palatka was fairly well established by the early 1850s, when Captain Jacob Brock brought his steamboat *Darlington* to Florida, but there was little steamer travel between Palatka and Enterprise, about seventy miles to the south. After purchasing 140 acres in Enterprise, Brock opened up the upper St. Johns to regular steamboat traffic, bringing sportsmen and invalids to what is now south Volusia County. Farther west, steamboat traffic began on the Suwannee River in 1836 and on the Apalachicola River as early as 1828.

After the Civil War a popular steamboat excursion took travelers from Palatka up the Ocklawaha River to see Silver Springs. A cruise on this narrow, twisting tributary of the St. Johns played on Victorian desires to explore what they perceived as a mysterious world of dark, impenetrable nature. Steaming into the clearing over Silver Springs, the largest array of freshwater springs in the state, was compared with a religious experience. The romance and exotic quality of Florida's wilderness that travelers experienced on such steamboat trips appealed to the sensibilities of nineteenth-century visitors. Between the end of the Civil War and the later introduction of railroads, no single technology had more impact on tourism in the state. In addition to increasing invalids' access to Florida's healing waters, steamboat travel opened up the state to writers, who whet the appetites of hungry readers up north with tales of Florida's magical waters.[6]

LETTERS FROM THE FRONTIER: TRAVEL WRITING IN ANTEBELLUM FLORIDA

Before the Civil War few written accounts were able to capture the sense of wonder of traveling through Florida as effectively as the work of William Bartram. Much of the antebellum writing about Florida was created to encourage agricultural and industrial development of the state and portrayed its waters as an exploitable resource. Other promoters, however, saw Florida's rivers and springs as ideal for attracting health-seeking visitors, who sometimes bought property and thus became part of the unfolding settlement of the region.

One early account, Major Henry Whiting's "Cursory Remarks upon East Florida in 1838," contained long passages describing the St. Johns River and surrounding territory—the center of much of the growth in early nineteenth-century Florida. Whiting described Florida's climate as "truly delicious," noting that when peace with the Seminoles was achieved, the St. Johns River would present "many places of great attraction to the infirm and the pulmonic."

Many early accounts of Florida's healing powers understandably featured the venerable city of St. Augustine, including Rufus King Sewall's *Sketches of St. Augustine,* written in 1848, shortly after the end of the Second Seminole War. Sewall, a Presbyterian minister who moved to St. Augustine from New England in 1845, had health issues of his own and devoted his narrative to promoting St. Augustine as an ideal place for recuperation. The climate had "peculiar advantages over any interior or northern locality," he wrote, noting that the excellent weather exhilarated "one's energies and spirits." The "atmosphere" of Florida's coast was "believed to be medicinal in its effects," Sewall wrote, because the "various chemical ingredients" acted as "powerful disinfecting agents, which are perpetually elaborated, from the prodigious evaporation and other chemical combinations of the mineral waters of the sea, whose grand elements are *soda* and *chlorine*." In addition, Sewall listed the

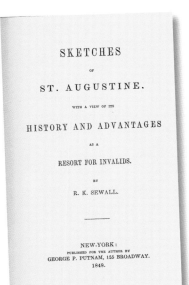

Title page and illustration from *Sketches of St. Augustine.*

diseases that were "favorably affected" by St. Augustine's climate, the accommodations for invalids (four public houses), and activities for recreation and amusement.

John Lee Williams's *The Territory of Florida* (1837) also described St. Augustine's well-established reputation as a destination for invalids. The city had become "celebrated for restoring tone to the system, in pulmonary and bronchial complaints," he wrote, noting that "invalids from every part of the United States resort here." Accommodations for visitors were rapidly improving, and soon St. Augustine would be hosting "persons of the first rank, who will be in no necessity for visiting Italy or the South of France, for the improvement of their health, as our climate is equally salubrious."

Beyond St. Augustine, Williams proclaimed that the ritual of sea bathing was practiced extensively in West Florida "by all classes of citizens," and it was "believed to restore more strangers to health than any other prescription." He also noted that "bathing has always been successfully practiced, in warm climates" and asserted that it had been "infinitely more beneficial in Florida, than medicine of any kind." Some of Florida's springs were "highly medical," Williams declared, noting the presence of "iron, sulphur, vitriol, and lime." Like Sewall, Williams had settled in Florida for his health, and although he devoted much of his book to descriptions of the topography, geography, and history of the territory, he also hinted at the healing potential of Florida's waters. Well before the outbreak of the Civil War, he and other writers laid the groundwork for the surge of visitors who would come to Florida later in the century in search of better health.

Illustration labeled "On the Florida Coast" from *Harper's Weekly*, 1888.

Above: St. Francis Street in St. Augustine. *Right:* St. Augustine Cathedral. *Bottom:* Ralph Waldo Emerson, 1859.

A TRANSCENDENTALIST'S TRANSFORMATION

ST. AUGUSTINE CATHEDRAL.

A pallid, sick Ralph Waldo Emerson traveled to St. Augustine in the winter of 1827, just six years after Florida became an American territory and only a few years before steamboat travel would introduce droves of northern visitors. Emerson suffered from tuberculosis that caused near blindness, joint stiffness, and a "pleurisy-like pain that increased in cold weather." Despite St. Augustine's lack of a real hotel until 1835, the town already had a reputation as a "haven for invalids from the north," as historian Patricia C. Griffin has noted. Emerson witnessed a slave auction, complained about the laziness of the locals, and described in a letter to his brother the monotony of his daily activities. "I stroll on the sea beach," he

wrote, "and drive a green orange over the sand with a stick. Sometimes I sail in a boat, sometimes I sit in a chair. I read and write a little, moulding sermons and sentences for an hour which may never arrive."

Despite his complaints, the solitary invalid was restored by his trip to Florida. He left with improved health, started his first poetry notebook, and was greatly influenced by an intellectual relationship with Prince Achille Murat, a St. Augustine resident and nephew of Napoleon Bonaparte. In what may have been a life-changing experience, Emerson "left New England as a youth, and came back from St. Augustine as a man."[7]

❧ PROMOTING AMERICA'S ITALY AFTER THE CIVIL WAR

When Florida officially entered the Union in 1845, it was a slave state, with almost half of the population made up of enslaved people. The economy of the middle portion of the state, between the Apalachicola and Suwannee rivers, resembled that of other southern states with large plantations worked by slave labor. Although a sizable portion of Florida's population opposed secession, Florida became the third state to join the Confederacy, just sixteen years after becoming a U.S. state, and sent 14,000 troops to the army of the Confederacy, a hefty number considering that the entire population of the state at the time was only 140,000.

The outbreak of the Civil War temporarily slowed the growth of Florida's tourist trade, but traffic rebounded after the war, and "Yankee strangers" began migrating to the South. *Strangers* was the common term for travelers before the war, according to historian Tracy J. Revels. In 1887 William Darrah Kelley documented a humorous exchange with some Florida pioneers, in which he asked them how they managed to eke out a living off the land. The settlers purported to survive "on sweet potatoes and consumptive Yankees," and when asked what they had to sell, they responded, "Our atmosphere." The seeds of Florida's tourism-based economy were already being sown.

"Yankees" were familiar with northeast Florida because Union troops occupied Jacksonville and nearby Fernandina Beach for much of the Civil War. During the war, escaped slaves followed the St. Johns River to freedom in Union-held parts of

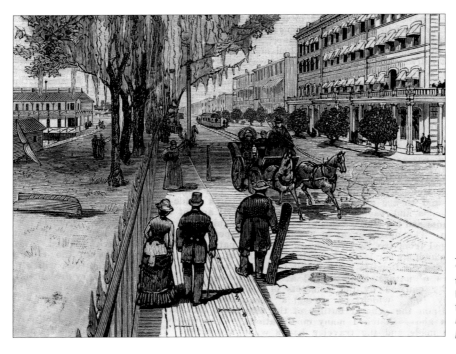

Jacksonville's "Points of Attractions for Pleasure-Seekers," from *Frank Leslie's Illustrated Newspaper,* 1883.

north Florida. Progressive northerners began arriving shortly after the end of the war to establish schools for children born into slavery and to help the Freedmen's Aid Society. Northern philanthropic and religious groups supplied both teachers and financial support, and boosters within the state encouraged northerners to come to Florida for social and economic reasons. Historian John T. Foster asserts that in the political melee to control Florida after the Civil War, some Floridians made a conscious effort to encourage northerners to move to the state to gain political control during Reconstruction. These efforts contributed to an expansion in the state's population—increasing it by almost fifty thousand people in the 1860s, despite the war, and by eighty thousand more in the 1870s.

The entry point for northerners coming to Florida during this period was most often Jacksonville; the city had convenient steamship connections to New York, Charleston, and Savannah, and its growth accelerated

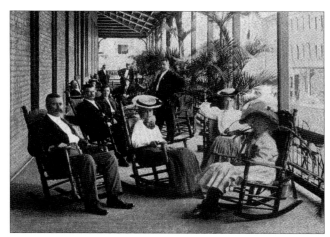

Porch of the Aragon Hotel, Jacksonville, circa 1910.

rapidly after the war. As early as 1865 Jacksonville boosters wrote promotional articles that were published in the North, extolling the benefits of living in the "Italy of America." Union soldiers returning to the North "carried with them glowing accounts of Jacksonville's mild, clear winters," and the entire state was portrayed as an "exotic place of natural wonders and powers that could rejuvenate frail health," according to a Jacksonville Historical Society essay. Ten years after the end of hostilities, Jacksonville boasted three large hotels, and every "fourth house was a boarding house," wrote T. Frederick Davis in a history of the city, adding that the hotels were often "filled to overflowing." By the 1884–85 season sixty thousand winter visitors descended upon Jacksonville, overwhelming the town's facilities to the point that many visitors were forced to go to other towns in search of accommodations.

A proliferation of postwar Florida guidebooks helped spur the state's tourism boom, and many directly addressed late-nineteenth-century readers' interest in physical well-being and spiritual restoration. In 1882 George M. Barbour published a Florida guide for "tourists, invalids, and settlers" that featured maps, illustrations, and agricultural information—anything a visitor to the state might need, including suggestions for invalids.

Despite Barbour's claims that he published the first guidebook about Florida, there is plenty of evidence to the contrary, including Daniel G. Brinton's 1869 *Guide-book of Florida and the South for Tourists, Invalids and Emigrants.* The author, a former Union Army surgeon, detailed transportation routes to Florida, along with its history and geography, and included descriptions of tourist accommodations from Pensacola to Key West. Among the mineral springs Brinton described were Green Cove Springs ("found of value in chronic rheumatism, cutaneous disease and dyspepsia"), large sulfur springs in Welaka ("which doubtless could be applied to sanitary purposes"), and a large sulfur spring in Enterprise ("as yet no provisions are made for the application of the waters to medical purposes").

Both Brinton's and Barbour's guides were typical of accounts written for northerners during the period and provide detailed information for both those wishing to visit Florida and those considering a permanent move. Extensive chapters directed toward invalids focused on climate, building a case that Florida's winter temperatures offered superior opportunities for recuperation, but also warning that weather alone might be insufficient to heal every patient. Brinton observed that often one saw in Florida "invalids deluding themselves with the idea that climate alone will cure them," and cautioned that rules of "personal hygiene and diet" were "half the battle." He added that a "plunge bath is good" and a "salt water bath is most useful to the invalid."[8]

Title pages for Barbour and Brinton guidebooks.

FLORIDA

FOR

TOURISTS, INVALIDS, AND SETTLERS:

CONTAINING

PRACTICAL INFORMATION

REGARDING

CLIMATE, SOIL, AND PRODUCTIONS; CITIES, TOWNS, AND PEOPLE;
THE CULTURE OF THE ORANGE AND OTHER TROPICAL FRUITS;
FARMING AND GARDENING; SCENERY AND RESORTS;
SPORT; ROUTES OF TRAVEL, ETC., ETC.

BY

GEORGE M. BARBOUR.

WITH MAP AND ILLUSTRATIONS.

NEW YORK:
D. APPLETON AND COMPANY,
1, 3, AND 5 BOND STREET.
1882.

A

GUIDE-BOOK

OF

FLORIDA AND THE SOUTH,

FOR

TOURISTS, INVALIDS AND EMIGRANTS,

WITH A MAP OF THE ST. JOHN RIVER,

BY DANIEL G. BRINTON, A. M., M. D.,

PHILADELPHIA:
GEORGE MACLEAN, 719 SANSOM STREET.
JACKSONVILLE, FLORIDA:
COLUMBUS DREW.
1869.

THE YANKEE PROSELYTIZER AND
THE CONSUMPTIVE CONFEDERATE

One of the Yankees who moved to northeast Florida—perhaps the best-known American author of the 1800s—would use the power of her celebrity to promote the state to fellow northerners. Harriet Beecher Stowe's novel *Uncle Tom's Cabin,* published in 1852, sold more than two million copies worldwide and became the best-selling book of the nineteenth century, next to the Bible.

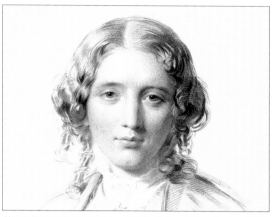

Above: Harriet Beecher Stowe, 1855. *Below:* Sidney Lanier, 1897.

Stowe first visited Florida in 1867, just two years after the end of the Civil War. She and her husband, famed minister Calvin Stowe, purchased a riverfront property in the small community of Mandarin south of Jacksonville. Over seventeen winters in Mandarin, Stowe published more than fifty articles in the *Atlantic Monthly,* the *Christian Union,* a newspaper co-edited by Stowe's brother Henry Ward Beecher, and the *Semi-Tropical,* owned by former Florida governor Harrison Reed. Her 1873 book about Florida, *Palmetto Leaves,* was a collection of seventeen articles that had appeared in the *Christian Union.* None of the other writers who promoted the state as an ideal destination for settlers, invalids, and tourists had the cachet and readership of Stowe at the height of her popularity.

For another author, the southerner Sidney Lanier, who fought for the Confederacy during the Civil War, writing about the scenery of Florida was a paid assignment for the Great Atlantic Coastline Railroad Company. Like Stowe, he created poetic prose glorifying the wonders of Florida with the intention of motivating travelers to follow in his footsteps. Though Lanier lacked Stowe's gravitas, his writing about the Sunshine State still resonates. A musician and poet as well as an author, over his lifetime Lanier worked as a teacher, attorney, musician, hotel clerk, and finally a professor at Johns Hopkins University. During his service in the Civil War he was captured and imprisoned in Maryland, where he likely contracted tuberculosis. During the three months in

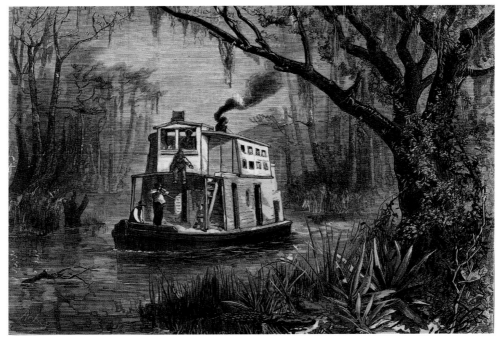

Lanier compared an Ocklawaha steamer to a "Pensacola gopher"; Stowe likened the boat to a "coffin in twilight."

which he toured Florida for the Great Atlantic Coastline Railroad Company, he earned $125 per month plus travel expenses and ultimately produced some of the most elegant descriptive passages about the state and its scenery written in the nineteenth century. Published in 1876, his completed project bore a lengthy title: *Florida: Its Scenery, Climate, and History. With an Account of Charleston, Savannah, Augusta, and Aiken; a Chapter for Consumptives; Various Papers on Fruit-Culture; and a Complete Hand-book and Guide.*

One of Lanier's best-known passages about Florida described the journey to Silver Springs. Depicting the St. Johns as a "place of abundant waters fed from eternal springs," he christened the Ocklawaha the "sweetest water-lane in the world." He compared the steamboat *Marion* to a "Pensacola gopher with a preposterously exaggerated back." For Lanier, absorbed in the beauty and mystery of the winding Ocklawaha, the sensation of cruising on the river produced a "mutual give-and-take" between the "natures of water and leaves" that in its totality seemed to "breathe coolly out of the woods."

Stowe, a veteran of the practice of taking the waters, described Green Cove Springs as a "great curiosity." The water feeding the celebrated sulfur baths there welled up from a chasm thirty or forty feet deep, "between what looks like great greenish ribs" of sulfur, she wrote, describing the small spring near the St. Johns River. The crystalline water was "so warm as to produce no shock"; the result "buoys one up delightfully," Stowe wrote. She described the spring's manmade pool as a "great bathing tank of about a hundred feet long, surrounded by a high wall

overhung by live oak trees," with a row of dressing rooms for bathers on one side, and concluded that after a dip in the spring, she felt a "peculiar feeling of refreshment and exhilaration"—altogether "most agreeable."

Lanier's chapter of advice to fellow consumptives was less poetic and proffered practical tips, such as partaking of "generous diet, fresh air, ameliorative appliances and muscular and respiratory expansions" as a means of controlling the disease. Oddly, he advised against getting "wet, cold or tired" yet offered accounts of medicinal springs such as Green Cove, where the water was useful "for the cure of rheumatism, gout, Bright's disease of the kidneys, and such afflictions," he wrote. Sadly, Lanier ultimately succumbed to the same disease that brought so many visitors to Florida; he died from complications related to tuberculosis in 1881, six years after his guidebook was first published. His rich descriptive prose, however, lives on as one of the finest examples of postbellum Florida travel writing and is closer in spirit to the vibrant writings of Bartram and Stowe than are the guidebooks by Brinton and Barbour.

The influence of these early travel writings was just one aspect of the late nineteenth-century body of narratives promoting Florida. The Sunshine State was touted in everything from conventional travel writing to sporting guides, newspaper serials (most notably in the *New York Times*), and articles in magazines such as *Harper's* and *Scribner's*. Health manuals, railway travel guides, letters and journals, scientific studies, and business-advice manuals all contributed to a wide array of writing about early Florida.

As the state's tourist infrastructure grew, the amount of ink taken up by Florida in print media increased exponentially. The Victorian era is marked by a huge increase in printed materials, in part because reading was incredibly popular due simply to the fact that more people knew how to read. Moreover, publication costs had dropped, distribution had improved due to better transportation, and toward the end of the century, the arrival of gas and electric lighting in homes made it easier to read after dark. Northern invalids were a primary audience for many of the articles and books about Florida, which often focused on the state's balmy climate.[9]

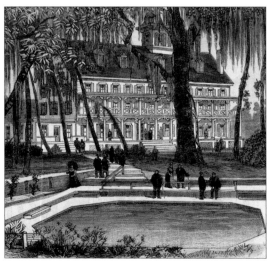

"People of modest means can find private board on reasonable terms at Green Cove Springs," Stowe wrote in 1874.

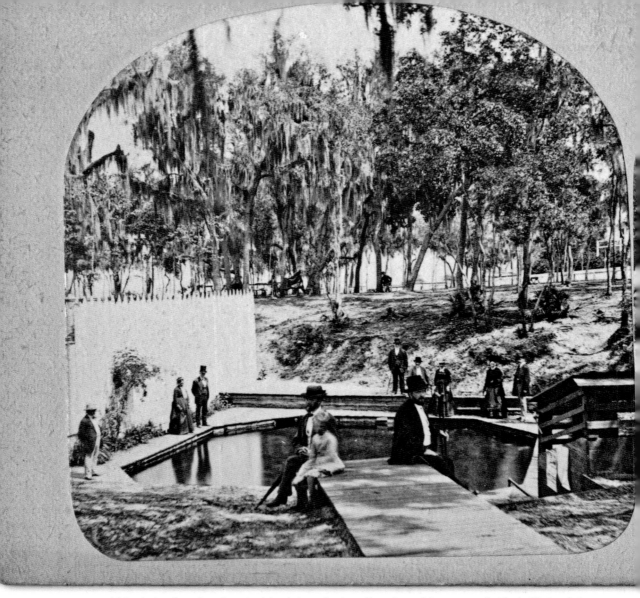

A late nineteenth-century stereograph by photographer Isaac Hass shows visitors surrounding the bathing pool at Green Cove Springs.

SPA SOCIETY COMES TO FLORIDA

As a result of all the publicity, many northerners became aware that Florida offered a climate that allowed for year-round bathing and a respite from the harsh winters in the cities of the North. In the nineteenth century both drinking and bathing in Florida's mineral waters were considered effective in curing a variety of ailments, and entrepreneurs explored a variety of investment options, from shipping bottled water out of the state to building luxury health resorts near springs with amenities such as tennis courts and golf courses. The advent of train travel to Florida made even more springs accessible to a larger group of potential customers, and

accessibility to railroads alone could determine a resort's survival. Eventually trains and improved roads unlocked even more of the state to visitors, allowing better access to the coasts for sea bathing and to inland sites where sanitariums were established to take advantage of the healthy climate. But spring-based spas were Florida's first well-developed resources for medical tourism.

When Victorian travelers took the waters at a Florida spa, it is likely many of them had also visited resorts such as Saratoga Springs or even spas in Europe. A handful of primitive antebellum spas were improved into more luxurious facilities after the Civil War, and as the state became more developed, greater numbers of visitors arrived, demanding comfortable accommodations.

Spa locations accessible by steamboat and railroad had distinct advantages over those that could be visited only by stagecoach or buggy. The harder-to-reach springs attracted a local client base and were more often used as sites for recreation than for healing. Not everyone who stayed at a spa was an invalid, although in the nineteenth century being incapacitated by illness was fairly commonplace. Participating in the spa lifestyle was seen as good for one's overall health, and like the spas of Europe, Florida spas offered social opportunities that were a crucial component of the experience.

Advertisements for spa resorts made every effort to assure potential visitors that they offered the luxurious rooms, the finest cuisine, and the most entertaining amenities, to rival any hotel up north. Promotions for the Altamonte Hotel in Altamonte Springs, for example, touted rooms furnished with gas lights, electric bells, and fireplaces, and the pine forest that surrounded the hotel exuded a "pungent aromatic air" that "science and experience unite in pronouncing wholesome." For dinner, the menu included the choicest cuts of meat, fresh seafood from Tampa Bay, locally grown produce, and of course, "the purest spring water that anywhere flows from the ground." For entertainment, guests could enjoy hunting, fishing, boating, billiards, bowling, and healthful walks through the "ever-green woods and fragrant orange groves."

Aside from bathing in and drinking the mineral water, there was no one typical experience for taking the waters in Florida. Arriving via a bumpy tram ride in Panacea Springs was radically different than stepping off a steamboat and being serenaded by a band at Green Cove Springs. Bathing in the multitiered Victorian springhouse at White Sulphur Springs was considerably different from soaking in the primitive natural settings offered at many other springs, or even filling a jug at an artesian well. Some resorts brought the spring water directly to

Guests sitting on the front porch of the Altamonte Hotel, 1890.

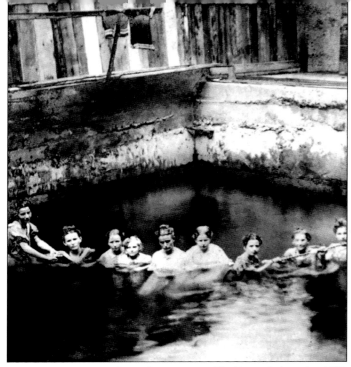
Female bathers in the pool formed from concrete at Worthington Springs, circa 1909.

the guests by offering private hot or cold water baths inside the spa itself. North Florida's Suwannee Springs boasted that the sulfur water was pumped to nearby cottages using a steam pump "without losing any of its gases."

Most of the natural springs at Florida destinations during this era were "improved" in some fashion. Wooden manmade pools that initially contained the spring water were later replaced by more permanent structures formed of rock or concrete walls. In a few places the entire spring was encased within a springhouse to ensure the purity of the crystal-clear water. Bathhouses were also constructed near the springs to give bathers privacy, although many Victorian bathing outfits virtually covered the entire body from head to foot, and bathing was frequently segregated by gender. Some facilities never developed overnight accommodations and were used only as day-trip destinations. A few property owners charged a small fee for visitors to soak and use their spring's bathing facilities, while others remained free.

In the Victorian era the language used to describe bathing in spring water was often flowery and grandiose. A bath at Espiritu Santo Springs was touted as "a delight, exhilarating, soothing, and most refreshing, leaving the skin a glow, and as free from harshness as an infant's." The proprietors of Magnolia Springs claimed a plunge into their pool of soft sulfur and magnesia water would make one's skin feel like velvet. Many springs, however, strictly promoted the efficacy of their water in curing specific aliments. Ads for Suwannee Springs, for instance, defined its medicinal waters as both "copious and perpetual" and provided a long list of ailments the waters could cure, ranging from rheumatism to chronic diseases "arising from the use of alcohol and opium."

It is difficult to say exactly how many of Florida's springs were developed into spas, because much of the built environment of that era has been lost. Only a few vestiges survive as archaeological relics, such as the pool at Hampton Springs or the remnants of the springhouse at White Springs. We have evidence, though, that at

least twenty-three spas once existed alongside Florida mineral springs. The best way to trace their evolution is through printed accounts: articles in travel guides, advertising ephemera, and newspaper ads. Scattered throughout the state from the end of the Panhandle to the edge of the Everglades, many of the same springs still flow but are today utilized mostly for recreation. Water from the Floridan Aquifer is still bottled and sold to health-conscious consumers nationwide by multinational brands, including Nestlé and Coca-Cola. But with the notable exception of a handful of survivors, most of these businesses closed decades ago.

The golden age of bathing at Florida springs flourished between the end of the Civil War and the beginning of the era of automobile travel. Invalid travel to spas that used water for restorative purposes helped to create the state's tourism industry. Contemporary promoters have dubbed the northeast portion of the state Florida's "First Coast"—the area where St. Augustine was founded in 1565—and it's a logical starting point for a survey of Florida's healing waters. Both St. Augustine and Jacksonville have long had reputations as havens for invalids. Steamboat travel out of Jacksonville made the springs of the St. Johns River accessible, and the spas along the river were among the first to welcome northerners who flooded the state after the hostilities of the Civil War ended.[10]

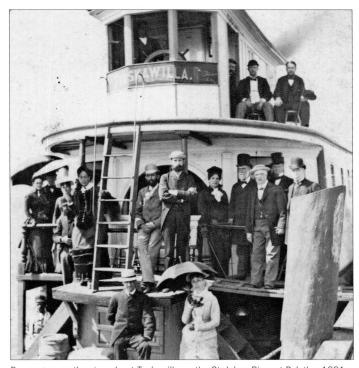

Passengers on the steamboat *Tuskawilla* on the St. Johns River at Palatka, 1881.

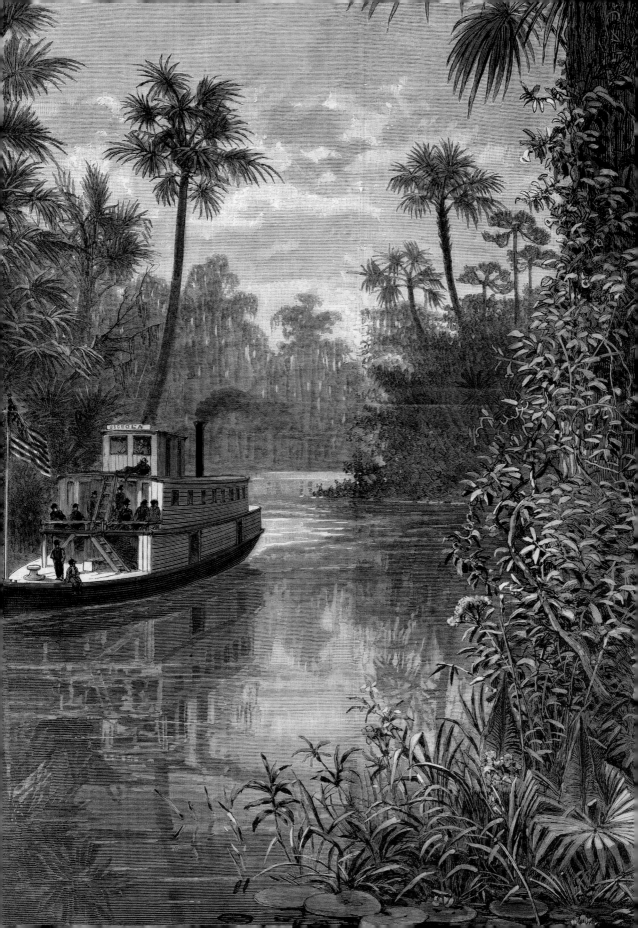

RESTORATIVE SPRINGS NEAR THE ST. JOHNS

Healing Waters along Florida's Heritage River

Thousands of tourists annually ascend the St. Johns River and its sole large tributary, the Ocklawaha, and numerous large hotels have been erected for their accommodation along the banks of these rivers in favourable localities, usually near the spot where rises some one of the immense number of mineral springs which empty into them.

—*Frederick Trench Townshend*, Wild Life in Florida, With a Visit to Cuba (1875)

It was called Welaka, river of lakes, in the Timucuan language, but Florida's great St. Johns River could just as easily have been called river of springs, because almost a hundred documented springs flow into it. The St. Johns flows north and, at 310 miles, is the state's longest river. Dubbed the River Mai (River May) by French explorer Jean Ribault, it was renamed the San Juan by the Spanish and anglicized by the English as the St. Johns. In 1998 President Bill Clinton proclaimed it an American Heritage River, one of just fourteen such rivers nationwide.

The St. Johns served as eastern Florida's main transportation conduit throughout the nineteenth century, when most of its riverboat traffic originated in Jacksonville, a city controlled by Union troops for much of the Civil War. After the war Yankee tourists descended upon Jacksonville, arriving from Charleston and Savannah by steamer and giving destinations along the St. Johns a head start in Florida's tourist trade. In 1840 Jacksonville had only about 350 residents, but by the century's end, it was drawing more than 70,000 visitors annually.

In addition to the warm weather, the primary attraction for northern tourists visiting Jacksonville in winter was the opportunity to venture by steamboat into the untamed, exotic interior of the state—on river excursions that "opened up the 'healthful influences of nature,'" as historian Henry Knight notes. Exploring the wild river by steamboat, travelers found oases of civilization at resorts located at

An 1880 illustration from *Harper's Weekly* depicts a steamboat on the Ocklawaha River, a tributary of the St. Johns River and a popular excursion route for those taking the waters at springs along the St. Johns.

mysterious springs that appealed to both the infirm and the healthy. Luxury accommodations awaited at destinations such as Green Cove Springs and Magnolia Springs, where the wealthy wintered, enjoying leisure activities and cosmopolitan entertainment while maintaining the lavish lifestyle enjoyed by elite society. The region's spring water became so famous that a hotel in Altamonte Springs (near Orlando), not connected to the river, could thrive, and mineral water from artesian wells near the St. Johns could be marketed through brands that became well known nationwide. The perceived healthfulness of the water as both a draw for tourists and an exportable resource had an enormous effect on the development of the entire St. Johns River region and Florida as a whole.[1]

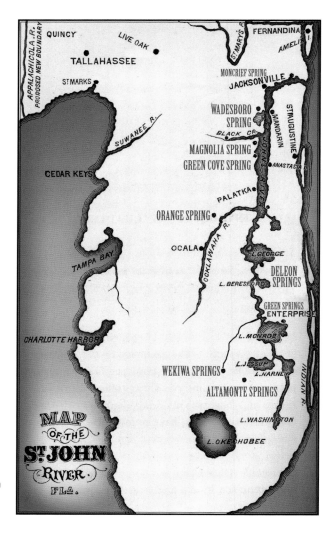

Above: At the peak of the steamboat era there were almost forty stops along the St. Johns River between Jacksonville and Enterprise. *Right:* A period map shows the watering places in the St. Johns River region.

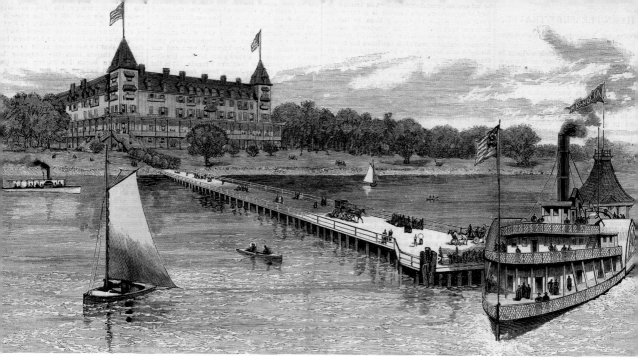

The grand Magnolia Springs Hotel was twenty-eight miles south of Jacksonville and offered a swimming pool, baths, and famed drinking water.

❧ MAGNOLIA SPRINGS: PIONEERING HEALTH RESORT WITH A HEFTY HISTORY

One of Florida's premier nineteenth-century destinations on the St. Johns in north Florida was the capacious resort at Magnolia Springs. The destination arose from inauspicious beginnings, originating as a health retreat for invalids created by doctors and then growing into a haven for the fashionable set, with a standard of luxury that eclipsed anything else in the region.

The area's recorded history goes back to an indigo plantation that East Florida's last British governor, Patrick Tonyn, established in what is now Clay County. The next owner, an Englishman named Thomas Travers, served as royal doctor to the Spanish during their second period of Florida rule, and so was able to retain his plantation. He was the first of several physicians to own the land that would become Magnolia Springs.

Plantation operations ceased during the Second Seminole War (1835–42) but resumed under the ownership of Joseph Finegan, who had married Rebecca Travers, the widow of Thomas Travers's son William. Finegan would later direct the Confederate forces at the Battle of Olustee and would ultimately command all Confederate forces in Florida during the Civil War. He sold the property to Joseph Summerlin, whose family fed the Confederacy with cattle they raised throughout the state. Summerlin, who owned a sawmill, built the first hotel on the property, which for a time was known as Magnolia Mills or simply Magnolia.

Above and *left:* Postcards and advertising for the Magnolia Springs Hotel promoted a luxurious setting in a healthful atmosphere.

The next owner, Dr. Nathan Benedict, established Magnolia's identity as a destination for invalids. A northern physician who had managed the New York State Lunatic Asylum, Benedict came to Florida in 1853 to convalesce from illness. He advertised the hotel as a health sanitarium; newspaper articles from the mid-1850s mention Magnolia Springs as a retreat for consumptives, noting the mild climate and accessibility via steamer.

During the Civil War both Confederate and Union troops occupied the hotel at different times, and in 1864 members of the 102nd U.S. Colored Infantry Regiment dug trenches on the property that, after the war, were transformed into bunkers for a hotel golf course. During the early days of Reconstruction the Freedmen's Bureau used the hotel as a hospital and orphanage (the physician in charge, Dr. Joseph W. Applegate, would also play an important role at neighboring Green Cove Springs).

In 1869 Benedict sold the hotel to Oliver F. Harris and Dr. Seth Rogers, a Quaker abolitionist who had joined the Union Army as a surgeon for the black soldiers of the First South Carolina Volunteer Infantry. Before the war Rogers had been the proprietor of the Worcester Hydropathic Institution, also known as the Worcester Water-Cure. He and Harris enlarged the hotel and built cottages nearby to accommodate even more visitors. But it was the next owners, Boston businessmen Isaac Cruft and Joseph Story Fay, who made the most dramatic expansion: the new 210-room Magnolia Hotel, constructed in 1881 after fire damaged the previous structure.

The 1881 hotel offered the luxuries wealthy guests expected: a hydraulic elevator, in-house telegraph, photographic darkroom, and even electric lights installed by Thomas Edison. Recreational options included golf, tennis, croquet, hunting, fishing, yachting, and swimming in a 70-by-30-foot indoor pool filled with "crystal spring water." Guests were served mineral water, bottled on-site, that possessed "medicinal qualities" in healing chronic disturbances of many kinds, advertisements proclaimed. Testimonials in hotel pamphlets raved about the water's ability to cure rheumatism, and a "prominent physician" testified that the water would benefit "gout and kindred afflictions." Around 1900, "springs" was added to the resort's name, and it became the Magnolia Springs Hotel.

Ironically, it is not clear that Magnolia Springs actually ever had a natural artesian spring. In his history of Florida's spas Burke Vanderhill wrote in the 1970s that Magnolia did have a small spring until 1882. According to the Florida Geological Survey in 1912, a well was drilled in 1882, and the water was "bottled and sold as medicinal and table water." The United States Geological Survey's comprehensive 1977 study of Florida's springs calls Magnolia Springs a former "pseudo spring." Perhaps the flow of a small spring at the site was supplemented by a manmade well.

Spring or no spring, the Magnolia Springs Hotel rose from its beginnings as a plantation and hospital during the Civil War to become a thriving destination that helped set the standard for Florida spa resorts in the Victorian era. Guests arriving by steamboat were greeted by a brass band, and those arriving by train were delivered to the hotel by a mule-drawn trolley. The interior decoration included

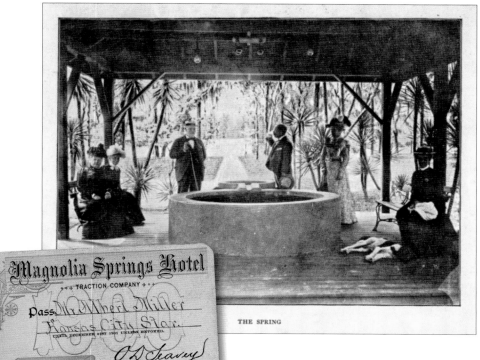

Bottom left: The Magnolia Springs Hotel Traction Company operated the mule-drawn trolley between Magnolia and Green Cove Springs. *Left:* Guests gather to sip the spring water, advertised as "wonderfully pure and free from all indications of contamination."

THE SPRING

"Mexican onyx columns," glistening floors that shone like "French plate mirrors," and "commodious" apartments that were beautifully carpeted and furnished, a brochure proclaimed. Guests often strolled the scenic riverside trail called St. David's Path, or the "Lover's Walk," to nearby Green Cove Springs, which greatly benefited from the early success of Magnolia Springs.[2]

MARKING MAGNOLIA SPRINGS

When Boston developer Isaac Cruft first came to Magnolia Springs in 1881, he was accompanied by O. D. Sealey, an experienced hotelier at Cruft's summer resort in New Hampshire. Sealey operated both the Magnolia Springs Hotel and Cruft's splendid San Marco Hotel in St. Augustine. While working at the San Marco, Sealey came to the attention of Standard Oil tycoon Henry Flagler, who hired him and relied on his extensive hospitality expertise in creating Flagler's opulent Hotel Ponce de Leon in St. Augustine.

In 1898 Sealey purchased the Magnolia Springs Hotel, upgraded the amenities, and moved into a cottage on the hotel grounds. In 1919 he rented the hotel to the Florida Military Academy, a boys' prep school, which used the once ostentatious hotel as its home until a fire destroyed the four-story building on November 11, 1923.

I first visited Magnolia Springs with members of the Clay County Historical Society, who showed me where water from the aquifer still trickles into the St. Johns River, just north of Governor's Creek. I also toured the former location of the grand hotel, now occupied by nondescript two-story apartments, used in the past as housing for government employees stationed at the Naval Station at Green Cove Springs.

Across the street an imposing wrought-iron gate guards a cemetery dating back to the mid-1800s. Most of the original headstones have been stolen or vandalized, including those of Civil War veterans from both armies. A contemporary granite obelisk that Clay County officials placed in the cemetery to honor the Civil War dead is the only indication that Magnolia Springs was once the site of such significant history.

This obelisk, dedicated to soldiers and residents buried in the cemetery at Magnolia Springs, was erected in 2011.

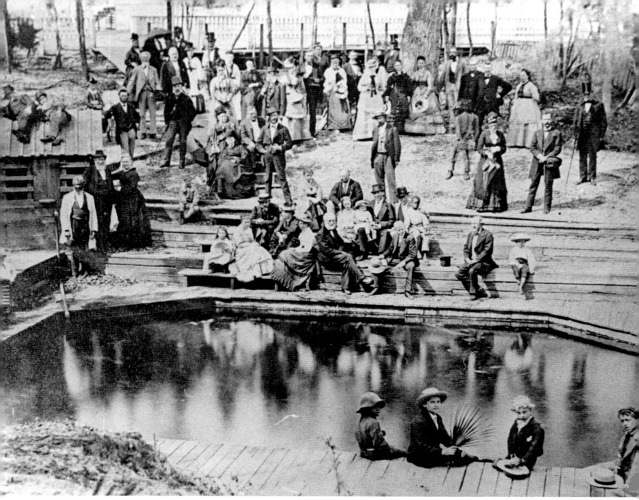

The guests photographed around the spring at Green Cove Springs in the 1880s included two dapper gents (*upper left*) reclining on the pump house that sent water to the Clarendon Hotel.

GREEN COVE SPRINGS: SARATOGA OF THE ST. JOHNS

Compared with the millions of gallons churned out every day at Florida's Silver Springs, the volume of water flowing from Green Cove Springs is modest. The power of this sulfurous third-magnitude spring, however, comes not from the flow it produces but from the enormous impact it has had on the state's history. This little mineral spring not only spawned a town that grew into a county seat but also helped establish the industry that connected ailing northerners to the state's health-giving spring waters.

The origin of this watering place dates back to 1834, when David Palmer, a shipbuilder from Connecticut, teamed with Darius Ferris, a real estate speculator from Jacksonville, to purchase a thousand acres around the spring for $750. Twenty years later Ferris's widow Sarah and Palmer developed the property by clearing land, surveying streets, and naming it White Sulphur Springs. Their venture was suspended during the Civil War, when soldiers occupied the town's only boardinghouse, the Gleave House, but the pace of development accelerated after the war.

Green Cove Springs photographer Isaac Hass captured an image of guests in a rustic setting.

In 1866 the town around the spring was renamed Green Cove Springs, and the post office moved from Magnolia Springs the same year. In 1871 Sarah Ferris donated land to Clay County to relocate the county seat, and in 1874 Green Cove Springs was officially incorporated. From the 1870s through the 1890s it expanded at a meteoric rate, catering to the northern visitors who flocked to its little sulfur spring, and taking its place as the St. Johns region's premier destination for taking the waters. Even during the late 1860s, when a New Englander named Ledyard Bill visited Green Cove Springs, the village was popular enough to have to turn away overnight visitors because all accommodations were booked. Rooms were for rent in private homes, boardinghouses, and the Union Hotel, which had space for about fifty visitors. Bill, who reported on his travels in a book titled *A Winter in Florida,* noted that the town's main attraction, the spring, was in an "unimproved state," but he rightly predicted that the settlement would become the primary destination for invalids on the St. Johns River.

In 1871 the opening of the Clarendon Hotel, built by John H. Harris and Arthur F. Aldrich, improved the accommodations in Green Cove Springs considerably. The Clarendon offered visitors modern luxuries ("spring beds, hair-mattresses, electric bells") as well as a bowling alley and billiard room. Through an agreement that gave the

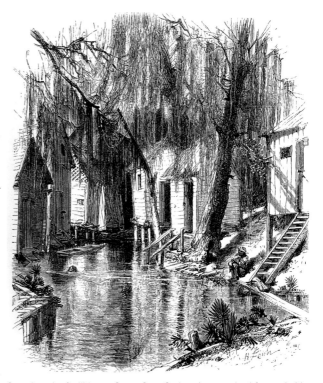

Over time the facilities at Green Cove Springs have evolved from primitive shacks (*above*) to a bathhouse complex to today's swimming pool and pavilion.

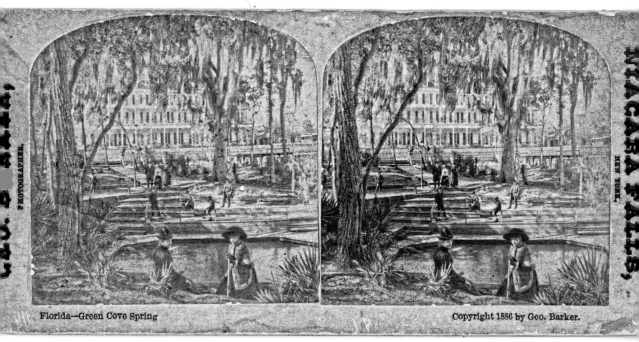

Florida—Green Cove Spring

Copyright 1886 by Geo. Barker.

NIAGARA FALLS, NEW YORK

George Barker gained fame as a photographer in Niagara Falls, New York, and produced stereograph images in Florida as early as 1886.

hotel exclusive rights to the spring water, guests could indulge in both hot and cold sulfur-water baths within the hotel. A few months after the Clarendon opened, Aldrich sold his share to Dr. Joseph W. Applegate, the doctor at the former Freedman's Bureau hospital and orphanage at Magnolia Springs. In addition to being the Clarendon's staff physician, Applegate presented lectures to guests on the benefits of the sulfur-laced water and, with his partner Harris, started a water-bottling business that shipped the spring water to New York.

Outside the hotel, the bathing area was upgraded with the construction of pools adjacent to the spring and separate dressing areas for men and women. In 1882 a Kentucky newspaper described the pool area as seventy-five feet long, twenty-five feet wide, and four feet deep, with "commodious dressing rooms." The water was touted as an effective cure for severe "rheumatic affections, kidney complaints and neuralgia," the writer noted, and tourists often asked to have bottles of water shipped "long distance for the benefit of others," despite the "peculiar taste."

With its two guest cottages and space for two hundred guests, the Clarendon was often billed as the largest hotel on the St. Johns River, rivaling the nearby Magnolia Springs Hotel in popularity and grandeur. Sadly, the wooden hotel, which can be seen in the background of many stereograph views of the era, burned down on April 3, 1900. Only one of its two cottages survives. However, despite the loss of the Clarendon, at the peak of its popularity Green Cove Springs and the surrounding area offered visitors a minimum of eight different accommodation options, with about six hundred rooms available by 1884. The town was dubbed the "Saratoga of the South" for its variety of winter activities, including dances, concerts, croquet, and horse racing. In the eventful 1880s the railroad came to town, a telephone line

The Qui-Si-Sana bathing complex was built behind the spring, which was enclosed in a circular basin, in 1907.

connected Green Cove to Magnolia Springs, and a weekly newspaper called *The Spring* was founded. In addition to two steamboat lines that brought guests from Jacksonville on a daily basis, smaller steamers and launches were available for visits to nearby waters such as Governor's Creek, hunting excursions up Black Creek, or day trips to Palatka.

Green Cove Springs was prominently featured in much of the travel literature of the era. In 1889 a "Pocket Directory" to the town was published to promote its businesses and services. In addition to describing "beautiful parks, mammoth hotels, commodious churches, schools, pretty residences and lovely flower gardens," it painted a romantic picture of the Lover's Walk, where one might wander by "sparkling rivulets" under moss-laden oaks. Distinguished visitors included President Grover Cleveland and P. T. Barnum, who described Green Cove as a "delightful winter retreat" that was "health restoring." Its charms were enough to entice Barnum to consider building a winter cottage there. Other northerners did purchase real estate in the prospering community, including John C. Borden of condensed-milk fame and retail giant J. C. Penney.

In 1907 a new era began in Green Cove Springs when a Spanish Mission–style hotel arose like a phoenix from the ashes of the Clarendon Hotel. In addition to this three-story concrete structure, dubbed Qui-Si-Sana (said to mean "here is health"), the bathing complex at the spring was completely rebuilt and now included "ten

bathing pools of naturally flowing water" beneath a roof of glass. The resort also featured a casino and bathhouse building, designed to match the hotel's architecture and modified and expanded over the years. In 1917 a dance hall and new outdoor pool were added. Other amenities for guests included Turkish and Russian baths, a solarium, and a golf course. Spring water was available in every room.

In the twentieth century, as the popularity of taking the waters diminished, so did the Qui-Si-Sana's fortunes. Occupancy increased for a short period after the creation of Lee Field and the Naval Auxiliary Air Station in Green Cove Springs during World War II. But by the 1990s the hotel was being used for apartments and storage; it ultimately fell into disrepair and was demolished in 2002. Green Cove Springs City Hall now occupies the site and was designed to resemble Qui-Si-Sana's architecture.

The previous city hall was built as a Works Progress Administration project in 1938 on the site of the Qui-Si-Sana bathing casino. A spring-fed swimming pool was located behind the New Deal–era building, and the spring was contained in a circular concrete basin. The old city hall, unstable on its foundation of the old bathhouse complex, was demolished in 2015, and a new two-story structure was built on the site in the summer of 2017. The spring-filled swimming pool was also rebuilt and is popular with residents and a small handful of tourists who still seek the waters.

Due to its proximity to Jacksonville, the popularity of steamboat travel on the St. Johns River, and the growth of Florida as a haven for invalids, Green Cove Springs prospered especially toward the end of the nineteenth century and enjoyed a two-decade reign as the epicenter of Florida's golden age of bathing. As a new century began, its popularity as a tourist destination began to decline. Today the sleepy river town is looking to encourage the growth of ecotourism with new amenities in Spring Park, home to the "mystical spring" that the city's website dubs "nature's signature piece of art."[3]

The Qui-Si-Sana bathing complex was built behind the spring, which was enclosed in a circular basin, in 1907.

A TWENTY-FIRST CENTURY PLUNGE

Steamboats and passenger trains no longer shuttle travelers to Green Cove Springs—so to take the waters at the "Saratoga of the South," I had to drive. It's about a thirty-minute trip from St. Augustine, crossing the St. Johns River on the Shands Bridge near the site of William Bartram's short-lived plantation. I checked in to a vestige of Florida's golden age of bathing, the River Park Inn, the sole cottage that survived from the Clarendon Hotel's era and the former home of Clarendon owner Dr. Joseph W. Applegate. The three-story bed and breakfast is just feet away from Spring Park, where the city-owned pool is open from early May through the end of September.

To bathe in the pool, which is surrounded by a metal fence, I had to sign a long legal disclaimer and pay four dollars. The springhead is fenced off now, surrounded by a shallow pool interspersed with randomly placed limestone boulders, and the water is piped from the spring into the pool. Nearby is a splash pad for kids, who seemed to be having a blast playing in the water jets.

Floating ropes divide the pool into three zones according to depth. The shallow end was full of about a dozen kids using the rope as a makeshift volleyball net, and I headed for the deep end for a more serene bathing experience. Around the edge of the pool is a recessed ledge where one can sit and soak. Although the advertised water temperature is 77 degrees—about 5 degrees warmer than most Florida springs—the water felt extremely cool on this overcast September day.

All in all, except for feeling chilly, my experience wasn't all that different from bathing in any municipal swimming pool. The biggest difference was smell. Instead of being overwhelmed by the odor of chlorine, I was engulfed by the aroma of sulfur (actually hydrogen sulfide gas—the same smell John Bartram had complained about centuries earlier). I tried to imagine what it might have been like for bathers in the 1800s and noted that many of the magnificent oaks surrounding the pool might have witnessed countless others soaking in these same waters. I also observed that the spring run is still lined with tropical banana trees as illustrated in early engravings in the travel literature of the period.

After thirty minutes I left the pool and headed back to the comfort of the River Park Inn. It took some time to get warmed up—not a bad thing on a hot, humid day. I also observed that I felt extremely relaxed, a feeling I've noticed after other hydrotherapy experiences. Maybe it was the Old Florida vibe of tiny Green Cove Springs. Or maybe it really was something in the water.

In 2017 the City of Green Cove Springs opened a renovated $2.2 million Spring Park with a 135,000-gallon pool.

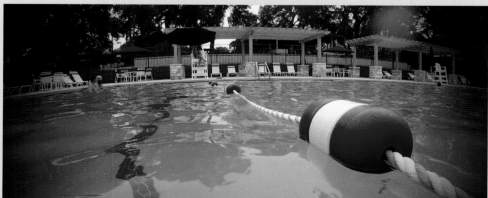

Among the stories associated with Wadesboro Spring is that the pirate "Dangerous Dan" McGirt hid his treasure in the spring.

WADESBORO SPRING: ORANGE PARK'S ROARING MAGNETIC MARKETING MACHINE

The Florida town of Orange Park was founded on land that was once home to the McIntosh plantation, also known as Laurel Grove. Washington G. Benedict purchased the 9,000-acre parcel in 1876 and organized the Florida Improvement and Winter Home Company to rebrand it and capitalize on northerners' dreams of owning orange groves. He platted a town, built a long dock extending into the river for steamboats, and opened a luxurious hotel for visitors.

Always the marketer, Benedict created colorful maps showing lots for sale and published a tabloid extolling the healthful virtues of the town, with frequent reminders of how sleeping on the "Pino-Palmetto Mattress" he patented could cure anything from asthma to "nervousness and general debility." To grab the attention of passengers on passing steamboats, he placed on the riverfront an enormous wooden sign, two hundred feet long by fifteen feet tall, with letters spelling out "Orange Park"—the name he chose for his town. Benedict also knew the power of

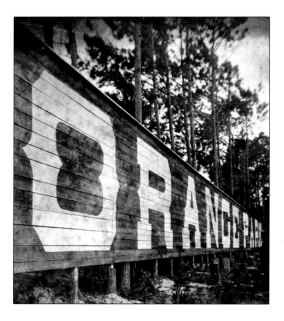

Orange Park's sign was two hundred feet long and fifteen feet tall.

public relations and invited a steady stream of celebrities to visit the fledgling settlement, including Presidents Ulysses S. Grant and Grover Cleveland.

Newspaper accounts from 1878 describe Benedict's discovery of a "running, magnetic, white Sulphur spring, flowing two thousand gallons of water per minute." He did not, in fact, discover the spring, which had been dammed to create a small mill, mostly likely by former plantation owner Zephaniah Kingsley. It had been known by many names, including Tulula Springs and Seminole Springs, and people had reportedly used its water for centuries, but it was Benedict who put it on the map by marketing it as the "Roaring Magnetic Springs." He hired barkers to holler at passengers as they stepped off steamboats, exhorting them to "visit the world-famous magnetic roaring springs," where they could "chill and thrill" and cure all their ills in the "magical magnetic waters."

An 1890s pamphlet for Orange Park presented an analysis of the spring's mineral contents and predicted it "must become one of the most attractive spots on the St. Johns, both for the pleasure seeker, and the invalid." While it never met that grandiose vision, the spring did briefly gain notoriety again in the 1920s when Leonidas E. Wade, a Clay County attorney, bought the land around it and rebranded the spring again. Wade intended to sell the spring's water, but he wanted to make sure he had clear title to the land, so he sued anyone who owned the spring between 1803 and 1929. When none of the defendants showed up in court (most of them had long since expired), Wade earned a default judgment and entered into the bottled-water business. He seems to have met with success, because his water was reportedly shipped everywhere from Henry Flagler's elegant hotels in St. Augustine to the White House. Today Wade's legacy survives in the spring's current name—Wadesboro Spring—and the prized land surrounding it is now the site of a housing development known as The Springs.[4]

MONCRIEF SPRINGS: A JACKSONVILLE TREASURE LOST FOREVER

The legend of Moncrief Springs goes like this: Pawnbroker Eugene Moncrief escapes the French Revolution with nine treasure chests stuffed full of royal jewels. He crosses the ocean, arrives in Jacksonville, stumbles across a spring, falls in love with an Indian maiden, and is killed by the maiden and her lover. The treasure is dumped deep in the spring. The tale, possibly written or embellished by Washington Irving, appeared in 1874 in Jacksonville's *Florida Union* newspaper and was followed by subsequent accounts that revealed the spring's location. Jacksonville's mayor, Peter Jones, apparently proclaimed the rediscovery of the "wonder spring" before he purchased the surrounding area in 1875 and developed it into a "swimming resort" complete with a hotel, dining facilities, bowling, horse-racing track, and dance pavilion.

When Sidney Lanier visited, also in 1875, he reported many improvements at the spring, including bathhouses for men and women, each sixty feet long by fifteen wide. The mineral water had not yet been analyzed, Lanier wrote, but its efficacy had been demonstrated in the cures of "intermittent fevers and of agues." His review provides the best surviving record from the spring's brief spa period. The racetrack, Moncrief Park, survived until 1911, earning the nickname "Belmont of the South." Around 1945 the land surrounding Moncrief Springs was purchased by Jacksonville civil rights pioneer Eartha M. M. White, and the spring became the location of the first public swimming pool for African Americans in the Jacksonville area. Today the spring is gone — some say buried under Moncrief Road — sadly, lost forever like the mythical treasure from France.[5]

Lanier described the spring's location as four miles from town near a creek that was also called Moncrief.

IN THE WOODS NEAR JACKSONVILLE.

֍ WELAKA SPRING WATER: THE FOUNTAIN OF HEALTH

A vintage postcard of the "Big Sulphur Spring" in Welaka shows Victorian-era visitors seated in rowboats hovering over the spring, surrounded by water hyacinths. The text on the reverse side notes that the water's "curative power" was "well known at a remote date," suggesting a deep history for this healing spring near the St. Johns River.

It's unclear whether formal spa facilities were ever developed at the spring, although in 1926 a tourist hotel called the Colonial Inn was built nearby. Also an 1855 novel, *A Trip to Florida for Health and Sport*, describes a wooden bathhouse over the spring and mentions sulfurous deposits on sections of the bathhouse that were in contact with the water.

But developers clearly once hoped to make the most of Welaka's waters. In 1907 the Welaka Mineral Water Company was incorporated with the intent to sell mineral water, "operate bathing houses," and "promote a health resort" at Welaka, according to a written history of Putnam County. These plans were perhaps triggered by the discovery of mineral water from an artesian well that a Boston chemist determined to be a "saline laxative" and a "first-class water for stomach troubles and rheumatism." A bathing casino was built a few blocks from the river, with steam-heated mineral baths and a public drinking fountain. Ads for Welaka Mineral Water appeared in the *Tampa Tribune*, with claims of a wonderful stimulating effect on the liver, kidneys, and bowels, while effectively eliminating the "poison from the system."

The tiny town of Welaka, once determined to be the "foremost health resort and sportsmen's land of paradise," ultimately focused on the latter, and from 1949 to the present day has touted itself as the "Bass Capital of the World." For a time the bathing casino was utilized as Welaka's town hall.[6]

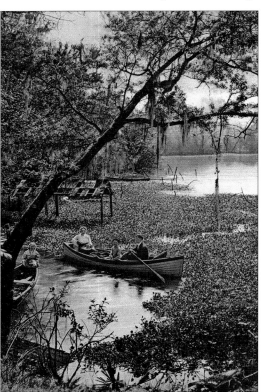

Welaka, Fla. Big Sulphur Spring.

A group of people in boats at Welaka's Big Sulphur Spring are surrounded by what appears to be water hyacinth, an invasive water plant introduced to Florida from South America in the late 1800s.

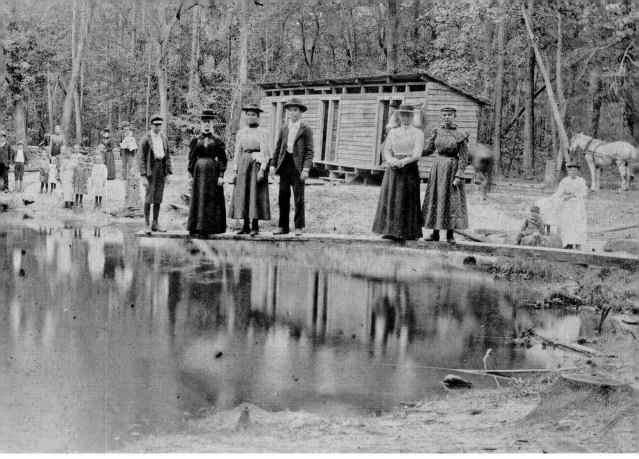

An undated image by photographer R. White of Hawthorne shows a group of schoolchildren and adults visiting Orange Spring.

ORANGE SPRING: A PINEY-WOODS PARADISE

The waters from Orange Spring, buried deep in the forest in the northeast corner of Marion County, flow into one of the St. Johns River's major tributaries, the Ockla-waha River. The town surrounding this third-magnitude sulfur spring was a popular stop for steamboats traveling to Silver Springs. Later the spring would be utilized primarily as a source of recreation and then for bottled water. Its short-lived glory days as a source of healing came about thanks to the efforts of several significant figures in Florida history.

The first to see the potential for developing Orange Spring was David Levy Yu-lee, who came to Florida in the 1820s from the island of St. Thomas with his father, Moses Levy, a Sephardic Jew born in Morocco. The elder Levy attempted to estab-lish a utopian community for Jewish immigrants near Micanopy. His son David, who changed his last name to Yulee after his 1846 marriage, became an attorney and one of Florida's first United States senators; he was also among the earliest builders of railroad tracks across the state to transport goods.

Yulee saw the potential of Orange Spring's location—it was near a fort built along a Seminole War military trail that connected Palatka and Tampa. Envisioning

the site as a focal point for a cross-Florida steamboat and railroad system, Yulee and plantation owner John W. Pearson purchased the land near the spring. When the transportation network failed to materialize, Yulee sold his share to Pearson, who platted the town of Orange Springs (plural, unlike the singular Orange Spring that had inspired it). He built a hotel that could accommodate sixty guests and also built a lumber mill, gristmill, church, mercantile store, and machine shop.

Born in South Carolina, Pearson had come to Florida in 1835 to serve in the Second Seminole War and later became a successful businessman and planter. His Orange Springs hotel provided lodging for visitors who arrived by steamer on the Ocklawaha River (about a mile east of town) or by the stagecoach that traveled between Palatka and Tampa. The spring was established as a location for taking the waters at least a decade before the outbreak of the Civil War. An 1855 South Carolina newspaper account confirms that Orange Spring was by then a place of "considerable notoriety" as a resort for northern invalids; the writer observed many "pale faces, emaciated bodies, etc." while visiting the spring. A similar 1855 story in the *Fayetteville Observer* in North Carolina described the spring as a great attraction, "25 feet in diameter and 20 feet deep" with strongly sulfurous water that was "beneficial for dyspepsia and cutaneous diseases." The writer described staying a week in the hotel at Orange Spring kept by J. J. Dickison, a "clever gentleman and excellent caterer" who would earn a very different reputation during the Civil War.

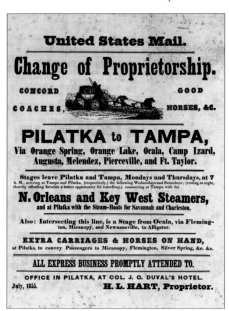

An 1855 poster announced Hart's stagecoach line from Palatka to Tampa, which stopped at Orange Spring.

Before the war, Hubbard L. Hart ran the stage line that went through the town of Orange Springs, and in 1860 he began operating steamboats on the St. Johns and Ocklawaha rivers. In 1862 Hart used Orange Springs as a hideaway while his steamboats were pressed into service for the Confederacy. After the war the state of Florida awarded him permission to clear the Ocklawaha River of obstructions. He resumed steamboat operations, ferrying northern visitors to see the immense underwater wonders of Silver Springs, often relying on African American pilots to guide his boats up the winding river.

The Civil War, plus the emergence of nearby Silver Springs as a popular destination, prevented Orange Springs from ever earning the reputation garnered by

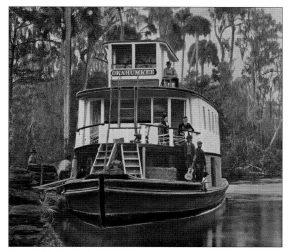

Hubbard L. Hart's Ocklawaha River steamboat *Okahumkee*.

other health resorts on the St. Johns. Both Pearson and Dickison would take up arms for the Confederacy, Pearson at the head of the Oklawaha Rangers company and Dickison as one of Florida's best-known Civil War figures, leader of Company H of the Second Florida Calvary. The town of Orange Springs became a refuge for families who were "threatened by Federal gunboats" on the St. Johns and also a manufacturing source for Confederate munitions. As the war wound down, the Orange Springs Methodist Episcopal Church, built by Pearson, became the last Confederate State Hospital.

Pearson succumbed to wounds suffered in 1864 during the war, and his widow had to sell the spring to pay back taxes in 1875. James and William Townsend,

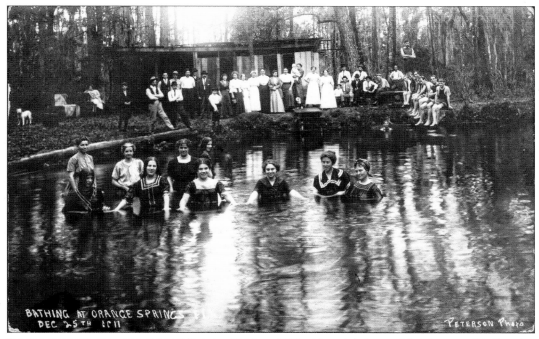

Female bathers enjoy the waters of Orange Spring on Christmas, 1911, while male bathers wait their turn on a diving board.

brothers from Georgia who had settled in north Florida at Lake Butler, purchased the spring and built a turpentine still at Orange Springs. The Townsend brothers prospered in the naval stores industry, with an extensive network in at least seven Florida counties, and owned property on Salt Springs as well. James Townsend built a house at Orange Springs, and by the time a railroad finally arrived in 1913, the spring had become a popular site for recreational activities such as picnics and barbeques as well as for political rallies. "So many people are learning the value of this water," the *Ocala Evening Star* noted in 1915; as a summer resort, Orange Springs was finally returning to its antebellum days, "when it was one of the greatest if not the greatest in the state."

The New South Farm and Home Company attempted to develop property around Orange Springs in the early teens of the century, advertising the spring water as possessing "wonderful medicinal qualities" and constructing a concrete edge around the spring basin. By the 1920s, however, both the development and the railroad line through Orange Springs met with failure. For much of the rest of the twentieth century, the spring was used mostly as a local swimming hole. James Walter Townsend died in 1944, but his family held onto the property until 1986. His Orange Springs home was added to the National Register of Historic Places in 1988 and served as the location of a bed and breakfast for a number of years.[7]

Orange Spring reached its zenith earlier than many spring-based health spas on the St. Johns River, and its remoteness proved to be both a blessing and a curse. Its inaccessibility made it an oasis for the Confederacy during the Civil War, but afterward it was bypassed by the progress that has engulfed contemporary Florida. Most recently the spring's healing waters have been used exclusively by a water-bottling company that celebrated the five hundredth anniversary of Ponce de León's arrival in the state by selling "Ponce Premium" bottled water.

James Walter Townsend purchased John W. Pearson's Orange Springs property, including the mineral spring, prior to 1900. The house Townsend built in 1912 was added to the National Register of Historic Places in 1988.

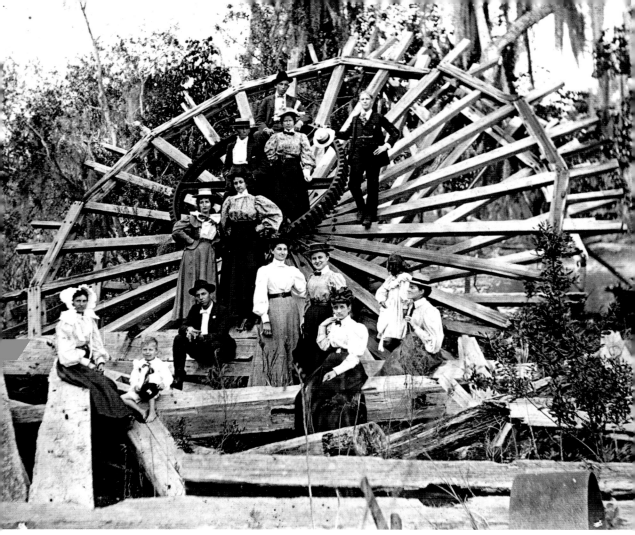

Well-dressed visitors gather in front of a large paddle wheel at the Old Mill at De Leon Springs, Florida, circa 1900.

❀ PONCE DE LEON SPRINGS: THE FOUNTAIN OF YOUTH AND PROFIT

Few Florida springs have a historical record as well documented as that of Ponce de Leon Springs in Volusia County. Two dugout canoes found in the spring indicate the presence of indigenous people there for thousands of years. Shell mounds also confirm that the site was occupied long before the arrival of the first Europeans. During Florida's British period (1763–83), the land around the spring was owned first by Panton, Leslie & Company, the mercantile firm that had a virtual monopoly on trade with Native Americans in the Southeast, and then by planter William Williams, who named the property "Spring Garden."

Williams and his descendants managed a plantation with enslaved labor until attacks by Seminoles forced them to flee. A subsequent owner, Orlando Rees of South Carolina, dammed the spring and built a sugar mill—a first in Florida. Artist

and naturalist John James Audubon visited the spring in 1831, when Rees owned the land, and noted that the water was so full of sulfur that he found its odor "very disagreeable and highly nauseous." Seminoles occupied the property during the Second Seminole War until they were driven off by American troops. When they

The De Soto House Hotel, built in 1855.

returned, General Zachary Taylor, a future U.S. president, arrived to remove them permanently. In the mid-1800s, the plantation and mill became operational again but were destroyed by Union troops during the Civil War. After the war Major George H. Norris, a New Yorker, and his brother A. Hart Norris acquired much of the former plantation and began a transformation from agriculture to tourism.

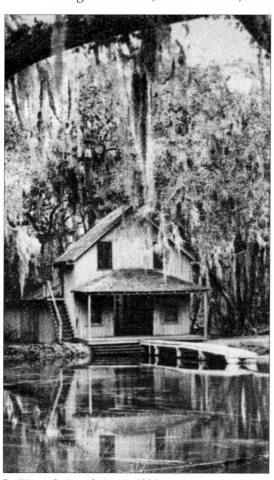

Facilities at De Leon Springs in 1904.

All the spring's owners of European descent saw it as a potentially profitable resource, but Norris was the first to attempt to establish it as a tourist destination for invalids by promoting the medicinal qualities of the spring in the late 1800s. Credit for changing the community's name from Spring Garden to De Leon Springs goes to Uriah M. Bennett, who hoped to establish a settlement in the area named De Soto. When he tried to open a post office in 1885, he learned that another town already had dibs on that name, so the settlement became De Leon Springs. Bennett also established one of the first hotels in the area, the De Soto House Hotel. In 1886 the railroad arrived, creating a second way for visitors to reach the growing destination. Norris had already built a wharf for his brother's steamboat, the *Spring Garden*, which shuttled passengers via the St. Johns River. To attract visitors Norris built a hotel near the spring as well as a pavilion (located atop a Native American shell mound) and a bathhouse. Guidebook writer George Barbour

visited the area and offered praise for Norris's work. Soon advertisements boasted marvelous effects from the sulfur and soda baths of the spring, reinvigorating the "frame exhausted by fatigue, weakness or heat" and leaving the skin "smooth and unctuous."

During the 1920s Florida land boom, a platted community was planned to sell home sites in the area, and a new Spanish-style casino building was constructed near the spring featuring hotel rooms, a dance floor, and a comfortable dining room. In the age of the automobile, accessibility to U.S. Highway 17 was considered more important to the resort's success than the beneficial effects of bathing in the spring waters. Around this time, the owners attempted to raise the water level

"Healing waters that Ponce de León sought but missed."

of the spring basin and inadvertently diverted much of the spring flow outside the pooled-in swimming area. This new, accidental vent had to be filled with concrete in order to restore the original flow.

It's likely that the real estate bust that followed the boom of the early twenties prevented the large-scale development envisioned by the spring's owners. The resort endured until the 1950s, when the property was transformed into a roadside attraction complete with water-ski shows, circus performers, alligator pens, jungle cruises, and a flowing "fountain of youth." In 1961 the Old Spanish Mill Restaurant opened at De Leon Springs with griddles set in every table so that diners could make their own pancakes with batter created from grains ground on-site. After the spring became a Florida state park in 1982, the restaurant continued to operate and remains extremely popular.

Legend has it that indigenous people called De Leon Springs "Acuera," thought to mean "healing waters," and considered it sacred. Over the years the site suffered a series of indignities, as the land surrounding it was found to be fertile for both agriculture and development. De Leon Springs saw forced labor by enslaved people; violence between Native Americans, settlers, and soldiers; and an alteration in the spring's flow that almost destroyed it. In 1973

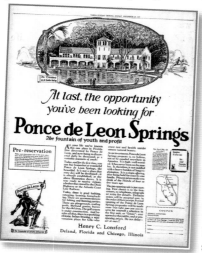

Tampa Tribune ad, November 29, 1925.

a plan to build high-rises next to the spring was given serious consideration. But today, in addition to delicious pancakes, the latest incarnation of De Leon Springs offers eco-heritage boat tours, hiking, fishing, scuba diving, and even a ramp and chair lift to make what was once dubbed "one of the finest medicinal springs on earth" accessible to everyone.[8]

Bathing through the years at De Leon Springs: *Below,* bathers pose for a photo showing a primitive bathhouse in the background; at *bottom left,* the mill wheel offers a backdrop in the early twentieth century; and, at *bottom right,* the spring today.

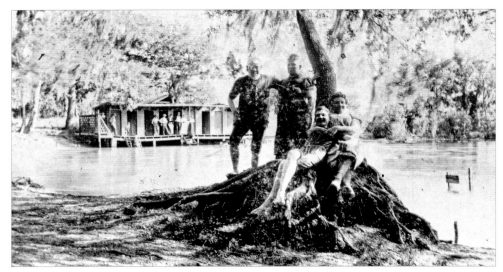

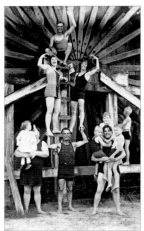

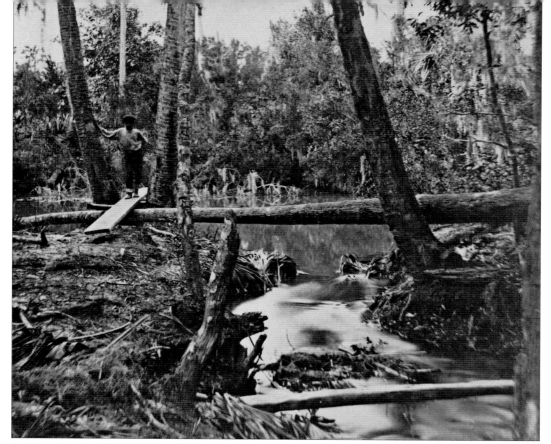

A photograph marked "Sulphur Spring, Old Enterprise" from the Florida Views series by Wood & Bickle, Photographers, Jacksonville.

THE SPRINGS OF ENTERPRISE: THE LAST RESORT

The Brock House in Enterprise was the terminus for many passengers during the heyday of St. Johns River steamboat travel. "This is as far south in Florida as invalids from the North ever think of going for the winter," wrote Dr. Robert F. Speir in 1873, noting that the landing of Enterprise was located in the "great alligator nursery of the St. John." Most of central Florida was still wild and undeveloped, and in some ways Enterprise was an outpost on the Florida frontier. While the abundance of mineral waters was a critical component in luring northern visitors there, abundant opportunities for hunting and fishing in the wilderness surrounding the springs were also a primary attraction.

Enterprise's founder, Cornelius Taylor—a cousin of President Zachary Taylor— came to the northern shores of Lake Monroe in the early 1840s as a timber agent for shipbuilders in Norfolk, Virginia. Finding an abundant source of live oaks for ship construction, the ambitious West Virginian filed a claim for a 160-acre grant under the Homestead Act, a law created to encourage settlement. Taylor's property had three sulfurous springs, identified as Upper Salt Sulphur, Lower Salt Sulphur, and Green Sulphur springs, and the inn he built nearby was perhaps one of Florida's earliest health spas. According to interpretive signage at Green Springs Park in

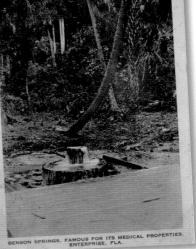

BENSON SPRINGS, FAMOUS FOR ITS MEDICAL PROPERTIES.
ENTERPRISE, FLA.

Left: Brock House guests on the steamboat
dock. *Above:* Postcard for Benson Springs.

Volusia County, Taylor "promoted his spring in the 1840s, offering bottled water
and promises of good health."

Steamboat captain Jacob Brock bought land about a mile farther west of Taylor's
and dubbed it "New Enterprise." His settlement included a store and a boarding-
house, and he laid out the streets of what came to be called simply "Enterprise." In
1855 Brock started construction on a massive 150-room, New England–style hotel
he named the Brock House. During the Civil War, Union authorities imprisoned
Brock as a Confederate sympathizer, and his steamboats were confiscated. After the
war he reclaimed his small fleet and was awarded a contract delivering emancipated
slaves to a Freedman's Bureau hospital and orphanage at Magnolia Springs.

Harriet Beecher Stowe reported traveling on Brock's steamer *Darlington,* which
was operated in part by a formidable woman named Rose, a former slave whose
skills and commanding presence had gained her the title "Commodore"; she knew
"every inch of the river, every house, every plantation alongshore, its former or pres-
ent occupants and history," Stowe noted. Arriving on the *Darlington* and Brock's
other ships, travelers to his Brock House propelled it to unprecedented levels of
prosperity after the war, and it became one of Florida's best-known resorts, with no-
table guests who included not only Stowe but also Ulysses S. Grant, Sidney Lanier,
and Winslow Homer.

The largest and best-known spring at Enterprise was dubbed Green Spring. One
1855 account described it as a "great curiosity," about fifty feet in diameter, with
water that looked "as green as the waters of Niagara Falls." When the water was
removed from the pool, however, it appeared "as clear as water can be." The Enter-
prise area was pockmarked with mineral springs; the water boiled up through the
clay and sand "wherever it found an outlet," wrote Thomas W. Fryer Jr. in "The
Story of Enterprise."

In the 1920s the town of Enterprise was renamed Benson Springs. A color-
ful story tells of a guest at the Brock House named Benson, perhaps New Yorker

Arthur Benson, who visited so that he might "try the waters of the mineral spring" to relieve his rheumatism. The spring brought him "much benefit," according to the tale, and he remarked that when "his time came to go," he would like to be near the same waters that had offered him such great relief. After he died while fishing near Enterprise, its residents decided to rename the community in his honor, according to a 1927 newspaper report.

In reality the new owners of the Brock House renamed the hotel and then strong-armed the town into the name change. Later the hotel was renamed the Epworth Inn and became a Methodist retreat center. The name Enterprise was reclaimed in 1937 when the venerable hotel that had hosted presidents and titans of industry was razed to make way for an orphanage—a historic site that still exists in the tiny hamlet of Enterprise. The community quietly marks the northern edge of the growing metropolitan area surrounding the twenty-first-century tourist mecca of Orlando. Many of the area's unnamed sulfur springs still bubble to the surface not far from Interstate 4, lost in the woods and forgotten by time.[9]

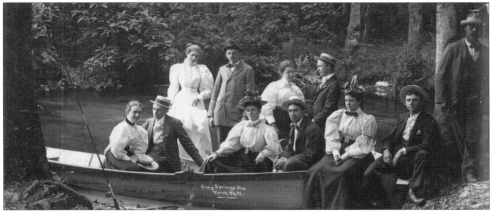

Wekiwa Springs has long been a popular destination for central Florida outings, as this 1897 photo shows.

WEKIWA SPRINGS: FROM IDEAL HEALTH RESORT TO NATURAL ATTRACTION

Clay Springs morphed from an early 1800s hub of commerce to a sanctuary for invalids to a setting for recreation—and was ultimately renamed Wekiwa, the Creek and Seminole term for "waters of the spring" (the name of the river it feeds is spelled Wekiva). Identified on an 1847 survey as being on L. H. Clay's farm, the spring is a main source of water for the Wekiva River, an important tributary of the St. Johns. The spring's proximity to the Wekiva made it accessible for shallow-draft steamboats, and the construction of a boat landing made it possible for early settlers

to ship out citrus and lumber while bringing visitors in. Clay Springs boomed as a destination for tourists traveling up the river after the Civil War, and it soon rivaled Apopka as the region's commercial and political center. An 1877 newspaper account claimed that the spring was "once a great resort for invalids" and saw potential for the land surrounding the spring to make a "very attractive place of resort."

That promise was fulfilled in the 1880s when an Iowa newspaperman named J. D. Smith erected a three-story hotel dubbed "Ton-Ya-Wa-Tha"—a name that supposedly meant "healing waters." Smith platted an entire community named Sulphur Springs, about three-quarters of a mile away from the water on "high rolling, pine land." While Smith's new town flopped, the hundred-room hotel survived, and new amenities were added when John D. Steinmetz took over hotel operations in 1898. Seminole County historian Jim Robison suggests that Steinmetz's additions of a skating rink, bathhouse, dance pavilion, and toboggan slide created what could be considered central Florida's first amusement park.

Clay Springs was renamed Wekiwa Springs in 1906, and by 1907 advertising for the hotel there proclaimed it be the "finest mineral springs in Florida." An early brochure promoting Wekiwa Springs Mineral Water claims that water from "Nature's Wonderful Fountain" had the power to cure rheumatism and kidney and bladder trouble. A 1920s advertising piece made even bolder assertions, boasting of the water's ability to cure diseases of the stomach, kidneys, and liver while acting as a "body builder," showing just a "trace of Lithium" and a "higher degree of

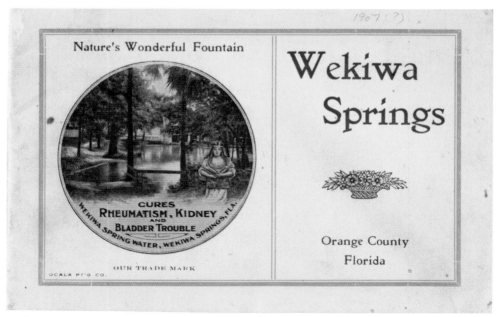

Ads for Wekiwa Spring Water claimed a state chemist testified that the water's value was due to its purity.

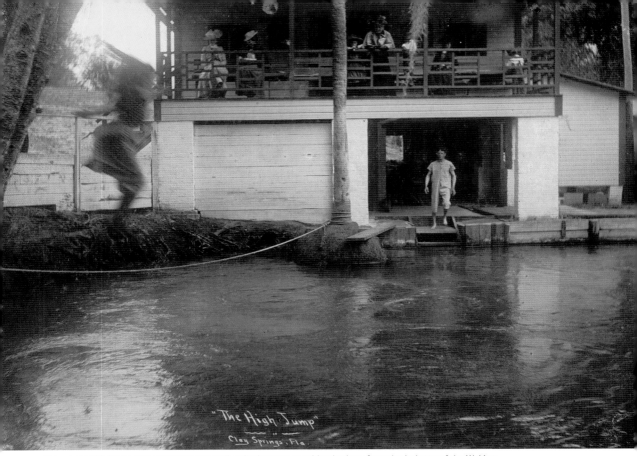

This photo titled "The High Jump" shows well-attired guests watching bathers from the balcony of the Wekiwa Springs bathhouse.

mineralization" than the famed Poland Spring water. An 1875 article in the *Atlanta Constitution,* however, said the spring reeked of "a villainous odor" of sulfur, and the author concluded that while water laced with sulfur might be healthy, he preferred Atlanta well water to "a liquid that smells like the extract of ten thousand polecats."

In full-page ads in the *Orlando Sentinel* during Florida's 1920s land boom, the wondrous waters of Wekiwa Springs were hyped as the number one reason to buy land near the spring. For years Wekiwa Springs had been waiting for someone to develop it, asserted ad copy from M. E. Miller Real Estate of Detroit; now Miller's firm was developing it "sanely, soundly, and permanently." But as historian Robison notes, when the boom collapsed in 1926, northern investors "took what money they had not lost and went home." The property ultimately passed from the Wilson Cypress Company to the Apopka Sportsmen's Club to the State of Florida. In 1969 these ever-changing waters became part of Wekiwa Springs State Park, now one of central Florida's most popular natural attractions.[10]

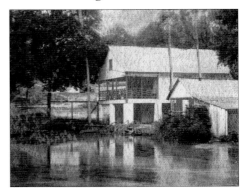

A hand-tinted photograph of the bathhouse at Wekiwa Springs.

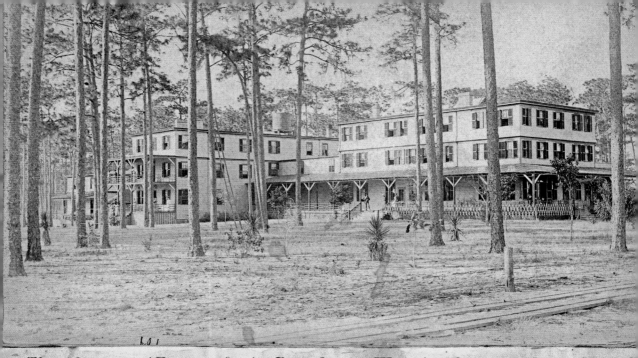

The Altamonte (Famous for its Pure Spring Water), Altamonte Springs, Fla.

The caption to this 1887 image by photographer T. P. Robinson declares the Altamonte Hotel to be "famous for its pure spring water," and the photo clearly shows a tank on the building's rooftop from which guests would have received spring water.

ALTAMONTE SPRINGS: THE CITY SURVIVES THE SPRING

Like most of the tourist destinations that popped up throughout the St. Johns region in Florida after the Civil War, Altamonte Springs was the creation of northern investors who saw the promise of attracting visitors with crystal-clear waters and a healthful climate. It differentiated itself from an early neighboring community called Altamont (with no "e") because of a spring on the grounds of its namesake hotel. But by the end of the nineteenth century, when Altamont and other neighboring settlements disappeared, Altamonte Springs prospered due to its reliance on snowbird tourists who came south each winter.

In 1883 the Boston-based Altamonte Land, Hotel, and Navigation Company created a luxurious hotel that was the focal point of a planned community surrounding two spring-fed bodies of water, lakes Orienta and Adelaide. Because it wasn't located on a river like most spring-based resorts in the region, the Altamonte Hotel owed its success not to steamboat traffic but to a nearby South Florida Railroad stop called Snow Station. A gazebo-like springhouse was built at the spring on the shore of Lake Adelaide, a hundred yards north of the hotel, and spring water was piped to a tank on top of the hotel. Advertising touted the purest spring water that "anywhere flows from the ground" and proclaimed the hotel was located at the "healthiest spot in Florida."

The Altamonte Hotel's bathing amenities improved substantially with the purchase of Shepherd Springs, which was a few miles away. In an 1883 promotional

booklet titled "Orangeland," the author marveled at the crystal waters of Shepherd and nearby Hoosier Springs and asserted that bathing in the spring water, or drinking it, was beneficial to "patients troubled with rheumatism or blood diseases," because it was full of sulfur and other minerals. Shepherd Springs, situated on the west bank of the Little Wekiva River, which ultimately connects to the St. Johns, is now known as Starbuck Spring and is on private property. Hoosier Springs was renamed Sanlando for its location between Sanford and Orlando and became a popular recreational site until the land surrounding the spring was developed into a gated residential community in the 1970s.

A 1902 advertisement for the Altamonte Hotel bragged of "every comfort, convenience, or amusement," including excellent cuisine, the finest fishing and hunting, and an atmosphere that was "social and homelike." The popularity of the hotel was tested during an economic panic in 1893, and the nearby community of Altamont met its demise after the devastating freezes of 1894–95 destroyed its citrus crop. But Altamonte Springs endured due to the wealthy northern clientele who patronized the hotel and bought property in the town.

In 1909 the hotel was renovated; it remained a popular destination as the age of the automobile dawned, helped by its proximity to the Dixie Highway. "The hotel had survived depression and war and was still filled to capacity during the winter season," wrote historian Jerrell H. Shofner in his study of Altamonte Springs. The hotel burned down in 1953. Many of its regular guests, who had been staying at the Altamonte Hotel for years, asked its owner to rebuild, but he declined, Shofner wrote.

A Victorian-style springhouse replaced a prior rustic version.

Beginning in the 1970s, the city of Altamonte Springs benefited from central Florida's meteoric, theme park–fueled growth and transformed itself into a bedroom community for Orlando, becoming one of the fastest-growing areas in the nation. A banking software company built its headquarters on the site of the hotel. The spring near the shore of Lake Adelaide that was said to have the healthiest water "anywhere" was capped and covered by the new office complex's parking lot.[11]

The success of resorts like Altamonte Springs demonstrated that spring-based spas could succeed without relying on steamboat traffic. Florida's expanding network of railroads would create opportunities for other properties to be developed at springs not connected to Florida's Heritage River.

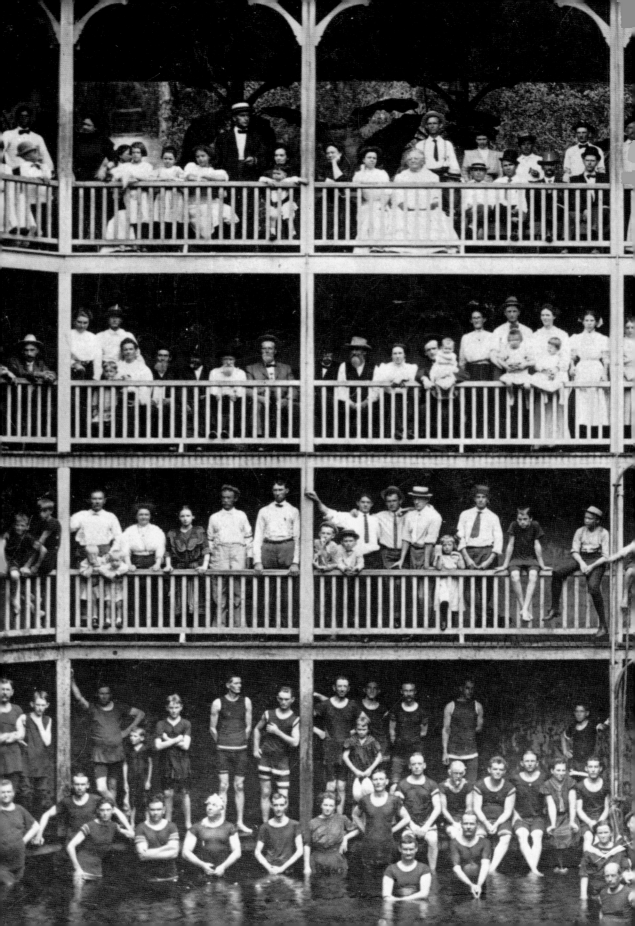

THE HEALING SPAS OF NORTH FLORIDA

Health Resorts from the Big Bend to the Suwannee Valley

The Spring itself is one of nature's beneficent miracles. A thing of beauty—clear, sparkling water bubbling over creamy rocks. More than beauty, it is healing. Its cures are almost incredible to any save those who witness the daily proof. Rheumatism, gout, kidney trouble, nervous and skin diseases all yield to its magic touch.

—*White Springs promotional brochure*

Early in the nineteenth century much of Florida's interior west of the St. Johns River was considered Indian territory. But when the Native Americans were forced out, American settlers moved in and developed an economy based on the natural resources of the land. Middle Florida, as it was then called—the area between the Suwannee and Apalachicola rivers—had cotton and tobacco plantations like those associated with neighboring southern states. Much of north Florida also boasted vast acres of virgin timber that was milled and used to build a growing nation. Naval stores such as pine-resin products used to waterproof wooden ships were crucial to the region's economic growth. Conveniently, breathing the scent of pine trees was in itself believed to be beneficial. "The pine lands of Alachua County, which are universally healthy, are nearly everywhere," Carl Webber wrote in *The Eden of the South,* a glowing 1883 review of the benefits of the area.

North Florida was also rich in springs, and many featured water laced with minerals, including calcium, sulfur, and magnesium—spring water was an abundant resource for economic development. As the Suwannee River winds its way down from Georgia to the Gulf of Mexico, dividing the peninsula from the Florida Panhandle, more than three hundred documented springs bubble up, providing ideal settings for health spas. As in the St. Johns River region, most north Florida springs that were "improved" with facilities for invalids were not first-magnitude wonders,

Visitors of all ages crowd four levels of the springhouse at White Sulphur Springs.

such as Wakulla or Silver Springs, but were smaller, second- and third-magnitude springs. Many of them share similar origin stories linked to the recently displaced Native Americans, who were often purported to have relied on the springs' healing powers. In truth, it is difficult to know the veracity of these tales, as promoters tended to make bold, outrageous claims.[1]

It took work to transform these small, out-of-the-way springs into luxurious resorts. Developers built elaborate structures both to collect spring water for bathing and to house guests seeking restoration. Transportation was critical for the development of these early facilities. Although steamboats navigated the rivers of north Florida and the Gulf of Mexico, they didn't have the same impact on the creation of health resorts that they had in the St. Johns area. Visitors often arrived via hack or stagecoach, and eventually automobiles would play a significant role in the success of these resorts for health and restoration. But in the late nineteenth century, railroads provided the primary mode of transportation to north Florida spas, including one of the most popular: White Springs.

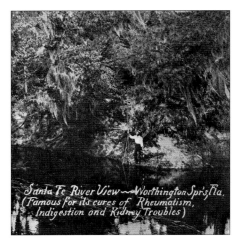

The Suwannee and Santa Fe rivers of north Florida both have features of karst geology and are fed by many springs. Worthington Springs on the Santa Fe (*above*) was a small spring that was enlarged to fill a manmade pool; the town of White Springs on the Suwannee River developed when the railroad made its sulfur spring more accessible.

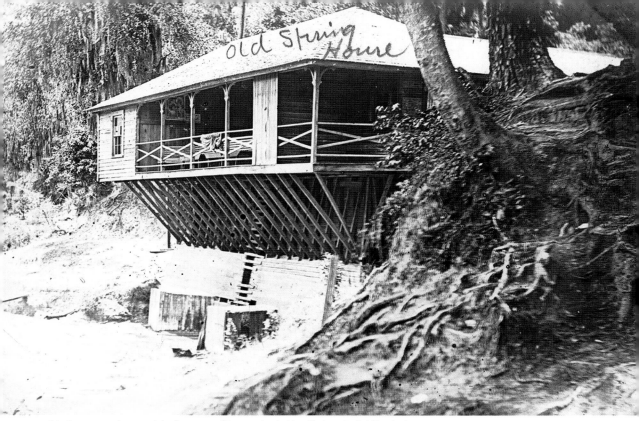

A balcony extends toward the Suwannee River at what is identified as the "old" springhouse.

WHITE SPRINGS: ANTEBELLUM SPRING BECOMES SPA TOWN

White Springs, also called White Sulphur Springs and Upper Mineral Springs, had primitive facilities for invalids well before the start of the Civil War. When the railroad arrived these pilgrims flocked to the settlement around the springs, making it one of Florida's best-known health destinations. On a par with Green Cove Springs, the town of White Springs had fourteen hotels and additional boardinghouses, totaling five hundred rooms available for rent. The multistory springhouse built around the spring near the start of the twentieth century offered bathers an unrivaled experience and was perhaps the most architecturally significant structure at any of Florida's healing springs.

In 1835 Bryant and Elizabeth Sheffield, owners of a thousand-acre plantation on the Suwannee River, much of which would later become the town of White Springs, constructed a rudimentary log hotel and springhouse at what was originally known as Upper Mineral Springs. According to geographer Burke Vanderhill's study of Florida's spas, the area had "well-marked Indian trails," and the spring was reported to have sacred significance for Native Americans. The village began to grow in the 1840s, and visitors to the spring arrived via stagecoach. In the early 1860s railroads connected nearby Lake City to Jacksonville to the east and Tallahassee to the west, making bathing in the springs even more accessible. Development

slowed during the Civil War and, like Orange Springs, the town of White Springs gained a reputation as a haven for Confederates—future Florida governor Napoleon Bonaparte Broward occupied a nearby plantation called "Rebels' Refuge."

According to Vanderhill, the spring was often mentioned in 1870s travel literature, but its use fell off after 1882, when Georgians John Powell and Thomas Wright became the spring's new owners. The town of White Springs was officially incorporated in 1885. Near the turn of the century Minnie Mosher Jackson, a Savannah temperance advocate and Confederate widow, bought the property with her physician brother, and in the early 1900s, they hired Jacksonville architects McClure and Holmes to design an imposing structure surrounding the spring. The concrete foundation was about 90 by 50 feet, and the spring spilled through wooden gates that could be closed to prevent the flow of the Suwannee River from contaminating the spring's mineral water. The ornate four-story structure, which was topped at one end with a decorative tower, included space for concessions, a clinic area, dressing rooms, and an elevator. The springhouse and the nearby 1912 Colonial Hotel operated together as a health sanitarium. After Jackson and her brother sold the spring in 1916, the hotel continued to operate for several more decades, eventually catering more to vacationing families than invalids.

Elevations of the springhouse were created by the National Park Service in 1973.

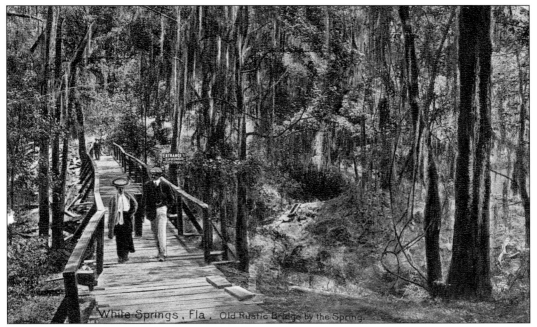

During the Victorian era getting fresh air and exercise grew in popularity, and the promenade stroll became a popular activity.

Initially visitors to White Springs had to endure an uncomfortable eight-mile hack ride from the train station in Wellborn, but a railroad stop was completed in 1889, making the growing resort community more accessible. As the town prospered, entertainment options increased. Cultured guests could attend the theater, go shopping, or try their hand at bowling or skating. The simpler pleasures of hunting or fishing with a rustic bamboo pole were also extremely popular.

The lumber industry contributed to the growth of White Springs, which also boasted a gristmill and cotton gin, two churches, and a newspaper. The Florida Normal School for the education of teachers was established nearby in 1893. Both President Theodore Roosevelt and industrialist Henry Ford were among the visitors who ventured to the booming north Florida town to take the waters.

The town of White Springs grew rapidly before the 1911 fire.

In 1911 flames destroyed thirty-five buildings, and the town would never again reach the level of prosperity it had previously enjoyed. A bottling plant was built to capture the water from the spring, which was promoted as "Nature's own laboratory of healing waters and tonic gases blended in a perfect medicine." Promotional literature warned that the mineral water alone was not

entirely responsible for miraculous cures, but for efficacy should be combined with "proper diet, hot bath treatments, and medicine."

The healing power of the sulfur water at White Springs was promoted until about 1950. The State of Florida bought the spring property in the early 1970s, and the crumbling springhouse was torn down in 1973. Later, however, the top story of the original structure was rebuilt on the springhouse foundation, creating a condensed version with a hint of the grandeur the demolished building had once possessed. The second-magnitude spring has for the most part dried up; it occasionally perks back to life when large rain events saturate its springshed. The entrance to Stephen Foster Folk Culture Center State Park, known for the annual Florida Folk Festival, is near the site where the Colonial Hotel once stood. Only the vacant Telford Hotel building survives from the glory days of White Springs as the home of what has been described as Florida's original tourist attraction.[2]

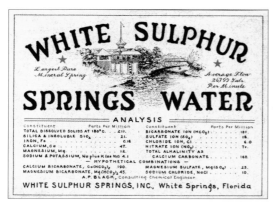

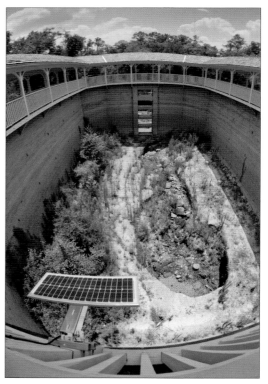

Top left: A contemporary reproduction of the spring water label lists the dissolved minerals present in water. *Bottom left:* The Telford Hotel opened in 1902 and is the last survivor of the golden age of bathing at White Springs. *Bottom right:* White Sulphur Springs in 2012.

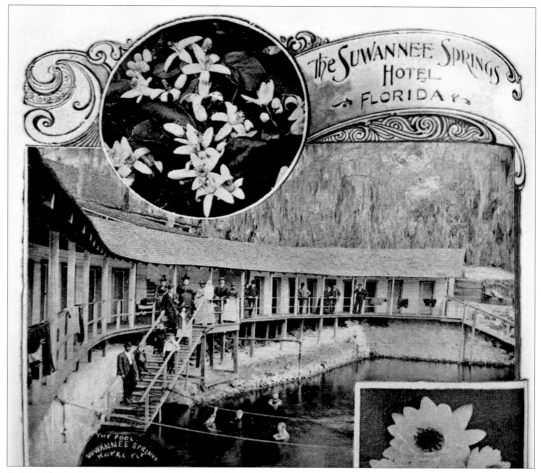
An image from advertising for the Suwannee Springs Hotel shows the bathhouse and bathers in the pool holding safety lines.

SUWANNEE SPRINGS: "THE SOUTH'S FAMOUS HEALTH RESORT"

Suwannee Springs prospered as a health resort during Florida's railroad era, boasting multiple hotels, famous mineral waters that were an "assured cure" for a variety of ailments, and a spring basin, confined by rock walls, that still stands today on the banks of the Suwannee River. It was once one of Florida's premier destinations for invalids, welcoming guests all year long, and it thrived into the early days of the automobile era. The last hotel there burned down in the 1920s, but a few scattered remnants of the resort remain in a park operated by the Suwannee River Water Management District.

A gushing account of the "great sanitarium" at Suwannee Springs in the *Pensacolian* newspaper of June 2, 1888, outlines the area's history to that point. Like so many other spring origin stories, the tale begins with "aborigines" who knew of the spring water's healing powers before the "white men set foot on the continent." Before the Civil War the spring area was an "immense hospital in the wilderness where invalids

Lower Mineral Springs in a primitive state before the pool was built.

gathered from all parts of the country," camping or living in temporary shanties, the writer noted. By 1851 there were accommodations for about a hundred individuals at the site, also known as "Lower Mineral" and "Lower Sulfur" springs, according to Vanderhill's history of Florida's springs. Facilities were primitive: visitors slept in tents until a rudimentary log hotel was erected.

By 1861 the completion of railroad lines to the town of Live Oak, just seven miles from the spring, allowed access from both the east and west, and plans were made to build a more sophisticated resort for invalids. The Civil War interrupted development, so it was not until 1883 that an "elegant hostelry of 120 rooms" was created by the renowned hoteliers George and Levi Scoville and their associate J. W. Culpepper. The Scoville brothers operated luxurious hotels throughout the South, including the Duval Hotel in Jacksonville, Sanford House in Sanford, and the Wigwam Hotel in Indian Springs, Georgia.

According to a flattering 1883 article in the *Atlanta Constitution*, when Culpepper told the Scoville brothers about the water at Suwannee Springs, he was determined to invest in bringing it to the world. Culpepper was quoted as saying that to Floridians, the "miraculous" spring waters were already as famous as the biblical pool at Bethesda. Thanks perhaps to that renown and to the hotel's accessibility by the railroad that dropped guests off at a small depot about a mile away, Suwannee Springs was at its zenith as a healing destination from the mid-1880s until approximately 1910. A horse-drawn trolley delivered guests from the depot to the steps of the sprawling hotel complex.

Scoville and Culpepper's hotel was described as a "four-sided, five turreted" structure with an open square in the center, and promotional illustrations of the resort show an elaborate array of buildings. Unlike at White Springs, a town never developed around the resort, so the amenities had to be contained on-site. As a result great attention was given to creating a first-class dining hall,

a wide variety of entertainment options from billiards to croquet, and "1,200 feet of verandah" for the enjoyment of their guests. "Ennui finds no place among the visitors, for the varied indoor and outdoor amusements bid dull care take flight," proclaimed an effusive newspaper account.

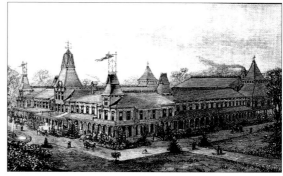
The 1883 hotel burned in early 1884.

In such descriptions, hotel guests checked into well-appointed rooms furnished with bedroom suites made of black walnut. They glided across stylish Brussels carpets, slept on feather pillows, and relaxed in "luxurious rocking-chairs." Boat tours of the romantic Suwannee River were available on a variety of watercraft. The service was outstanding, and unlike many other Florida resorts, the hotel at Suwannee Springs was open year-round.

Even with such luxurious accommodations, the famed water was the main attraction. The hotel advertised a "perfect system" of hot and cold sulfur baths brimming with pungent water and its "native medical qualities." The spring water, available for drinking as well as bathing, was said to cure a long list of diseases from the usual rheumatism and dyspepsia to "female troubles, eczema, and all blood affections." In its bottled form it became a fashionable brand, marketed as Suwanee (one "n") Spring Water. Samples were given away free at the Scoville Brothers' hotel in Atlanta, and the water was advertised in newspapers as far away as New York and Vermont.

On January 17, 1884, the *New York Times* reported that the hotel, "probably the finest structure of its kind in the state," had burned less than a year after it was completed. According to the *Times,* an estimated one hundred guests, many of them invalids from northern states, were asleep when the fire broke out, but all survived by leaping off verandas or from open windows in their rooms. Soon construction was underway on a new main building with

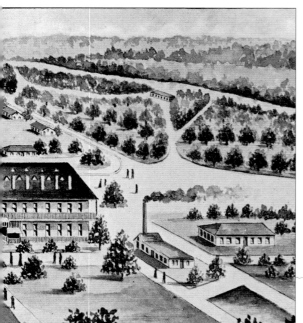

A bird's-eye view of the entire Suwannee Springs Hotel complex. Promotional copy bragged that the antidotal properties of the water charged the atmosphere for a mile around the complex so that the "germs of no disease can exist there."

a dining room, parlor, and kitchen on the grounds that already included eighteen cottages, a bottling plant, and a bathhouse. Around this time a rock structure was built around the spring to prevent the spring water from mixing with tannin-stained river water, and photos show a bathhouse positioned on top of the stone-masonry basin facing the spring and the river.

Businessman Andrew Hanley Sr. purchased the property in the 1890s, and his son, Andrew Jr., operated the resort into the early 1900s. In the coming twentieth century the spring would surely be "the favorite health giving place of the South," predicted Dr. W. H. Morse of the Electro Medical Institute of New York, describing the resort at Suwannee Springs as the "Southern Saratoga, the Spa of the Land of Flowers." Concluding in poetic fashion, Morse praised "the sweet and amatory song that is voiced by the tangle of oak land, the grace of moss, the green of meadow, the thrill of birds, the coolness and enchantment of a basin of water, from which the giant pines keep back the ill of germs, and heat, and moil."

A 1902 notice in the *Montgomery Advertiser* announced the resort's opening for the summer season with the unlikely claim that the summer weather was cool and pleasant, "free from malaria and mosquitoes." But later the same year the property's main building was again destroyed by fire, and the property was sold in 1904. In the teens and twenties the resort transitioned from catering to invalids to attract-ing a fun-loving crowd seeking recreation, and the ballroom became well known for lively musical entertainment. After the last hotel on the property burned down in 1925, the cottages on the grounds continued to be utilized by guests into the 1970s. Today a few of the cottages still exist, crumbling in the woods, vestiges of the spa's golden age and one of the few places in Florida where original accommodations from this era have survived.[3]

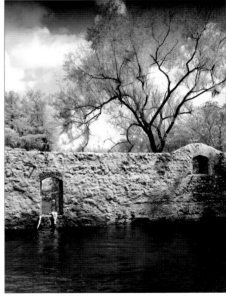

Suwannee Springs and the Suwannee River, 1948.

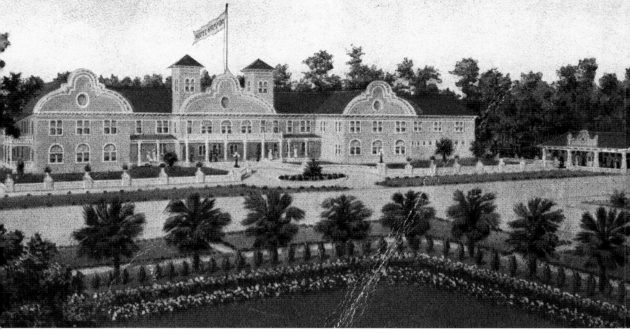

Advertising for this, "The National Health Resort," claimed its water would alleviate rheumatism, indigestion, bladder troubles, skin diseases, and more.

HAMPTON SPRINGS: REMOTE RESORT IN TIMBER COUNTRY

Hampton Springs in Taylor County, which is situated on the Gulf Coast near the intersection of the Panhandle and the peninsula of Florida, was off the beaten path for most nineteenth-century travelers to Florida. As a result the first hotel there wasn't built until 1908, despite the fact that the sulfur-laced waters had attracted campers for decades. The arrival of the railroad made the construction of a modern resort practical, and travel to Hampton Springs peaked in the 1920s. The refuge offered such a variety of recreational options that taking the waters was almost an afterthought. The Great Depression, however, delivered a blow from which Hampton Springs never fully recovered. Today the spring still flows into the walled basin of what was once the interior of the stylish bathhouse, an architectural ruin of what may have been Florida's most complete resort built around a spring.

After Benjamin and Joseph Hampton bought forty acres around the spring then known as Rocky Creek Mineral Spring in the mid- to late 1800s, the name was changed to Hampton Springs. According to local lore, an "Indian medicine man" had shown the location to Joseph Hampton and his rheumatic wife, who was miraculously healed after two weeks of bathing in the spring. The Hamptons' heirs are credited with building a small twenty-seven-room hotel on the property around 1904.

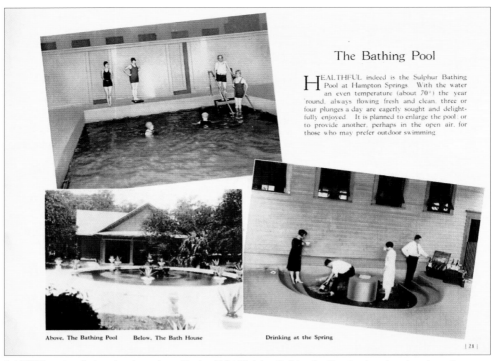

A 1927 Hampton Springs brochure shows the healthful "Sulphur Bathing Pool" and notes plans to enlarge the pool in the future.

The next owner, James W. Oglesby, improved the property with a luxury hotel in 1910. Oglesby, president of the South Georgia Railway, and his brother Zenas owned a sawmill in southwest Georgia and sought to expand their railroad connections as far south as Tampa. Their railroad had reached nearby Perry by 1904 but did not extend to Hampton Springs until 1915. For several years the hotel was the southern terminus of their line. One account calculated that as many as ten trains a day from two separate railroad lines served Hampton Springs at its peak of popularity.

James Oglesby's interest in the spring may have been related to his own health. In a promotional advertisement, the railroad magnate said he had suffered from "muscular rheumatism since boyhood" and was first attracted to the property by the reputed healing effects of the water. He testified that Hampton Springs mineral water permanently cured him of his malady.

Ads for Oglesby's hotel often included sizable sections devoted to the

Hampton Springs Water ad, *Atlanta Constitution*, June 20, 1913.

efficacy of the spring water; it's unclear whether the hotel depended on the fame of its bottled water to garner more attention or vice versa. The water, marketed as Hampton Springs Sulphur Water, was advertised widely in markets such as Montgomery, Alabama, and Atlanta, Georgia, and was guaranteed to taste good, quench thirst, cure a long list of internal and skin diseases, and boost the immune system. In Atlanta a pharmacy supplied pint and half-gallon bottles to other drug stores, retailers, and restaurants. Advertisements boasted that the flow from Hampton Springs supplied the only water that could be shipped and retain its "virtue" due to the modern bottling plant that operated with electricity from the resort's own power plant.

Marketing materials also claimed that after bathing and drinking the water during stays at the spa, hotel patrons would then request Hampton Springs water after they returned home. Guests could soak up the supposedly miraculous water in "Turkish, electric, shower, needle, and Sulphur water baths," in facilities constructed by 1912. The grounds of the "palatial" hotel also included a swimming pool and auditorium, and a remote off-site clubhouse gave access to bountiful fishing on the Gulf of Mexico.

Unlike many Florida spring-based spas that relied almost solely on winter visitors from northern climes, Hampton Springs was marketed as a year-round retreat catering to both northern travelers in cooler months and visitors from the South in the summer. A large portion of the hotel's winter guests came from the Midwest, especially from Chicago, after a syndicate from the Windy City acquired a ninety-nine-year lease on the property in 1927.

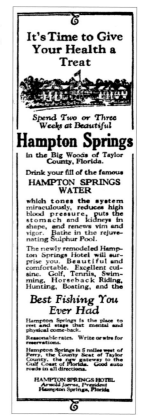

Ad from the *News-Press* (Fort Myers, Florida), July 13, 1928.

The president of the syndicate, Hampton Springs Properties Inc., was advertising man Arnold Joerns, a World War I veteran who had big plans for the property. "We expect to make much of it," Joerns boasted, describing changes that included "the Hampton Springs Club," a country club for the "approved folks of the nearby Florida and Georgia cities." As with traditional country club memberships, those who signed up paid no greens fees on the resort's nine-hole golf course and enjoyed free use of the tennis courts and swimming facilities. In addition, members received part ownership of the Hampton Springs properties, an interesting aspect similar to contemporary time-share arrangements.

In the summer of 1929 the all-inclusive resort offered rooms for $3.50 to $5 a day ($21 to $30 a week), including meals featuring fresh food from the dairy, poultry farm, and garden located on the premises. The hunting and fishing available to guests offered one of the hotel's chief attractions. "The Bass are Biting," crowed a 1929 headline in an ad that also listed horseback riding, side trips to the Gulf for bathing, bridge parties, and dancing as entertainment options during a Hampton Springs stay.

Access was improved by the creation of good roads for automobile travel when Taylor County opened up miles of paved highways. As a result, dual development companies were formed to sell land in the area, both of which made liberal use of the fame of the nearby spring in their marketing materials. One of the companies, the Perry-Hampton Springs Land Company, touted Taylor County as the "pivot point" of Florida's west coast development and offered lots for $150 and up.

Prosperity never really returned to the Hampton Springs Hotel after the Great Depression. After World War II the resort was refurbished with fresh paint and repairs, but the business could not match the success it tasted in the early 1920s. The "sprawling complex" was never used as a hotel again after 1950, and it burned to the ground in 1954. Today the location is owned by Taylor County, which used grants in the early 2000s to survey the site carefully, hire archaeological consultants, and turn it into a park.

The resort at Hampton Springs bridged Florida's golden age of bathing and the contemporary era. Well into the twentieth century, promoters of the hotel continued to advertise the health benefits of the water, even as the practice of taking the waters was considered old-fashioned. Yet in other ways, the wide array of all-inclusive recreational activities available at the resort anticipated the contemporary Florida vacation experience.[4]

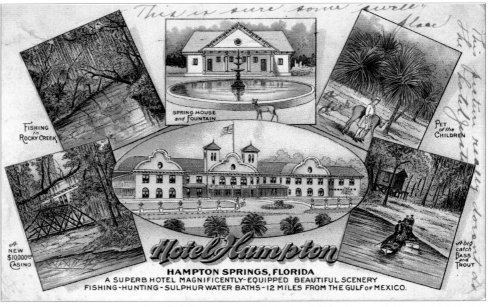

Handwritten notes on this postcard say, "This is sure some swell place" and "This picture really doesn't do the hotel justice."

A 2015 photo of the spring pool at Suwannee Springs, flooded with river water.

ARCHITECTURAL RELICS OF A GOLDEN AGE

Most of the grand architecture that was built around Florida's springs during the golden age of bathing has been lost. But in north Florida, one can see vestiges of the great springs resorts at several locations.

The tiny town of White Springs, for example, is just a short jog off Interstate 75 between Lake City and the state line. Crossing over the Suwannee River and driving into town is like going back in time, and every time I've visited, the streets have been eerily quiet. There is abundant interpretive signage about the town's history, so simply by walking around it's easy to learn about the days when it was a Gilded Age destination. The reconstructed springhouse is just off U.S. Highway 41, and it's well worth stopping to explore it to get a sense of the magnitude of the original structure, even though only a portion remains today.

The first time I visited, the spring was dry; the second time, the springhouse was full of Suwannee River water, since the gate that once separated the river water from the spring no longer exists. But whenever there are large rain events north of the spring within the springshed, sulfurous spring water occasionally flows again, and with it, the unforgettable smell of rotten eggs returns.

The site of the spa at Suwannee Springs is on the opposite side of the river, just a bit north of White Springs in a recreational area owned by the Suwannee River Management District. During my visit there, tannin-stained river water filled the manmade spring basin, leaving only a few feet

Sulfur water flows from the wading pool into the swimming pool at Hampton Springs in 2018 shortly after the fill was removed.

protested the loss of a favorite swimming hole, and officials had the pool emptied of the debris that had been deposited there.

My initial exploration of Hampton Springs was on a cold day in 2014. There was no one in the park as I poked around; a "polar vortex" threatened north Florida with potential snow flurries. I saw evidence of ugly vandalism throughout the park, which contrasted with the stark natural beauty of the dark creek that ran behind the spring. Malicious damage and liability issues had contributed to the county's initial decision to fill in the spring pool.

Taylor County officials had the foresight in the early 2000s to survey and partially restore this historic resource, creating an opportunity for future generations to learn about the forgotten resort that used to stand here. Beyond maintaining a swimming hole for locals, preserving the ruins offered a glimpse back in time to when "taking the waters" at Florida springs sparked today's tourist economy. It's too bad the vandals don't see the value of this window into the state's past.

of the rock wall that encloses the spring visible above the water line. When water levels are lower, the spring still flows, but without much volume. In addition to the rock walls that surrounded the spring, I located a couple of the surviving board-and-batten cabins and a building of rock and brick that was once the kitchen annex for the long-absent hotel. An old bridge crossing the Suwannee dominates the location; it's covered in colorful graffiti, somewhat out of place in this park full of history and nature. Once health seekers flocked to the resort, but time and the Florida wilderness are eroding the remnants of that colorful age.

The home of the Hampton Springs Hotel—now a county park near Perry, Florida—offers another opportunity to see relics from that era. The bathing pool received much attention in the spring of 2018 after Taylor County officials decided to fill it in. County commissioners quickly reversed their decision, however, after residents

The White Springs springhouse flooded with river water, 2015.

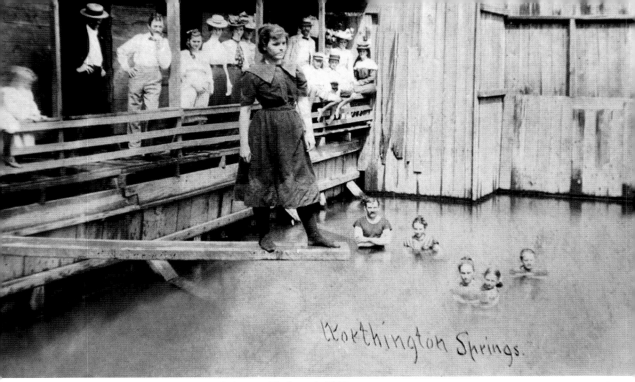

Bathers and onlookers at the Worthington Springs pool in the early 1900s.

WORTHINGTON SPRINGS: FAMOUS CURES AND A RUMORED CURSE

The potential for a heath resort at Worthington Springs, just twenty-one miles north of Gainesville, was discovered before Florida became a state. Bathing facilities and a hotel weren't constructed, however, until the mid-1890s, and the spring's promise wasn't fulfilled until the railroad arrived in 1900. Postcards advertised Worthington Springs as "famous for its cures of Rheumatism, Indigestion & Kidney Troubles," but at the height of its popularity, north Florida residents also regularly ventured there for recreational outings. The last hotel near the spring burned down in 1937, and the location of the spring's pool is now underneath the asphalt of the parking lot for Chastain-Seay Park.

Unlike so many of Florida's springs, the origin story of Worthington Springs starts not with wise American Indian guides but with curious children. According to legend, the sons of pioneer Sam Worthington discovered the spring while they were playing near the Santa Fe River. The boys supposedly noticed a "trickle of water" flowing from under a tree root, so they dug out the earth surrounding it, and the hole soon filled with water. Upon seeing this, their father soon had a pool dug that ultimately became Worthington Springs.

Sam Worthington, an Englishman, came to north Florida from the St. Marys River area of northeast Florida, perhaps as early as 1812. He was a successful cotton planter in Newberry, South Carolina, before moving to Florida and settling on land on the Santa Fe River that would become known as Worthington Springs—but

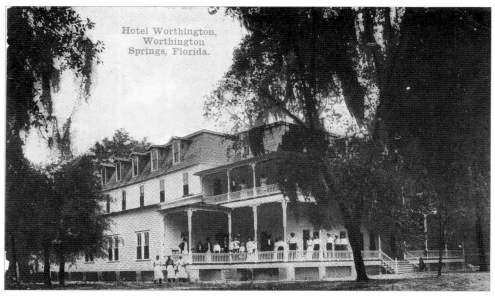

"Fine accommodations for seekers of the famous baths," reads a newspaper article, which also mentions that the spring water was pumped directly into tanks inside the building so that guests could go "directly to the bath" without leaving the hotel.

not in his honor. In a strange coincidence, the settlement was named after another Worthington—William G. D. Worthington, secretary and acting territorial governor of East Florida.

During the Second Seminole War, Sam Worthington and his family sought refuge from Seminole uprisings in a stockade in Newnansville, and his wife died during this time. After returning to his homestead Worthington attempted to open a store in what was becoming a growing community. According to a history of the town, his hopes were dashed when his partner, flush with Worthington's money, took off on a mission to buy provisions in Georgia and never returned. Worthington was so distraught over the loss of his money that he "stopped the flow of water at the spring and prayed down the curses of heaven on the place and left." The spring would not be developed until its next owners, Mr. and Mrs. William Lastinger of Georgia, restored its flow.

In 1895 a primitive springhouse was constructed with separate men's and women's bathing areas and dressing rooms. Bathing times were also separated by gender: during ladies' bathing hours, a bonnet would be flown atop a tall pole; a straw hat would indicate men's bathing times. In the summer of 1906 the spring's new owner, I. F. Lamb, upgraded the facilities again, constructing a concrete basin with deep and shallow ends to confine the spring water. He also built an improved springhouse that included a popular second-floor dance hall.

A hotel named the Scarborough rose near the spring, also in 1895, but it was demolished just a decade later. Other nearby properties included the Dubose and Wells hotels, but they both burned down in 1906. Lamb's initial hotel fell victim to fire in 1910, but he rebuilt, and the second iteration lasted until 1937 before

also being consumed by flames. The devastating fires led locals to wonder if Sam Worthington's curse might have been fulfilled.

Postcards of Lamb's Hotel Worthington show a three-story wooden structure with a mansard roof, gabled dormer windows, and a spacious covered porch along the front. The "New Hotel Worthington" had covered second-floor balconies as well as first-floor verandas on multiple sides of the building. The hotel also had quite the reputation for fresh food and first-class entertainment—newspaper accounts gushed about summer performances with musical talent from Gainesville and Jacksonville.

A postcard of the springs and bathhouse uses the term "Summer and Winter Resort," indicating that the owners sought both winter visitors from the North and summer clientele from the South. A 1908 *Tampa Tribune* article noted that inquiries had been received from northern tourists who were contemplating construction of vacation cottages near the spring. "No healthier nor more beautiful place could be selected in Florida for the building of winter homes by our northern brothers," the writer raved. Other early 1900s news articles attest to activity in the warmer months, detailing the visits of prominent residents of north Florida towns who enjoyed the cool water as well as concerts, picnics, and political rallies at the springs. Special trains ran on holidays such as the Fourth of July, when two or three thousand people would descend upon the small Santa Fe River town.

After the last hotel burned down, Worthington Springs became mainly a site for recreation into the 1950s, when the spring appears to have been greatly diminished. Ultimately it dried up completely. Until recently a park on the site of the old resort had once again become the scene of picnics and holiday celebrations. But after damage from Hurricane Irma in 2017, the park closed again for a time. Perhaps it was Sam Worthington's curse at work again. Today a photo display by the road offers the only evidence of locale's history of healing waters.[5]

Well-dressed visitors to Worthington Springs pose outside the fence surrounding the spring pool on June 4, 1901.

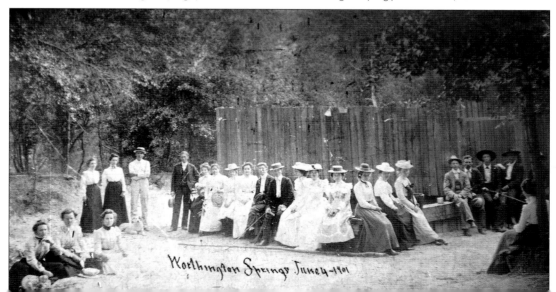

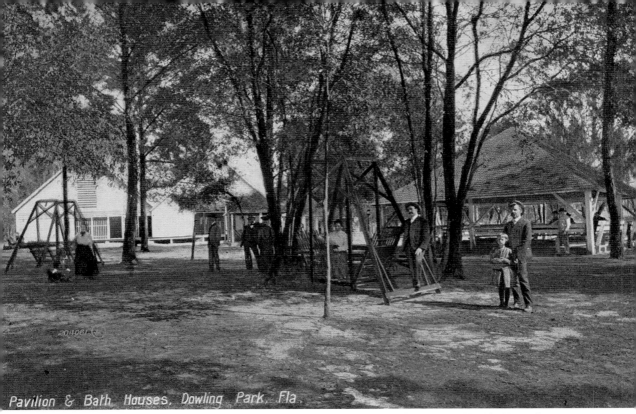

Pavilion & Bath Houses, Dowling Park, Fla.

"The shady walks, the cool, restful seats, and the charming scenery, the fine baths and health giving spring water are potent factors, but would fall short of happy completeness without three square meals a day and a clean, restful bed at night," noted the *Live Oak Daily Democrat*, September 26, 1906.

DOWLING PARK: FOUNTAIN OF YOUTH TO RETIREMENT HOME

The Dowling Park resort was an early twentieth-century complex consisting of the Park Hotel, rental cottages, and mineral baths located near the banks of the Suwannee River west of Live Oak—the creation of Thomas Dowling, a self-made man who earned his fortune in the lumber and railroad industries. Dowling's sawmill was one of the largest in the state, and a town called Dowling Park grew up around his business ventures.

Dowling built the Park Hotel in 1904. Two years later, an article in the *Live Oak Daily Democrat* on September 21, 1906, reported it was on a "boom," stuffed with guests "nearly all the time." Promotional materials called the hotel a "perfect paradise for the sportsman, tourist, or invalid." For the sportsman, good fishing and hunting were available within walking distance or via gas launch on the river. For the tourist, the hotel was ideally situated on the bank of the picturesque Suwannee and offered bowling, billiards, and horseback riding. For the invalid, there were both hot and cold baths in every room, plus a bathhouse and pavilion at the health-restoring spring.

Business at the hotel appears to have peaked in 1906 and 1907. The *Miami News* reported the destruction of Dowling's sawmill in a devastating fire on August 21,

An ad in Tallahassee's *Weekly True Democrat* for September 21, 1906, touted "the popular health and pleasure resort" at Dowling Park.

1907. Two years later a fire broke out at the resort, resulting in the loss of the hotel, three cottages, and the bathing pool. In 1910 Dowling sold some of his assets to Richard W. Sears of Sears, Roebuck and Company. The following year, at the urging of his minister, Dowling set aside 120 acres for a campground for the Advent Christian Church. That property became the American Advent Christian Home and Orphanage in 1913. Today what was conceived as an orphanage and place of refuge for "tired and worn-out Christian workers" is home to the Advent Christian Village, a retirement community of eight hundred residents. Its establishment in 1913 made it Florida's first retirement community, paving the way for such large-scale developments for seniors as the prodigious Villages area with more than a hundred thousand residents in Sumter, Marion, and Lake counties.

The health spas developed at the springs along the Suwannee and Santa Fe rivers in north Florida varied in scale and luxury, and several rivaled the grandeur of the better-known resorts on the St. Johns River. As the economy of the state's interior evolved, these facilities helped to entice visitors to spend much-needed capital and provided recreational outlets for residents. Eventually, railroads would extend farther down the peninsula, opening larger portions of the state, including much of the Gulf Coast, which previously had been largely primitive.[6]

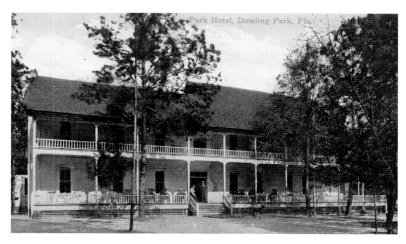

The Park Hotel was advertised as "high and dry and free from mosquitoes," with hot and cold water in every room and an "excellent sewerage system."

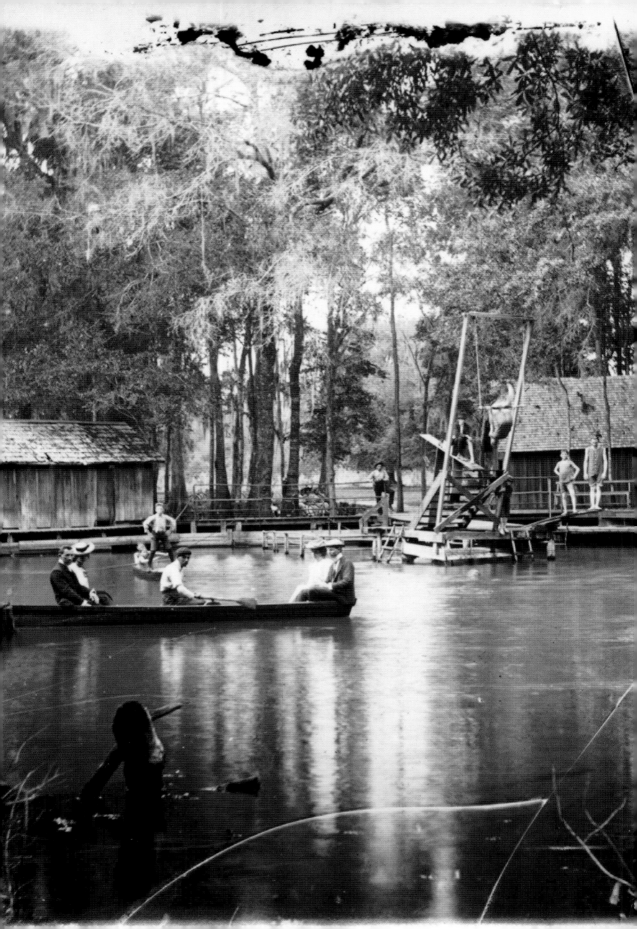

MINERAL SPRINGS NEAR THE GULF

Spring-Based Spas near America's Sea

Its territory is watered by fine navigable rivers, be-gemmed with lakes and ponds, laced with the clearest brooks, and all are fed from the most marvelous springs, many of them possessing medicinal virtues.

—*"Florida, Cuba & Jamaica," brochure, Plant System (of railroads, steamboats, and hotels)*

The area of Florida near the Gulf of Mexico contains some of the largest springs in the state, including first-magnitude tourist favorites Weeki Wachee and Homosassa. But many of the spa facilities near the Gulf Coast were developed at smaller springs, often due to the minerals in the water that were generally believed to possess healing qualities. As the region around the Gulf experienced an influx of settlers in the nineteenth century, opportunistic entrepreneurs saw the healing mineral waters as potentially lucrative commodities that could be used to attract attention to the communities they were building.

"Every new train line that reached the coast, every new hotel that opened, and every new craving for a marketable resource" brought Florida's Gulf Coast region closer to the "furious pace of change and consumption that possessed the rest of the nation" in the late nineteenth century, writes historian Jack Davis, who dubbed the Gulf "America's Sea." The spas built near Gulf Coast springs were surely part of that rush of development.

Again, transportation was critical for the success of these destinations. Waterborne travel accounted for some visitors, but it was not the critical factor for development, as it was for the Florida springs along the St. Johns River. Despite their proximity to water, whether the Gulf of Mexico, bays connected to the Gulf, or a river or creek, the development of spas at mineral springs along the Gulf often relied on land-based transportation. Horses, mules, trains, and later automobiles made these locations accessible for throngs of visitors seeking restoration and rejuvenation.

As with the rest of the state, the popularity of these spas waned as recreational bathing in sea water became fashionable and luxurious waterfront resorts attracted

Sulphur Springs in Tampa in the early 1900s, in an image by North Carolina photographer Abraham Lincoln Ensley.

more northern visitors. Some of the investors behind spas in the Gulf region were perhaps always more interested in land sales than in the salubriousness of their waters. Disasters, both natural and economic, critically impacted some of the resorts. Today at several of these locations, the water is fenced off or piped away and can no longer be accessed. But miraculously, at a few of them, the healing waters still flow.[1]

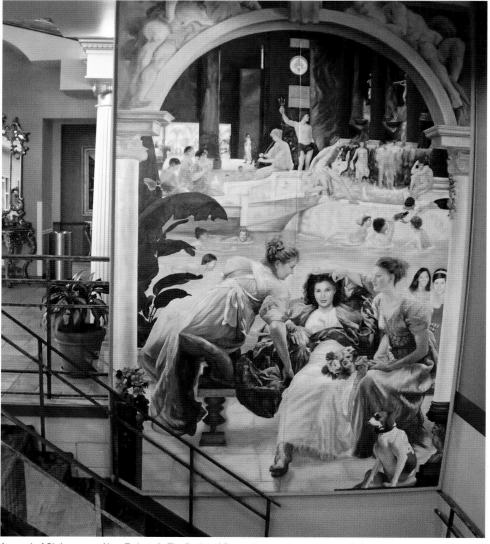

A mural of Sir Lawrence Alma-Tadema's *The Baths of Caracalla* greets guests at the Safety Harbor Spa and Resort.

THE "OLE SWIMMIN' HOLE," NEWPORT, FLORIDA, P.O. R.D.1, WAKULLA, FLA.

William Miller's "Ole Swimmin' Hole" at Newport, filled with water from sulfur wells, opened in 1930 in an effort to capitalize on the town's past as a watering place for invalids and pleasure seekers.

NEWPORT SPRINGS: SHORT-LIVED SUMMER SPA TOWN

After a hurricane destroyed the small town of Port Leon in 1843, its former residents established a new village called Newport, farther away from the Gulf. The settlers chose the site on the St. Marks River about twenty miles south of Tallahassee because it was on higher ground than Port Leon, yet still accessible by oceangoing vessels, and because it had a number of flowing springs. Former Maine resident Daniel Ladd, considered the town's founder, owned many of its successful businesses and much of its real estate.

In 1846 Ladd opened the Wakulla Hotel in Newport on the shores of the sulfur spring there, the waters of which were said to have medicinal value. The hotel was also known for its excellent seafood cuisine, which featured green turtle, fresh fish, and oysters. A second establishment, the Washington Hotel, did not have the luxury of being located near the spring, so guests who wanted to take the waters had to be shuttled to the spring by carriage. Ladd built a bathhouse for privacy and offered plenty of social activities such as dancing, boat trips down to St. Marks, hunting and fishing excursions, and sports at something called Maddon's Bowling Saloon.

In the mid-1850s most visitors arrived in Newport via stagecoach on a wooden plank road from Tallahassee. Later a slow-moving, mule-powered "railroad" was added, and steam locomotives arrived in 1859. By now many of Newport's prominent residents were transplants from northern states and the United Kingdom, but most of the resort's summer visitors came from north Florida's prosperous plantation region and from nearby Thomasville, Georgia. Their wealth couldn't protect them from disease, though: the constant flow of sailors arriving at Newport's waterfront increased the town's risk for infectious diseases, and between 1852 and 1854

it suffered three onslaughts of yellow fever.

In the 1860s the Civil War greatly affected Newport Springs. Although Ladd, its chief developer, owned slaves, he also opposed secession and presented his views at Florida's secession convention in 1861. During the war Ladd stayed with his investments in Florida, but his steamship,

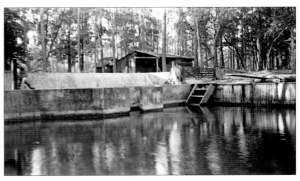
Newport Springs pool, 1921.

the *Spray*, was pressed into service as a Confederate gunboat. In 1865 Union forces landed off St. Marks and headed toward Newport. To keep the town from falling into enemy hands, Confederate forces set it ablaze. Although Ladd rebuilt some of his businesses after the war, Newport Springs never fully recovered as a spa destination for health seekers.

Ladd died in Newport in 1872. In the late 1890s several people made attempts to build a sanitarium at the "famous medicinal spring property" there, including midwestern railroad owner and real estate developer Charles G. Wicker. One newspaper account optimistically dubbed Wicker the "Henry Flagler of Middle Florida," but the former Chicago alderman died in 1889 without seeing his plans for Newport come to fruition. A bathhouse for recreational swimmers was added in 1910, but facilities for invalids were never rebuilt. In 1930 William Miller of Thomasville, Georgia, built a new concrete pool filled with artesian-well water in an effort to "develop the mineral water and create a high class pleasure resort." Called the "Old Swimmin' Hole," Miller's facility billed itself as the finest picnic place on the Gulf Coast, with "excellent bathing" and "fine fish dinners."

Today about all that is left in Newport is Ouzts Too Oyster Bar, located next to the Old Plank Road on U.S. Highway 98. Like the Old Swimmin' Hole and the Wakulla Hotel before it, Ouzts Too proudly promotes fish dinners (mostly smoked

mullet). But instead of a dip in mineral waters, the closest thing Ouzts Too has to a water amenity are porcelain toilets, used as planters, lined up in a row against a fence behind the restaurant.[2]

Ouzts Too Oyster Bar's "Toilet Garden" in Newport on U.S. Route 98.

✺ PANACEA SPRINGS: THE HEAL-ALL SPA

Early settlers along Dickerson Bay in the late 1800s knew about the array of a dozen or so small mineral springs that came to be called Panacea Springs. According to one account, the area was once called Smith's Springs because four Smith brothers from New York bought land around the springs, and one brother lived there for a short time. Other stories tell of covered wagons negotiating primitive trails in order to transport the sick to the healing waters of these springs.

It was thought that the water of each spring had a slightly different chemical composition and could thus cure a different malady. One spring was believed to alleviate arthritis, while the famed Cedar Stump Spring was said to help kidney issues. Beauty Springs was supposed to retard the effects of aging, and drinking the waters of Calomel Spring supposedly had a laxative effect. So when the settlement near the array of springs was large enough to get its own post office in 1898, it seemed appropriate to call the place Panacea, the Greek word for cure-all. After having his own health-restoring experience at the springs, W. C. Tully founded a town there by establishing the post office, building cottages, and opening a small hotel.

Initially getting to Panacea was challenging for those seeking the restorative waters—travelers had to take a train to the town of Sopchoppy and then endure a two-hour journey on a tram pulled by a pair of mules along wooden rails. Around the turn of the century a sawmill was built next to the spring to produce the wooden rails. As the destination's popularity grew, seasonal residents built cottages, and the

Cedar Stump Spring at Panacea was named for a tree stump with holes drilled in the branches from which mineral water flowed into a basin.

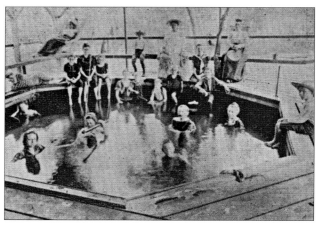

town boasted two hotels: the Bay View Inn and the 165-room Panacea Mineral Springs Hotel, operated by Bostonian Thomas H. Hall. By 1901 Hall's hotel had been enlarged and offered mineral and saltwater pools, baths in the hotel, billiards, and indoor shuffleboard. In addition to bathing at the

Bathing in a pool at one of Panacea's mineral springs, 1902.

springs, hotel visitors enjoyed the Gulf—sailing, fishing, and sea bathing in salt water beneath a bathhouse constructed at the end of a hundred-yard-long pier.

After 1917 the mule-drawn tram was discontinued, and guests arrived either by horse and buggy or by automobile. The array of springs was a short walk from the hotels, and some of them had been enlarged with concrete pools that could accommodate multiple bathers. Others were sheltered with pavilions, and paths connected the individual springs—there was no admission charge for bathing in them. Some springs were set up for drinking; guests brought their own cups or jugs, and enterprising businesses supplied promotional water dippers as advertisements. Tallahassee hotels offered Panacea Mineral Spring water in fountains and coolers in their lobbies to entice visitation to the springs. Home delivery of the mineral water was also advertised—five gallons was just fifty cents.

Despite the loss of one of the hotels to fire in 1924, two new hotels were built the following year, and Panacea Springs reached the peak of its popularity as a spa between 1925 and 1928. Ironically, as improved roads were developed and it became easier to visit Panacea, the volume of visitors seeking restoration decreased and recreational travel increased. After the Great Depression the bathing facilities fell into disrepair, and by the end of the twentieth century the "heal-all" springs were for the most part forgotten.[3]

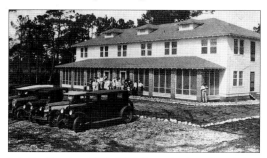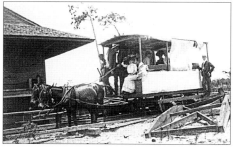

Left: Bay View Inn, 1929. *Right:* The mule-drawn tram between Sopchoppy and Panacea had a reputation for jumping off the rails.

The remnants of the pool at Newport Springs, photographed through a fence, 2018.

SEARCHING FOR HEALING WATERS IN FLORIDA'S BIG BEND

The best route for exploring the mineral springs of Newport and Panacea is the eastern section of the Coastal Trail of the Big Bend Scenic Highway (U.S. Route 98) extending from the St. Marks National Wildlife Refuge to Apalachicola. In Newport the spring is just off the historic Plank Road, still unpaved but no longer covered with wooden boards. The spring was a local swimming hole until recently, but at the time of my visit it was surrounded by a chain-link fence covered with no-trespassing signs. I was disappointed that I couldn't get closer to the water, but it was good to know the spring still flows. When I visited, there was no obvious evidence of the town that used to boast two hotels for visitors who wished to take the waters.

Farther west is the unincorporated town of Panacea. Panacea Mineral Springs Park is directly across from the Wakulla Welcome Center, and at the time a large sign marked the spot where about a half-dozen small mineral springs still trickle into different-sized basins. The spring

Panacea Mineral Springs, 2018.

closest to U.S. 98 had a brick wall around it leading to a circular opening, so I guessed it might be Cypress Stump Spring, from which water flowed directly out of a stump. Nearby were several other rectangular basins of differing sizes, some sheltered and others open to the elements. One spring filled a pool large enough for several bathers; others were smaller than hot tubs. All the springs had cloudy water that seemed to indicate a high concentration of minerals.

I found the most interesting spring near the rear of the park, where three brick columns supported a roof above a small round basin. It reminded me of a spring one might find in a temple in the ancient world—all it needed was an oracle. Right next to the creek, one of the columns had been pushed down into the water, and another was covered with graffiti. This place where the water was at one time believed to have miraculous properties seemed to be very much at risk.

These spring pools are invaluable assets of our state's history where enormous opportunities exist to create connections between people and place. To let these relics crumble and disappear should be unacceptable. One does not need an oracle to see the cloudy future facing these irreplaceable historic resources.

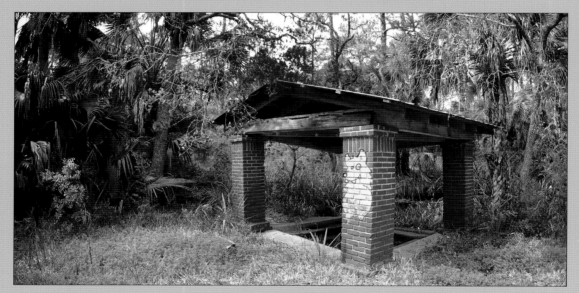

Ads claimed that twenty-five springs were available for bathing and drinking. Here are a few I found in Panacea Mineral Springs Park in 2018.

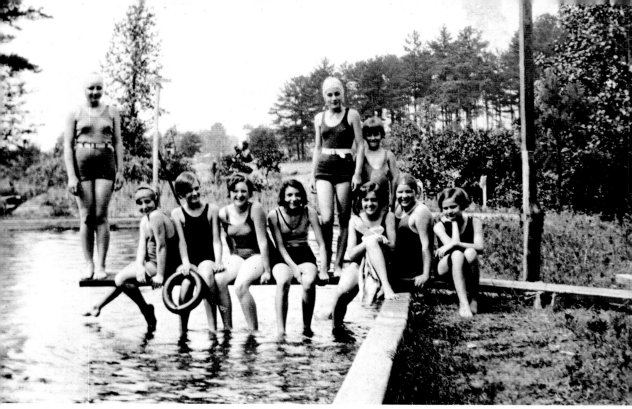

Girls crowd a diving board at a Lanark pool in the 1930s. Patrons found "great pleasure and refreshment in spending a day or two fanned by the invigorating breezes and cooled by a cold morning plunge in the briny deep," the *Pensacola News Journal* noted in 1911.

ᎦᏕ LANARK SPRINGS: MINERAL WATERS AND SEA BATHING

This once popular seaside resort near Carrabelle survived hurricanes, devastating fires, and the demise of the railroad but could not endure in modern Florida. Created by an investment syndicate headed by Scotsman William Clark, Lanark-on-the-Gulf was a planned community featuring a stylish resort at the southern terminus of the syndicate's railroad. The magnificent Lanark Inn opened on the Fourth of July in 1894 near what advertisers called the "Famous Lanark Mineral

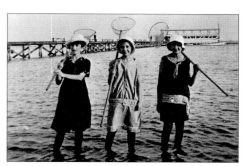

Girls with crabbing nets near the pier and swimming pavilion, 1911.

Spring." The spring had a bathhouse with private dressing rooms, and spring water filled a twenty-thousand-gallon water tank, so that fresh mineral water could be used throughout the hotel. Sea bathing was a major attraction, and a long pier topped with a dance pavilion and bathhouse stretched into the Gulf. Newspaper accounts of the bathhouse described seating that allowed guests to observe experienced swimmers as they "plunge from

Lanark Inn
Lanark, Florida
on the
Gulf of Mexico
Bathing, Fishing, Boating, Dancing, Excellent Cuisine.
Mineral Waters of Exceptional Curative Powers.

Reached by the

GEORGIA, FLORIDA AND ALABAMA RAILROAD

Through Sleeping Car Service Between

Atlanta, Macon, Americus, Ga., and Tallahassee, Fla.

For Vacation Railroad Rates Write

C. J. ACOSTA, Assistant General Passenger Agent
GEORGIA, FLORIDA & ALABAMA R. R., Bainbridge, Ga.

Ad from the *Atlanta Constitution*, June 15, 1919.

spring boards to frolic in the water beneath" as well as the "more timid" bathers who used the usual "accompaniment of steps and ropes."

In 1899 newspaper front pages across the nation described the hurricane that blew the resort at Lanark Springs into the Gulf. The hotel was rebuilt, but it was destroyed again in 1907, this time by fire. It was reconstructed in 1908 with "miles of veranda" and a unique triangular layout. Guests soon returned to take the waters, go crabbing in the Gulf, and try their luck at fishing or hunting. In the age of the automobile the resort's appeal to northern visitors disappeared, so the hotel was marketed primarily to residents of Tallahassee and Atlanta. "Drive Down, Dip Dance Dine," urged 1920s display ads with additional reminders not to forget your bathing suit or fishing tackle.

During World War II thousands of American troops trained for the D-Day invasion on Lanark Beach, and the Lanark Inn became the headquarters for the U.S. Army's Camp Gordon Johnson. In 1951 the inn burned down, and developers swooped in later in the decade to create a community called Lanark Village. In 1957 developers tried to enlarge the spring using dynamite, and as a result the spring most likely collapsed and no longer flows.[4]

"LANARK INN!"
LANARK·ON·THE·GULF
RATES $2.50 TO $3.00 PER DAY.

Special Rates by the Week or Month. This Popular Summer and Winter Resort will Re-open under New Management,

MONDAY, JANUARY 28th!

The Only Hotel Conveniently Located to Accommodate Sportsmen, who wish to avail themselves of the opportunity for Deer and Turkey Shooting, for which James Island and Wakulla county are famous. Fishing Excellent. Boats for Sailing, Rowing or Fishing. Shore Dinners a Specialty; also, New England Sunday Morning Breakfasts, Boston Brown Bread and Baked Beans.

The Hotel is Supplied with Water from the Famous Lanark Mineral Spring!
And Lighted and Heated Throughout with Gas.

45 Miles from Tallahassee, on C. T. & G. R. R. Daily Train at 7:30 A. M. Sundays, at 8:00 A. M. Special Accommodation Sundays, at 4:00 P. M. 47-tf

A newspaper ad for the Lanark Inn boasted of rates from $2.50 to $3 per day, as well as "New England Sunday Morning Breakfasts," complete with baked beans, and water supplied from the "Famous Lanark Mineral Spring!"

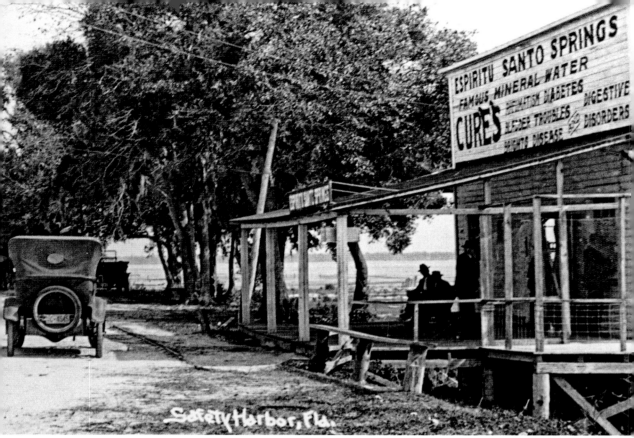

Signage on the facade of the waterfront entrance to Espiritu Santo Springs, circa 1910, lists cures for a variety of ailments.

ESPIRITU SANTO SPRINGS: SAFETY HARBOR'S SPA SURVIVES

"A beneficent Creator has placed in chosen spots over this earth certain springs with healing waters to cure the ails of man and beast," declared a 1929 ad for the small town of Safety Harbor, on the west side of Old Tampa Bay. The layers of human history here stretch back to the Tocobaga, indigenous people who lived in the region for centuries, who surely utilized the springs. What makes this place unique today is that it still functions as a haven for healing and restoration, where ancient waters still work their magic.

The Tocobaga left ceremonial mounds on what became the property of Odet Philippe, a native of France who became the first person in the region to grow citrus commercially. Philippe was likely the first European settler of Pinellas County, arriving in the early 1820s, although much of his life is clouded in myth. According to one story, he had studied medicine in France and used the restorative waters of a Safety Harbor spring to heal sick Native Americans. Another tale claims the reverse—that the natives showed the healing springs to Philippe in exchange for medical services he performed for them.

What is known for sure is that after the Second Seminole War ended in 1842, Col. William J. Bailey Jr. acquired the springs in Safety Harbor, and non-native people were introduced to the curative power of their waters. According to local legend, Colonel Bailey was directed to the location of the springs by a sick Seminole prisoner. Originally called Bailey Springs or Bailey-by-the-Sea, the settlement around the spring was later known as Green Springs—a name that honored either a paralyzed farmer named Green who received a miracle cure from the waters or the doctor who practiced medicine at the spring complex, Dr. J. T. Green.

When the community that grew up around the spring was ready for a post office in 1890, its name was changed to Safety Harbor instead of Green Springs, to avoid confusion with Green Cove Springs. The town's five springs, however, were collectively known as Espiritu Santo Springs ("Springs of the Holy Spirit")—a designation inspired by Spanish explorer Hernando de Soto's name for Tampa Bay: Bahia Espiritu Santo ("Bay of the Holy Spirit"). Early twentieth-century ads for Espiritu Santo Springs often included the line "Formerly Green Springs"; other ads continued to promote the destination as Green Springs through 1906.

With all the confusion about what to call the place, it's a wonder anyone could find the springs at all, but they did, and in large numbers. A 1906 newspaper account reported such a rush of visitors in search of healing waters that the people overflowed the available rooms and produced a "town of tents." At first steamers and sailboats ferried visitors across the bay from Tampa daily, but in 1914 the railroad

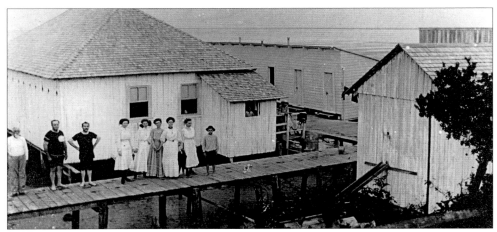

Top: Capt. James F. Tucker and Virginia Tucker, 1880s. *Above:* Bathhouse and pier showing improvements made in 1902.

arrived, shuttling a steady stream of thirsty pilgrims to the restorative waters. Bailey constructed a large pool as well as a pier, a water tower, and an assortment of wooden buildings along the bay.

The facilities were upgraded by Bailey's son-in-law, Capt. James F. Tucker, and his wife, Virginia, who took over operations at the springs around the turn of the century and created the Espiritu Santo Springs Corporation. The couple built the Espiritu Santo Springs Hotel, as well as the Safety Harbor Sanatorium (a place for treatment of chronic illnesses), with a new pavilion and improved dressing rooms. A 1908 account raved, "It is little to be wondered that this spot on the bay is thronged with people coming from every section of the state and country"—as patrons were

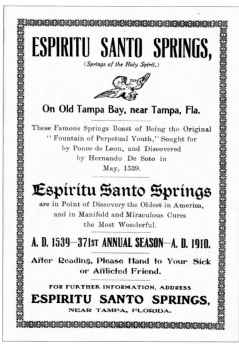

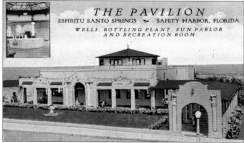

Above left: Reproduction of a brochure from the 1910 season. *Top right:* Guests sample "Santo Water" at the spa. *Bottom right:* A postcard for the pavilion building, with "wells, bottling plant, sun parlor, and recreation room."

inspired by the "many testimonials by the beneficiaries of the waters." After Captain Tucker died in 1913, Virginia carried on and named the new St. James Hotel across from the sanatorium in her late husband's honor.

Much like at Panacea Springs, each of the five Espiritu Santo Springs was promoted as having qualities to cure specific ailments. A sign in the springs pavilion where guests could sample the water listed the springs by number, but they were also identified by the healing powers associated with each spring. The water of "Beauty Springs" was said to heal eczema, psoriasis, and other skin disruptions.

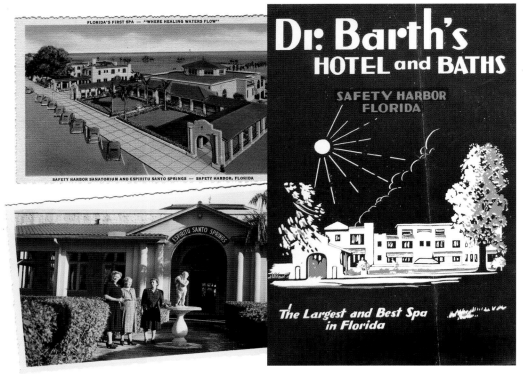

Top left: A postcard for Safety Harbor Sanatorium proclaims it "Florida's first spa." *Bottom left:* Ladies in front of the spa entrance. *Right:* A brochure for Dr. Barth's Hotel and Baths boasts of "cures prompt and certain."

"Stomach Springs" was for "general health problems" and supplied excellent drinking water. "Kidney Springs," in addition to curing kidney stones, was touted as alleviating arthritis, dropsy, neuritis, rheumatism, Bright's disease, and diabetes. "Liver Springs" water acted as a mild laxative in addition to clearing up liver and gall bladder disorders. The fifth spring, dubbed "Pure Water Springs," was used for bottled water.

In 1910 promoters of Safety Harbor Sanatorium published an analysis of its "Radio-Mineral Water," boldly claiming that the water's "efficacious and miraculous" qualities indicated the presence of radium in "unusually generous qualities" in the depths of one of the springs. Radium was considered desirable at the beginning of the twentieth century, but scientists later learned radioactivity could actually be unhealthy in bathing or drinking water, and the outrageous promotion was short-lived.

The business of healing water was good in Safety Harbor, and soon the original resort had competition. Daniel M. Pimpkin opened his Pimpkin Mineral Wells Hotel in 1914 after he tapped into a source of mineral water on property near the Espiritu Santo Springs. Pimpkin shared his mineral water with Dr. Con F. Barth, who opened up yet another hotel and bathing enterprise in Safety Harbor. Pimpkin's advertising asserted that only "strong mineral baths are given," and he offered treatments ranging from a plain bath for twenty-five cents to a regimen consisting of a mineral tub soak, salt rub, sweat shower, and massage for two dollars.

After World War I, Florida boomed in the early 1920s with a tremendous influx of visitors and potential investors. In 1923 Espiritu Santo Springs undertook an ambitious program to upgrade its facilities to compete better with "well-known health resorts in the country." The pavilion was outfitted with "modern devices," buildings were constructed in the Spanish architectural style popular in Florida, and a new water-bottling department was added in the basement. Directly upstairs, the water from the different springs was served to guests from an octagonal-shaped bar that served as the focal point of an expansive lobby. Virginia Tucker relinquished control of the Espiritu Santo Springs Corporation, which promoted the Safety Harbor Sanatorium as a health resort modeled after John Harvey Kellogg's famed Battle Creek establishment. Ads touted exotic remedies such as the "Ultra-Violet Ray, the X-Ray and other light treatments, as well as Diatherma, the Morse Wave, and other modalities."

During the Great Depression the resort fell on hard times until a new owner, physician Alben Jansik, purchased the property in 1936. Jansik renovated existing facilities and created recreational amenities such as an outdoor swimming pool, a solarium (for nude sun bathing), and tennis courts on about twenty acres of new property created when the old waterfront was filled in. The Jansik era saw Safety Harbor become a haven for well-known northern families ranging from the Kresges and Grants of department-store fame to the Seagrams, who made their fortune as distillers of alcohol, and the Ebbetses of baseball lore.

After World War II a syndicate headed by Dr. Salem Baranoff, a naturopathic physician from New York, bought Jansik's Safety Harbor Sanatorium and ushered in the modern age, turning the resort into the Safety Harbor Spa. The spa still offered mineral-water bathing, but a new holistic regimen now included healthy dining, golf, tennis, art classes, and entertainment including dancing and concerts. Devoted patrons, the majority mostly from New York, made wintering at the spa an annual tradition.

After Baranoff's ownership the Safety Harbor Spa had ups and downs that included a period of mid-century expansion and renovation. By 1980 it evolved again to include exercise areas, jogging trails, saunas, facials, and yoga. As the spa changed to accommodate modern tastes, its unchanging historic value was recognized. In 1964 the U.S. Department of the Interior declared the Safety Harbor Spa site a National Historical Landmark, and the State of Florida followed with its own declaration in 1997. Today a state historical marker near the spa's entrance presents a sketch of its multifaceted history. Inside visitors can stop by History Hall and read more about the spa's heritage on their way to a soak in the famed mineral water or to participate in wellness regimens such as yoga or massage.[5]

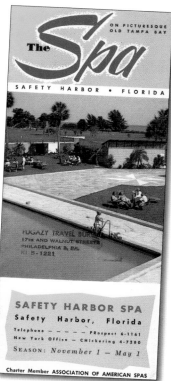

A brochure for "The Spa" after its mid-century makeover.

AN OASIS OF OLD FLORIDA

On the eastern edge of Florida's most densely populated county, the town of Safety Harbor offers a remarkable refuge from the hustle-bustle of the modern world. Many of the original commercial buildings from the spa's glory days still line the main street, which remains a hub of commercial activity. The focal point of the town continues to be the Safety Harbor Spa and Resort, and it offers a wellspring of activities along the waterfront.

The thirteen-acre property between the spa and the bay is now Safety Harbor Waterfront Park. Home to events such as the Safety Harbor Songfest, the park features a scenic boardwalk that offers spectacular views of the sunrise. Hidden to most eyes, a concrete culvert snakes its way underneath the park, delivering a small flow of sulfur-laced water to Old Tampa Bay. At the adjacent marina, manatees are often observed at an underwater spring bubbling up offshore.

When I visit Safety Harbor I like to follow the boardwalk toward Philippe Park, watching for colorful roseate spoonbills working the shoreline with their comical spoon-shaped beaks. At Philippe Park the Tocobaga-built temple mound where Odet Philippe reportedly escaped the rising waters of a hurricane still exists, and climbing the steps is an intense workout. The gravesite of

A remnant of the spa's history hangs outside the beauty salon.

the storied pioneer is in the park, and I've read that one can still find citrus trees from the long-ago time when the property was his plantation.

The Safety Harbor Resort and Spa is a comfortable place to stay, and most of the town's restaurants, shops, and entertainment venues are within walking distance. One of the resort's oldest buildings contains a room furnished as it would have been in the early part of the twentieth century when visitors arrived by boat or train. Today guests can experience taking the waters in a twenty-first-century setting. I've tried both the indoor and outdoor pools, but I found my favorite way to take the waters is a sublime soak in the whirlpool. The best thing about bathing in spring-fed pools is no overwhelming odor of chlorine, although by law, the water now has to be processed before one can drink it or bathe in it. I was thrilled to find the original sign describing the waters from springs No. 1, No. 2, and No. 3 still on display in the spa reception area. A glimpse of the source of the water can be seen in the floor of the beauty salon, where beneath a thick glass window, PVC pipes emerge from where they dip into the famous springs, long advertised as a fountain of health and well-being, if not perpetual youth.

The indoor pool is one of three fed with water from the famed springs.

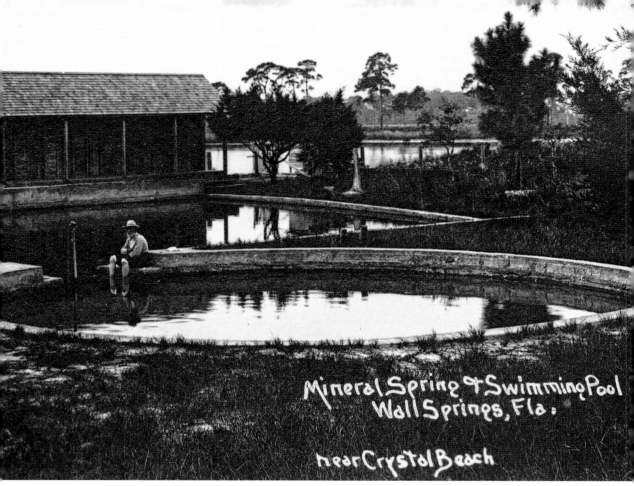

Mineral Spring & Swimming Pool
Wall Springs, Fla.

near Crystal Beach

A lone bather soaks his feet in the mineral waters of Wall Springs. Bathhouse facilities and a swimming area are behind him.

WALL SPRINGS: A FOUNTAIN OF YOUTH ENDURES

Local lore maintains that Charles Wall bought the spring near Palm Harbor that now bears his name in the 1870s for four hundred dollars and a pair of mules. That purchase doesn't appear in official records, but it is clear that under Wall's stewardship the spring began to attract large numbers of bathers coming to take the waters. The spring's proximity to a stop on the Orange Belt Railroad made it accessible to visitors, and after the turn of the century, Wall Springs hosted "300 bathers daily," according to a 1907 newspaper account. "The water at the spring has an agreeable taste, with just enough sulfur and magnesia to make you feel—well, as if it was a matter of duty," claims the article, and other newspaper ads show that the spring water was later bottled and sold by the St. Petersburg Coca-Cola Bottling Company. Buses from hotels in the nearby town of Sutherland also shuttled visitors to the spring.

"Cozy bungalows and stretching tents" were available as well as a bathhouse, where twenty-five cents would pay for a room, a towel, and a "neat bathing suit." The spring basin was walled off, creating a circular bathing area that remained

popular through the 1920s, when the spring was sold to New Yorker Henry Davis and renamed "Health Springs." Davis promoted the water's ability to relieve high blood pressure, bladder and kidney issues, and joint inflammation. He also marketed the spring as the fountain of youth and even claimed that Ponce de León thought the shape of the spring's limestone cave reminded him of his wife.

Davis sold the spring to the Cullen family in 1949; they went back to calling it Wall Springs, and it operated as a swimming hole for locals until 1966. Pinellas County purchased the property in 1988, and today it is a popular park. The railroad route that once delivered bathers to the spring is the Pinellas Trail, a much-used recreational resource for bikers, hikers, and joggers seeking a healthy lifestyle.[6]

Top: An image shows Wall Springs as a recreational resource. *Bottom left* and *right:* A vintage postcard and contemporary view of the profile visible in the karst features of the spring vent that supposedly reminded Ponce de León of his wife.

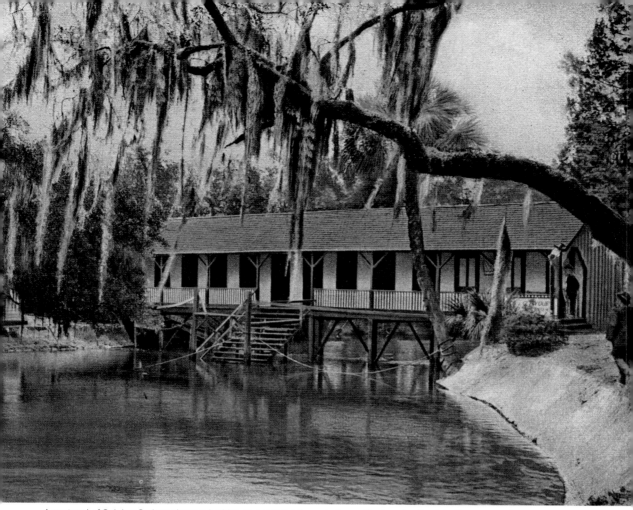

A postcard of Sulphur Springs shows a bathhouse spanning the spring run with steps leading into the water and safety lines for bathers.

SULPHUR SPRINGS: MINERAL-LACED WATERS BECOME A TAMPA ATTRACTION

According to the 1915 *Rinaldi's Guide Book to the City of Tampa*, Sulphur Springs was discovered by the Seminoles, who called the spring "Stomawa," meaning "Stomach Water." The guidebook also claims that the water was comparable to the famed spa waters of Kissingen, Germany, and that "thousands of Americans" visited the spring every year. In 1899 the spring was purchased by Dr. J. H. Mills, who also bought one of the first automobiles in the Tampa area, to drive guests to his property. Mills embellished his investment by creating a park-like landscape, adding bathhouses, and constructing a pool around the spring. In 1903, in a move reminiscent of a contemporary time-share pitch, Mills brought in hundreds of folks from Tampa by bus and barge to enjoy the then-famous resort for free and have an "opportunity" to buy a lot nearby. Eventually streetcars delivered locals and tourists to the spring, which was the final stop on Tampa's streetcar line.

Between 1906 and 1925 the property was developed further by Josiah Richardson, who turned it into a full-fledged amusement park, complete with an alligator farm, high-dive platform, toboggan slide, dance pavilion, and updated bathhouses. In early 1918 the spring was used as a location in the silent film *Birth of a Race*, produced by the Tuskegee Institute's Dr. Emmett J. Scott in protest against D. W. Griffith's deeply racist film *Birth of Nation*. During the 1920s Richardson's improvements were followed by the addition of a commercial arcade and an impressive 225-foot water tower that still stands today. The area thrived as a recreational destination for many years before the spring was closed for swimming in 1986 due to high bacteria levels.

Today the spring is located in a city park next to a municipal swimming pool full of highly chlorinated water. A 1920s gazebo that sheltered a fountain where the spring water could be obtained for drinking was recently renovated, although the water is off-limits for consumption. A tall metal fence surrounds the spring, from which lime-colored water flows freely, topped with floating hairy brown algae. Sadly, just gazing into the spring the Seminoles reputedly called "Stomach Waters" is enough to make you feel queasy.[7]

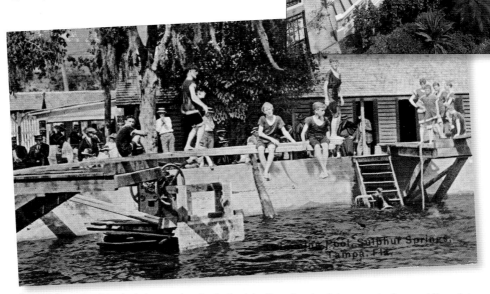

Top right: The restored gazebo features a mineral-water fountain. *Above*: A postcard shows young swimmers at the spring.

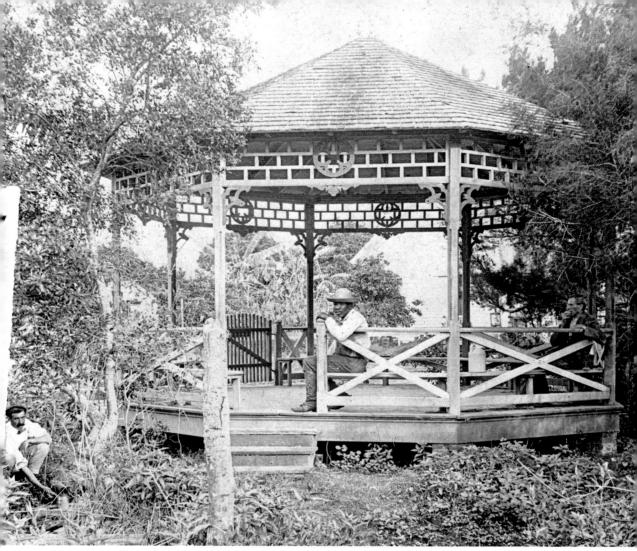

In this 1880s image a man identified as "Tom" fills a jug at Manatee Mineral Spring while two unidentified men look on.

MANATEE MINERAL SPRING: A FORGOTTEN PARK EMERGES AS UNDERGROUND RAILROAD STOP

In 1842 Josiah Gates left Fort Brooke in Tampa after the Second Seminole War, searching for a place to homestead on the south side of the Manatee River. With the help of Spanish fishermen acting as guides, he came across a spring surrounded by shell mounds on the river's south bank, the story goes, near the remnants of a Seminole farm—corn stalks and a few pumpkins—and decided to live there, thus becoming one of the first documented non-native settlers south of Tampa.

Archaeologists now think the spring on Gates's homestead was once part of a larger community of Black Seminoles, free blacks, and runaway slaves, settled during Florida's second period of Spanish rule between 1812 and 1821. The settlement was known as Angola, a common name for Maroon (Black Seminole) encampments,

according to historian Canter Brown Jr. Its population expanded after Andrew Jackson and his Indian allies pushed Seminoles and black communities southward from north Florida in 1816. By 1821 the Angola settlement was abandoned after raids by Creek Indians working with Jackson captured many of the people who lived there. Others fled to the south, and some ultimately escaped to the Bahamas. Today descendants of the Maroons of Angola live in the village of Red Bays on Andros Island—the largest island in the Bahamas. Gates settled the former site of Angola with his family and eight enslaved people in 1842, creating what was essentially a wilderness hotel where future homesteaders could stay before settling into the area.

Allegedly, the Seminoles had called the spot "Medicine Spring" and bathed in the healing waters there. Dr. Franklin Branch, a physician from Vermont, saw the spring's potential and in 1849 purchased adjacent land where he constructed his home and a second building to use as a sanitarium. Branch envisioned a clientele of northerners who sought relief from chronic maladies such as tuberculosis. When the Third Seminole War erupted in 1855, however, Branch's compound served instead as a makeshift fort, offering refuge to the area's settlers. In 1859 Branch apparently abandoned his plan for creating a healing resort, sold his property to Capt. John Curry, and moved to Tampa. The Curry family helped found a Methodist church and start a Masonic Lodge, and by the late 1880s the settlement had grown into a small town called Manatee.

In the twentieth century the spring remained an alternate source for drinking water. Helen and John Crews Pelot, whose family were Manatee pioneers, remembered bringing "five gallon demijohns" to the spring to fill with mineral water, because despite the availability of municipal drinking water, "most people wanted to drink" the spring water. A 1960s newspaper article reported that the spring, eventually reduced from its twelve-foot-wide natural basin to a four-inch-wide pipe, had been covered with a permanent concrete housing by the City of Bradenton. The course that the spring water followed into a creek was filled, and the remaining flow from the spring was apparently piped into the storm sewer, before flowing into the Manatee River.

The site of the springs also became a popular spot for community picnics and other recreation. The city established a park there, first called Indian Spring Park and then Manatee Mineral Springs Park, and a state historical marker was unveiled in 1965. A volunteer group called Reflections of Manatee now works to preserve the rich history of the springs, and members have teamed with archaeologists to register the location with the National Park Service as an official Underground Railroad historic site. This little spring with such a diverse, rich history, covered up and piped away, may finally receive the respect it deserves.[8]

Mid-century spa-goers at Warm Mineral Springs enjoy "healing mineral waters" ideal for year-round bathing enjoyment.

WARM MINERAL SPRINGS: HOT SPRINGS WITH A PREHISTORIC PAST

People have visited the waters of Warm Mineral Springs for thousands of years. Its mineral-rich waters are still used as a day spa today, and there are plans to upgrade the amenities in the park around these unusual springs that contain remarkable archaeological artifacts—evidence of its colorful history.

In contrast to the coolness of most Florida springs, the water at Warm Mineral Springs near Northport, Florida, stays about 87 degrees year-round because it originates from so deep within the earth. It also contains high amounts of dissolved magnesium, sodium, potassium, calcium, silica, and chloride. But the spring was very different thousands of years ago when the climate of a significantly larger Florida was much more arid and desert-like. In this environment, sinkholes with fresh water at the bottom, like the one that became Warm Mineral Springs, were a critical resource for both people and animals. Because of the ancient activity at this spring, just beneath the surface lies a significant archaeological cache, including one of the oldest prehistoric human burial sites ever recorded in Florida, as well as the bones of mastodons, saber-tooth tigers, and giant sloths.

Countless centuries passed before the spring, in its current configuration, was rediscovered by nineteenth-century cattle ranchers, likely the first non-native people to know about these waters. A written account of what was then called Big Salt

FOR YOUR FUTURE HOME

Warm MINERAL

VENICE, FLORIDA

A graphic encourages home-site investment.

Spring appears in Frederick Trench Townshend's *Wild Life in Florida*, published in 1875. In the twentieth century one of the spring's earliest known owners, the wife of wealthy Philadelphian George K. Brown, purchased the property, and newspapers speculated that it would be developed into a great health resort due to its "remarkable medical qualities." However, the Browns did little to develop the site, although a caretaker did operate a make-shift bathhouse to serve bathers who came to visit what one article dubbed the "Florida Mystery Pool." It was reported that circus magnate John Ringling, who resided in nearby Sarasota, offered to pur-chase the spring for $250,000, but his offer was rejected.

In the mid-twentieth century develop-ers bought the property, built more per-manent structures, and branded it "Warm Mineral Springs"—a place where people suffering from ailments including "arthri-tis, neuritis, Rheumatism, and crippling diseases" could pay a small admission fee to bathe. The spring was promoted as the "Real Fountain of Youth," supposedly vis-ited by Ponce de León, and newspaper ad-vertisements offered lots in the community around the spring for only $25 down and payments of $7.50 a month.

The Fountain of Youth claims were the result of a 1943 article by Dr. Jonas Emerson Miller of Sarasota, who maintained that the location of the spring was consistent with waters mentioned in the writings of Juan Ortiz, a former member of a 1528 expedi-tion led by Spaniard Pánfilo de Narváez. The bold assertions of Dr. Miller, who would later be part of an ownership group operating the

WARM Mineral SPRINGS

ON U. S. 41 SOUTH

one of the
WORLD'S GREATEST MINERAL SPRINGS

prings

ONE OF THE **WORLD'S GREATEST MINERAL SPRINGS** 87°F WINTER and SUMMER

Float!

BATHE, RELAX! IN THE WARM, BUOYANT, MINERAL LADEN WATERS OF **WARM MINERAL SPRINGS**

HUNDREDS HAVE COME IN WHEELCHAIRS AND WALKED WITHIN A FEW WEEKS OR MONTHS

We invite you to Compare...

WARM MINERAL SPRINGS	MILLION GALLONS	PARTS PER THOUSAND	WARM MINERAL SPRINGS
AIX les BAIN FRANCE	HOT SPRINGS ARKANSAS	AIX les BAIN FRANCE	BADEN BADEN GERMANY
VICHY FRANCE	BADEN BADEN GERMANY	VICHY FRANCE	HOT SPRINGS ARKANSAS

THE APPROX. **TOTAL DAILY FLOW** OF WORLD FAMOUS MINERAL SPRINGS | THE APPROX. **TOTAL FIXED SOLIDS** OF WORLD FAMOUS MINERAL SPRINGS

WHAT CAN PREVENT WARM MINERAL SPRINGS FROM BECOMING A RESORT CITY OF INTERNATIONL FAME? WHAT WILL THIS MEAN TO YOU, AS AN INVESTOR, A HOME OWNER OR OPERATOR OF A BUSINESS?

4,000 HOMESITES • MILES OF WATERWAYS, NAVIGABLE TO THE GULF OF MEXICO • MODEL HOMES • TWO MILES ON U. S. HIWAY 41, NEAR VENICE, FLORIDA

WARM MINERAL SPRINGS BOX 597 VENICE, FLA.

- 21 -

A chart compares Warm Mineral Springs waters to Aix-les-Bain and Vichy in France, Baden Baden in Germany, and Hot Springs in Arkansas.

spring, were never verified, but this supposed connection to Spanish conquistadors became especially useful when Warm Mineral Springs joined in the celebrations of the four hundredth anniversary of the European settlement of Florida. The Florida Quadricentennial took place between 1959 and 1965—dates that marked four hundred years since the founding of Pensacola and St. Augustine.

Warm Mineral Springs celebrated the commemoration with displays of historical artifacts from Europe, wax mannequins depicting historical figures, a Seminole "village," water ballet demonstrations, and a cyclorama showing the life of Ponce de León. New buildings near the spring, designed by noted Sarasota School architect Jack West, were erected in 1959. Victor Lundy, another well-known Sarasota School architect, designed the Warm Mineral Springs Motel on the Tamiami Trail at the entrance road to the spring. The distinctive mid-century architecture has endured, and the City of Northport designated the springs' buildings as the first historic structures on their historic register.

Developers' schemes to use the spring as a magnet for sales of residential lots never met with much success, and the quadricentennial celebration was not nearly the boon that promoters had envisioned. But the springs found a fan base among foreign visitors from cultures that still believe in the efficacy of the power of soaking in mineral water. In recent years immigrants from Eastern Europe have even moved to Northport to give them more opportunities to take the waters year-round. Faithful patrons were outraged when the spring closed in 2013 after the contract with the vendor who operated the facility was not renewed. Now the City of Northport owns the spring, and new plans are taking shape to develop the area surrounding this unique natural resource into a large-scale health and wellness destination.[9]

Facing page: This brochure claims visitors can float with ease and "relax urges" in water that induces a marvelous feeling of well-being.

OLD WORLD MEETS NEW AGE AT WARM MINERAL SPRINGS

I first heard of Warm Mineral Springs in my quest to discover all the places that claimed to be Ponce de León's Fountain of Youth throughout Florida. Despite living in a state surrounded by water, when I first visited the place in 2011, it had been so long since I had been swimming that I must sheepishly admit I couldn't find a bathing suit in my wardrobe. So perhaps I was a little giddy to be back in the water again. Or maybe, just maybe, Warm Mineral Springs really is the Fountain of Youth, and I was deliriously enjoying the effects. As I dog-paddled around the circular springs, I felt incredibly happy, unusually buoyant, and at peace while surrounded by dozens of health-seeking strangers speaking foreign languages.

My first impression as I approached the springs was that the housing development surrounding it never quite reached its potential, but when I reached the parking lot, I was surprised at the large number of cars packed in on a beautiful warm February day.

The Jack West–designed buildings all still have a classic mid-century look, although it was clear that the company managing the property at the time I was there put effort into marketing the facility to contemporary health-conscious spa-goers. Signs all over the property reinforced the message of health benefits of the mineral-laden waters—and their association with the fountain of youth!

Patrons staked out turf around the spring, and there were several ramps leading into the water, which felt surprisingly chilly at first, despite its 87-degree temperature. The water wasn't crystal clear, like most Florida springs, but rather a pale green with a bit of sulfurous odor. A floating rope separated the wading area from the swimming area, and the spring was crowded with folks of all ages moving through the water in a clockwise direction. Piped-in classical music made for a surreal setting, and when the aqua aerobics class started, up-tempo tunes filled the air. Aside from the modern exercise, I was thrilled to be taking the waters at one of the few Florida springs still devoted exclusively to healing and restoration.

I floated on my back, dodging an occasional ball of algae, a sign that not even the Fountain of Youth is exempt from Florida's water-quality issues. I felt as if I could drift for hours. After a great lunch at the spa's cafe, I stopped in the gift shop and bought a plastic bottle of the legendary water. It appears that one of the minerals in high concentration in the water is magnesium, and the water is sold as a laxative. Maybe that explains its wondrous powers!

I purchased a liter bottle, with no idea that historically drinking the mineral water from the springs was an essential aspect in the ritual of taking the waters, almost as important as bathing. But I soon learned that the brand of Florida's famed healing waters had such power that any bottled water from our state appealed to consumers, whether it came from an actual spring or not.

The view from the Jack West–designed spa looking toward the spring, 2011.

Evidence suggests that Milwaukee Springs was planned as a facility for health and recreation for African American soldiers in the early 1940s.

 ## BEYOND THE SPAS: MORE HEALING WATERS

As the practice of modern western medicine in the United States became more advanced, the popularity of the cultural tradition of bathing in spring water for restorative purposes diminished. Although germ theory originated in the nineteenth century with the work of Louis Pasteur, Robert Koch, and Joseph Lister in Europe, it was not until the twentieth century that it became widely accepted by mainstream doctors in the United States. Across Europe and Japan, however, despite a modern understanding of the sources of disease, the cultural bathing tradition remains strong at spas and Japanese baths called *onsen*.

In 1924 Franklin D. Roosevelt sought relief from polio at mineral springs at Bullochville, Georgia. Roosevelt purchased the resort in 1926 and, a year later, established the Warm Springs Foundation devoted to curing polio. While spring-based spas in the 1800s centered around the social activities of the upper classes, a trend developed in which water cures were used in a more hospital-like setting, such as the facilities at Warm Springs, with a focus on restoration and rehabilitation. Many of Florida's grand Gilded Age resorts served as hospitals during World War II and in the postwar period. Near Gainesville, a short-lived recreational and rehab complex called Milwaukee Springs was created specifically for African American soldiers. This rehabilitative approach to hydrotherapy can be seen in the sanitarium movement that led to the creation of many Florida hospitals.[10]

The Safety Harbor Spa and Resort (Espiritu Santo Springs) and Warm Mineral Springs, however, still use spring water in their treatments, and both offer a variety of modern spa therapies as well. Most patrons of Florida's springs use them solely for recreational purposes, but there are those who arrive at the crack of dawn at springs such as Ponce de Leon and Green Cove to bathe in and drink the water. While consuming the spring water was always part of the Florida spa experience, the reputation of the state's water went far beyond the walls of spring-based resorts. And water from sources other than springs, from manmade wells to sea water, was used to lure people to the Sunshine State for healing.

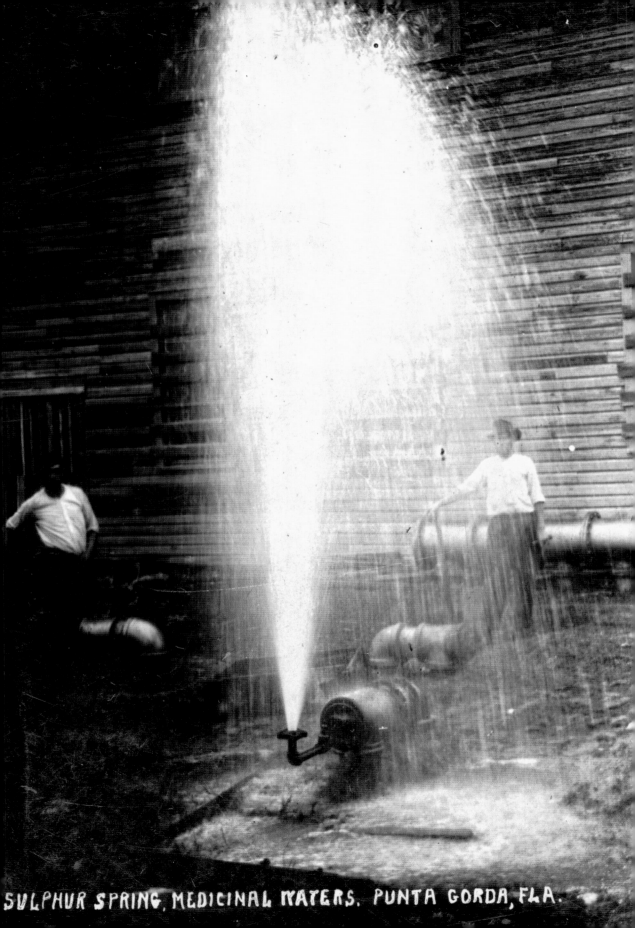

SULPHUR SPRING, MEDICINAL WATERS, PUNTA GORDA, FLA.

DRINKING FLORIDA MINERAL WATER

Liquid Cure-Alls from the Aquifer

Bottles and jugs have been lowered into Florida's mineral springs at least from the time of the first American settlement; and persons suffering from rheumatism, arthritis, and a host of other chronic disorders early came to immerse themselves in the healing waters and sometimes camp for extended periods.

—*Burke G. Vanderhill, "The Historic Spas of Florida"*

The corporate website for a popular brand of drinking water bottled in Florida suggests that "naturally occurring minerals" create the water's great taste. The presence of these minerals in Florida's groundwater, consumed by locals and tourists alike for centuries, helped make the case that the state's water was health-giving and that drinking it was good for you. Most spring-based Florida spas in the nineteenth and early twentieth centuries provided pitchers full of mineral water for guests to drink; imbibing it was considered an important part of the healthful measures one took on the path to restoration.

Several of these spas had commercial operations that bottled the water and sold it regionally or even nationally at pharmacies, groceries, and other resorts. Where a spring didn't exist, entrepreneurial businessmen simply tapped the aquifer by drilling wells. To some, the rotten-egg sulfur smell that John Bartram found so foul was considered an indicator of health-restoring minerals, making the water valuable. The power of the Florida-springs brand was so strong that spring water could be used both as an amenity for promoting land sales and as the basis of a water-bottling business. Today millions of gallons of water from the aquifer are bottled by major corporations and sold as a healthy alternative to sugary sodas.

Left: Water spouts from a well on a real-photo postcard labeled "Sulphur spring, medicinal waters, Punta Gorda"—proof that waters did not need to originate from a naturally occurring spring in order to be called "medicinal." *Right:* Wall Springs was just one of the Florida mineral springs with bathing facilities to create a bottled-water brand.

❧ HEALTHFUL WATER FLOWS FROM THE SUNSHINE CITY

In 1910 St. Petersburg adopted the slogan the "Sunshine City" at the suggestion of Lew Brown, editor of the *Evening Independent*, the city's first newspaper. In a long-standing publicity stunt, the *Evening Independent* gave away free newspapers every day the sun didn't shine, and city promoters bragged that free papers were only handed out about five days a year. But early in the city's history, when St. Petersburg transitioned from a small fishing hamlet to a vibrant tourist destination, it was the city's health-giving waters, not the image of never-ending sunshine, that caught the imagination of northerners.

St. Petersburg's connection to health-restoring waters dates back to 1885, when Dr. W. C. Van Bibber announced at an American Medical Association conference that he had found the ideal location for a "Health City"—the Pinellas County peninsula in Florida. St. Petersburg promoter Frank Davis built on Van Bibber's idea and heavily exploited the notion that St. Petersburg was an oasis of good health. Davis had established a medical publishing business in Philadelphia before moving to Florida in 1890 in an effort to cure his rheumatism. Historian Ray Arsenault

Out-of-town visitors gather at St. Petersburg's Fountain of Youth well to fill their water jugs in this 1945 press photo.

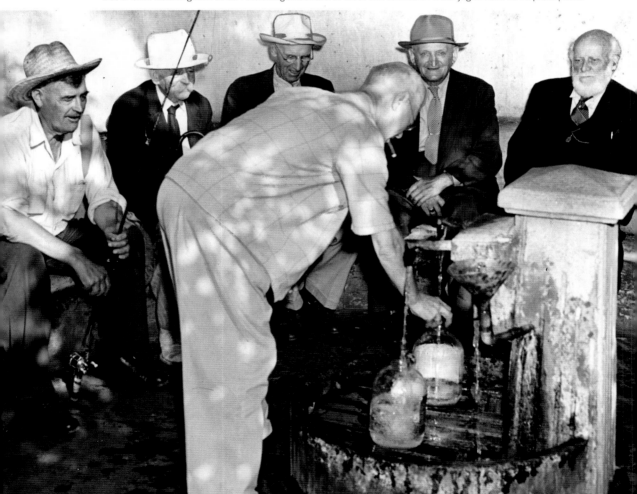

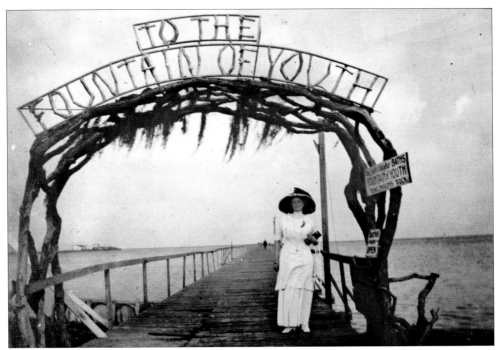

A sign on the right side of this rustic arch reads "Hot, Salt & Sulphur Baths/Fountain of Youth/Tomlinson's Dock."

notes that for about a decade Davis created publications that raved about the health-building virtues of St. Petersburg's climate and were read by thousands of doctors, whom Davis encouraged to waste no time in sending their patients to the Health City, "on the next train."

Just six years after Van Bibber's "Health City" assertion, a wealthy Connecticut visitor, Edwin H. Tomlinson, arrived in St. Petersburg and was immediately attracted by the opportunities presented by the then primitive settlement. Tomlinson had made a fortune in the mining and oil industries and was an avid fisherman. Now he would show his love for his adopted winter home by becoming its first philanthropist. He created the first vocational school in the state, built an Episcopal church, constructed the city's open-air post office, and inspired what would become St. Petersburg's beloved Festival of States celebration. Some of his contributions, however, were a bit unorthodox, such as the 137-foot-tall tower he constructed near his home after meeting Guglielmo Marconi. Tomlinson saw the tower as a platform for the Italian inventor's experiments in wireless transmission, but Marconi never made it to St. Pete, and a lightning strike burned the tower to the ground just six months after its completion.

In an effort to gain access to fertile fishing grounds, Tomlinson built a long pier into Tampa Bay in 1901. At the pier's end was a cottage with a hole cut in the floor, where he and his father could fish. From the pier Tomlinson drilled an artesian well, and the water that flowed was said to have reeked so strongly of sulfur that locals claimed it could be smelled a block away. Soon the odiferous water garnered a

reputation, and thirsty residents and tourists flocked to the well. In 1908 Dr. Jesse F. Conrad, who operated the baths at Magnetic Springs in Ohio, visited the spring, tasted the water, and was quite impressed. Noting the water's potential as the basis for a health spa, Conrad joked that if fellow Ohioan William Howard Taft won the upcoming presidential election, he would buy the property from Tomlinson. After Taft's electoral landslide, Conrad was true to his word and purchased the well, the pier, and two hundred feet of frontage on Tampa Bay for $2,800.

Soon Conrad erected an arched sign at the pier's entrance, spelling out "Fountain of Youth" in rustic letters formed from willow branches. With assistance from J. E. Newhouse, an associate from Magnetic Springs, Conrad's venture offered hot sulfur and salt baths at the Fountain of Youth Bathhouse, advertised as "Nature's Sure Cure for Rheumatism, Neuralgia, Kidney, Liver and Skin Trouble"—all for just 25 cents, or 50 cents with an attendant. By 1909 Newhouse proclaimed that his registration book had a thousand signatures "from every state in the union, Canada, Mexico, Bahamas, England, etc.," left by visitors who had received treatment at their facility.

The City of St. Petersburg assumed ownership of the pier and a portion of the property in 1911, but by early 1914, a four-story resort hotel called the West Coast Inn opened and assumed control of the bathhouse. The new hotel's operator, Dr. C. W. Hargens, also had a background in hydrotherapy, as owner of a sanitarium in Hot Springs, North Dakota. The hotel's spa offerings now advertised Turkish and Russian baths in addition to the saltwater or sulfur treatments. The hotel, located next to the city's Waterfront Park, gained fame in baseball lore after a baseball field was added to the park in 1922. The New York Yankees used the ballpark for spring

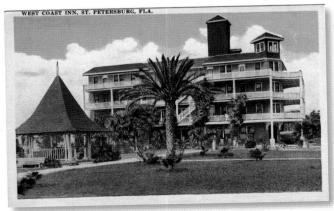

training, and in 1930 Babe Ruth crushed a home run that flew (or bounced) at least six hundred feet into the veranda of hotel—perhaps the longest home run in Major League history. Ruth was quoted years later as saying that

A postcard image of the West Coast Inn.

"the day he hit the [expletive] ball against that [expletive] hotel" was one of his fondest memories of the area.

While the West Coast Inn used the sulfurous mineral waters first discovered by Tomlinson in its spa, water piped from the artesian well to a public fountain in Waterfront Park continued to be a popular St. Petersburg attraction. A 1917 newspaper account estimated that a "thousand people each day visit the fountain and fill their bottles for drinking and bathing purposes." The same writer reported on city plans to improve the well and build twin fountains to accommodate visitors, noting that "heretofore those wanting to fill their bottles or get a drink at the fountain had to wade through water and stand in it while the water was filling."

Fans of the water testified to its recuperative powers. A tailor named J. A. Massey came to Florida on a stretcher in 1919 after suffering from rheumatism and a "general breakdown" and left a "new man" after drinking the celebrated water, the *St. Petersburg Daily Times* reported in April 1919. "In threading a needle, his hand is as steady as that of a man without nerves," the article proclaimed. In the same year a man from New York found the water to be so effective in curing ailments that he consumed eight quarts of the restorative elixir every day. Another New Yorker in 1925 declared that the water made her feel so youthful and "full of pep" that she investigated the costs of shipping an entire railroad car full of the magical elixir to her aged friends up north. The water was later found to contain high levels of lithium, a naturally occurring mineral that has been used to treat mental conditions. In some cases invalids from the North who felt they had been healed by the water would become year-round residents of St. Petersburg, and their descendants still populate the Sunshine City today.

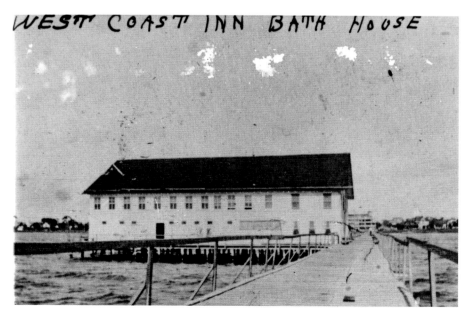

The West Coast Inn's bathhouse on Tomlinson's pier on Tampa Bay with the hotel in the background.

Storms frequently damaged the Fountain of Youth pier. In 1921 a storm that devastated the entire waterfront caused massive destruction. The city frequently paid to repair the pier and also relocated the famed well several times, most notably in 1946, when the well was moved to create space for Al Lang Field. Postcard images from prior to 1946 show a keyhole-shaped sitting area filled with dandily dressed tourists guzzling glasses of the health-sustaining water from the well. The next configuration was an octagonal space with benches surrounding a central fountain. Over the years modifications to the fountain included the additions of a large overhead sign, a small Ponce de León statue, a sculpture depicting a water-bearing maiden, and lion-head fountains.

Today the Sunshine City has two small fountains of youth near the St. Pete waterfront that celebrate the spirit of rejuvenative drinking water. The first is the historic location built by the city when Al Lang Field was constructed. It occupies the corner of a parking lot near the Mahaffey Theater, where water can still be sampled from a drinking fountain. The second, not far from the first, is near the entrance of the Salvador Dali Museum. A spigot emerges from large rock with a sign that reads "Under this ground are pooled the legendary waters of St. Petersburg's Fountain of Youth."[1]

In this linen postcard scene, visitors to the Sunshine City enjoy the waters from the Fountain of Youth flowing well.

Florida's "radioactive" Fountain of Youth is located on Taylor Street in downtown Punta Gorda.

PUNTA GORDA'S RADIOACTIVE ARTESIAN WELL

Many cities in Florida drilled free-flowing artesian wells near the center of their downtown for residents to use. Few still exist without purification because water today is heavily treated to make it safe for consumption. One of the few municipal wells that continues to flow is actually known to be radioactive, yet it's still used by locals who swear the water is more health-giving than plain tap water. It's in Punta Gorda, a small southwest Florida city on Charlotte Harbor, about a hundred miles south of Tampa.

The well in downtown Punta Gorda has been dubbed the Fountain of Youth, which seems somewhat inevitable, because the small city has more Ponce de León statues and historical markers than any other Florida city except St. Augustine, in part because Charlotte Harbor is often cited as the location of Ponce's fatal wounding by Calusa Indians. According to a *National Geographic* online article, the well dates back to 1894. Its current configuration, a tiled rectangular column with a spigot protruding from the side, was built in 1926. An enduring story states that the tap handle had to be replaced every six months in the fountain's heyday because it was turned so often.

In the 1980s the state tested the water and discovered that it had almost twice the allowable amount of radium for drinking water. Officials said the chance of being harmed by radioactivity was "minuscule" but urged residents to drink the city's municipal drinking water rather than the unprocessed water from the fountain. Still, the radioactive fountain has its true believers. "This water is good for you," hundred-year-old Olga O'Feth told a newspaper writer in 1983 as she filled plastic jugs with the water. "It's healthy . . . good for the heart and arthritis." The fountain continues to flow freely today.[2]

According to an 1889 promotion printed by the DeLeon Springs Company, one of the most remarkable sulfur springs in Florida is the "great Blue Spring, a few miles north of Lake Monroe." The writer, however, cautioned that the water contained "carbonate of lime" in amounts that made it "undesirable for bathing, and also for drinking." But in nearby Orange City, when wells tapped the aquifer, the water was found to be "99.9 percent pure."

It must have tasted good, because in 1904 bottled Orange City Mineral Water earned the "highest award that the world can give" at the Louisiana Purchase Exposition (the St. Louis World's Fair). "Be Safe—Protect Your Health—Drink Orange City Daily," advertisements urged. An often-repeated tale maintains that Standard Oil tycoon John D. Rockefeller, who had a winter home in nearby Ormond Beach, was such a fan of the water that he not only drank it at home but carried it with him when he traveled, and was even said to bathe in it.

In 1919 the Orange City Mineral Spring Company expanded, creating bottling and distribution plants in Jacksonville, Tampa, Miami, and West Palm Beach, and shipping the water from central Florida by railroad tank cars. The water, originally marketed as a cure for everything from kidney and bladder ailments to rheumatism and indigestion, was shipped worldwide until 1987, when the municipality of Orange City purchased the well. The city maintains eleven wells as its municipal water source, but a popular spigot where the famed mineral water used to flow freely has been capped.[3]

Orange City Mineral Water could cure everything from the common cold to constipation, according to advertising for the brand.

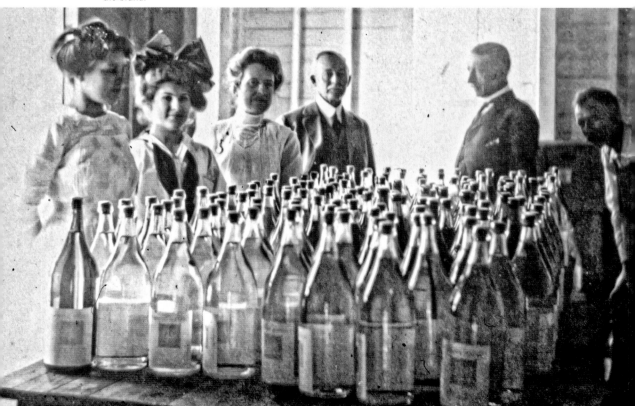

🌿 MAGNESIA SPRINGS: CELEBRATED MEDICINAL WATER

Near Hawthorne, Florida, east of Gaines-ville, Magnesia Springs was a popular recreational swimming hole for decades but was never fully developed as a health resort, despite boasts of the waters' "cura-tive properties." Its mineral-laced spring water, however, once supplied a success-ful bottling enterprise. At its peak during World War II, the operation sold as many as a thousand five-gallon bottles a week to the U.S. Army's Camp Blanding in Starke, Florida.

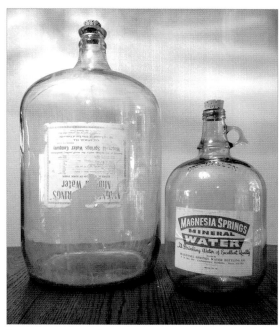

The label on the five-gallon bottle provided a mineral analysis of the water.

The first person to develop the spring was Cicero A. Simmons, a doctor from Georgia who owned the spring between 1873 and 1882. Evidence indicates that a bathing pool with a concrete bottom and cypress sides was built adjacent to the spring basin during his ownership. The next owner, a Civil War veteran from In-diana named John L. Brown, came to the Gainesville area in search of health—perhaps relief from serious injuries he suffered during the war. Sadly, Brown died before he could finalize his vision of developing the spring into a health spa; his 1906 obituary notes that it was his intention to make a "great resort for kidney and bladder complications," but he could not com-plete the project due to "litigation over the property."

Brown's son Roy did develop the site, however, adding a bathhouse around the turn of the century and most likely launching the first attempts to bottle the water. Brown's sister Nellie married a physician named James L. Kelley, and they devel-oped the facilities at the spring further, enlarging the swimming area and rebooting the water-bottling operation in 1929. Their water-delivery business prospered, and a fleet of five trucks served Gainesville, Ocala, and Camp Blanding in Starke. Because the five-gallon bottles each weighed fifty-five pounds when filled with water, a cus-tom stand was created to allow for easy pouring when the glass bottle was pivoted downward. Water bottling continued at Magnesia Springs until 1966, when the equipment was sold to the Zephyrhills water-bottling company.

The Kelley family sold the spring in 1964; it remained in private hands and open to the public until 1974, when it was leased to a "nudist group." It was reopened to non-nudists in 1977 but became private property after a former Gainesville city commissioner purchased it in 1997.[4]

HOPE SPRINGS ETERNAL

My father told me that my family visited Magnesia Springs when I was young, but all I remember was the icy cold water. I recall that I couldn't stay in the water for long without feeling as if I was freezing. In 2014 I was fortunate enough to visit Magnesia Springs again with photographer John Moran and artist and educator Lesley Gamble of the Springs Eternal Project (see chapter 9).

I observed that the spring first emerged in a pool choked with hydrilla, an invasive aquatic plant. On either side of this pool were two artesian wells where the water bubbled up with enough force to create boils on the surface. The spring and the wells fed two larger swimming pools nearby that were covered with a layer of duckweed, a native plant that floats on the surface. But the water underneath appeared to be crystal clear.

Surrounding the pool were several dilapidated buildings, survivors from a not so distant time when the spring was heavily used for picnics, parties, and swimming excursions. There was also a large water-storage tank outside the bottling facility, a concession area, changing rooms, and storage areas. The entire complex seemed frozen in time; the buildings were still identified with bright signage, and children's toys were scattered over the pool deck. As the sun set, the place had a surreal quality, a locale of many happy memories slowly being reabsorbed by the Florida wilderness.

The privately owned spring was for sale when we visited, and local residents expressed a desire in newspapers and on social media to restore their beloved swimming hole and reopen it to the public. It was clear that Magnesia Springs would require an extensive amount of money and maintenance to welcome swimmers again. We all agreed that the spring and the facilities had potential, but restoration would be a challenging task requiring huge financial resources. Yet hope springs eternal.

Although there were several plans to develop a health resort at Magnesia Springs, it was primarily used for recreation and water bottling.

OTHER FLORIDA MINERAL WATERS

Bottled water was big business in Florida in the late nineteenth and early twentieth centuries, judging by the number of attempts at marketing water from the aquifer beneath the state. Many of the brands bottled in Florida existed for only a short period of time, and the water no longer fills bottles from their wells and springs. Some of the springs, however, still flow, although their days as sources of commerce have long since passed.

DEERFOOT SPRINGS was actually a well, a hundred feet deep and located near a steamboat stop on Lake Beresford off the St. Johns River. DeLand businessman J. B. Taylor marketed Deerfoot Mineral Springs water with ads asserting that while his product was not a cure-all, it was without peer as a blood-purifier and "corrective" for stomach and kidney disorders.

FENHOLLOWAY MINERAL SPRING WATER, bottled from a spring near Perry, was distributed throughout north Florida and south Georgia in the early twenties. The water's "medicinal properties" were touted as a remedy for arthritis and kidney ailments. For a time, a two-story hotel with a spring-fed pool fronted the Fenholloway River. Nearby industry that used groundwater contributed to a reduction in spring flow, and the Fenholloway River became Florida's only industrial river, used as a waste dump by a cellulose plant.

PURITY SPRINGS WATER, bottled from a spring just west of Sulphur Springs in Tampa, boasted in ads that it was as pure as "any water on earth" and would not only heal whatever ailed you but also keep you from getting sick. Perhaps its purity was

derived from the fact that the "earth is the very best filter ever known," as a 1909 ad proclaimed; a spring of such absolutely pure water was "God's blessing for any community."

In 1982 businessman Michael Cameron bought Purity Springs and Zephyrhills Water, both later absorbed by the Perrier Group. Today Zephyrhills is a brand of bottled water owned by Nestlé Waters, one of several corporations tapping Florida's aquifer in an effort to quench our nation's thirst for bottled water.

Around 1913 a hotel and guest cottages were constructed at Chumuckla Springs near the Escambia River between Pensacola and the Alabama state line at the western end of the Florida Panhandle. The spring water was piped into the cottages, and a screened spring pavilion was erected for bathers. The resort could accommodate a hundred guests, who enjoyed excellent hunting and fishing as well as a large dining room that was described as light, airy, and delightful for dancing.

The water from the spring was bottled and sold as far away as Chicago; it was advertised as superior to any "preparation compounded by man." On the opposite side of the river, farther north, water from a well dubbed "Mystic Springs" was bottled and sold as well.

Despite the infrastructure created to bottle the mineral water and provide lodging for guests, the destination's popularity diminished during the Great Depression. Like so many of the properties of this era, the hotel burned down.

The efficacy of HEILBRONN SPRINGS near Starke, Florida, was described in a 1989 article in the *Bradford County Telegraph,* which noted that the mineral water's name meant "healing well." Residents tell of farmers utilizing the spring to cure afflictions that befell their horses. Around the turn of the century Heilbronn Springs water was bottled and sold in cities in north Florida and south Georgia; sales peaked in the 1920s.

ELDER SPRING WATER, bottled near Orlando, was promoted as "bottled health" and was marketed as an aid to digestion. In 1915 businesses and homes were supplied with a free water cooler, and five-gallon bottles were delivered at ten cents a gallon.

The notion of drinking water to stay healthy persists today. So does the idea that a visit to the beach can be good for you. As improvements in transportation developed in nineteenth-century Florida, the coast became more accessible, and sea bathing became a popular substitute for taking the waters at mineral springs. Railroad barons opened grand resorts that surpassed the accommodations at spring-based resorts, and salt water surpassed spring water as the preferred path for those seeking health and restoration.[5]

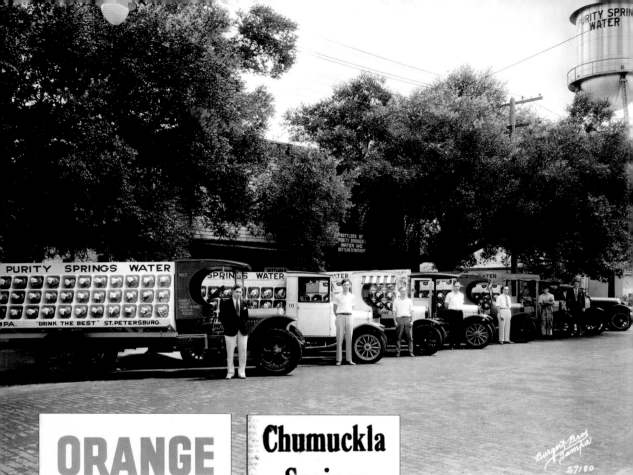

ORANGE CITY FLORIDA

Orange City's wondrous Blue Springs Park

Home of the "World's Finest Drinking Water"

Chumuckla Springs Water

Is not a patent medicine. It is a wonderful product direct from Nature's Laboratories and is delivered to you just as nature made it.

It is delightful to drink, and will aid you more on the road to health than any preparation compounded by man.

If you are troubled with any ailment of the Stomach, **Kidneys**, Bladder or the **Blood**, Chumuckla Water will quickly relieve you.

If you have Eczema, Sores or Ulcerations Chumuckla water will heal them rapidly

For your health's sake drink Chumuckla Water every day, it will keep you well. Order a case today.

Ray Hardware Co.

PHONE 124

Top: Men stand by delivery trucks in front of the bottling department of the Purity Springs Water Company in Tampa. *Far left:* A mid-century brochure for Orange City Mineral Water. *Center:* An ad for Chumuckla Springs Water in the *Pensacola News Journal*, May 17, 1924. *Below: Orlando Sentinel* ad, July 8, 1915.

It's An Economy To Buy Now!

"ELDER" Spring Water

Is a standard for purity, aids digestion and eliminates acidity. :: ::

This being accomplished a world of sickness is saved. Nature provided Spring Water and Spring Water alone for mankind and nothing can take its place

BEGIN NOW!

Elder Spring Water Co.
ORLANDO, FLORIDA
Phone WRIGHT, 444

CHAPTER 7 ❧

SEA BATHING IN FLORIDA
Discovering the Healing Power of Salt Water

Many factors are concerned in the origin of seaside resorts, but the medical profession is primarily responsible for their birth. From the middle of the eighteenth century, some doctors advised patients to visit the seaside for their health's sake . . .

—*Edmund W. Gilbert*, Brighton: Old Ocean's Bauble, *1954*

The beaches of Florida have become a ubiquitous symbol of the Sunshine State. They stretch for 825 miles, from the turquoise waters of trendy Miami Beach to the sugar-sand shores of the Panhandle—the so-called Redneck Riviera. Surprisingly, large-scale development of seaside resorts at these beaches didn't take hold in Florida until the age of the railroad, decades after the first inland resorts hosted travelers at spring-side spas. Native people had thrived along the coasts for thousands of years before Ponce de León came ashore in 1513, but during the years the Spanish controlled Florida, they mostly left the shoreline alone; "the Spanish cared little for Florida's panoramic sunsets over pristine beaches," historian Gary Mormino notes.

What is today valuable beachfront real estate was then seen through the lens of centuries of European beliefs that the sea was a place to be feared, full of horrifying mythological creatures. "From earliest childhood, the medieval Christian was introduced to a horrid host of diabolical sea creatures in depictions of the Last Judgement," authors Lena Lencek and Gideon Bosker write in *The Beach: The History of Paradise on Earth*. Moreover, the sensuous nature of bathing or swimming in the sea was viewed as sinful by the clergy of the Middle Ages.

That paradigm shifted when the water-loving Mediterranean cultures of the ancient Greeks and Romans were rediscovered during the Renaissance. By the seventeenth and eighteenth centuries, upper-class northern Europeans learned about the values of the ancients on the traditional trip across the continent known as the "grand tour." They took breaks from their travels to soak in spas and in the sea and often returned home with newly evolved perspectives on bathing. The view that the sea was something to be feared and avoided changed as Romanticism emerged in Europe in the late eighteenth century, and by the time of the Victorian era, a trip to the sea was considered a sublime, soulful experience—good for what ailed you.[1]

A postcard of "Sea bathing in Florida" shows women at a crowded beach in the early twentieth century.

139

The European use of salt water for aquatic therapy seems to have originated in Scarborough, England, an ancient medieval fishing village where the discovery in 1620 of mineral water flowing beneath a cliff led to the creation of a primitive spa. In 1660 Robert Wittie, a medical doctor from the nearby city of Hull, became an inspired advocate of the water at Scarborough, promoting its effectiveness in a published treatise titled *Scarborough Spaw.* In addition to drinking Scarborough's mineral water, Wittie suggested immersion in the cold sea water as a beneficial treatment for gout; in so doing, he transformed the small Yorkshire town into Britain's first seaside resort for health and recreation. Wittie also actually proposed the value of drinking the sea water at Scarborough; any aversion to taste could be overcome by combining it with milk, he claimed.

In 1697 Sir John Floyer, an English physician best known for inventing the first watch for taking a patient's pulse, published *An Enquiry into the Right Use and Abuses of the Hot, Cold, and Temperate Baths in England,* in which he reviewed the practice of cold-water bathing in ancient cultures and suggested it could be useful in treating both physical and mental diseases. A few years later in 1701, Floyer joined physician and poet Edward Baynard in publishing a history of cold-water bathing that proved to be highly influential in the hydrotherapy movement. As a result of these discoveries, combined with cultural changes across Europe, coastal spas became a fashionable alternative to the older, more established inland spas that utilized warm spring water such as the venerable destination of Bath.

The title page of *An Enquiry into the Right Use and Abuses of the Hot, Cold, and Temperate Baths in England.*

Many of the new seaside resorts were modeled after inland spas at sites like Bath, which peaked in popularity from the mid-seventeenth to the end of the eighteenth century. In addition to Scarborough, English seaside resorts at Brighton, Weymouth, and Blackpool evolved into popular watering spots. As railroad networks evolved, traveling to these destinations became accessible to the growing middle class as well as the aristocracy. Visits from royals could help put a watering place on the map; it was George, Prince of Wales (later King George the IV), whose patronage

An 1814 illustration of a horse-drawn bathing machine in the Yorkshire region of England.

helped establish Brighton when he visited there as early as 1783. While the invention of sea-bathing therapy was largely a British phenomenon, the practice spread to the rest of northern Europe and then to North America by the start of the nineteenth century.

As with spas based around mineral springs, a daily routine developed at seaside resorts. Mornings would be devoted to bathing. Originally men bathed in the nude, but when women began taking the waters, that was deemed improper. Bathing areas were then segregated by gender, and women, rather than wading out beneath the inquiring eyes of the men (who often observed them with telescopes), instead used a marvelous Victorian contraption called a bathing machine to reach the water.

Horses generally pulled these large, roofed carriages into the surf, where the modest ladies, sheltered from the sun, would emerge and descend steps or a ladder into the arms of an attendant called a "dipper." Female bathers wore thick wool skirts, weighed down with lead disks, so that the fabric couldn't float in the surf, complemented by shoes that completely covered the ankles. Such a surf-bathing experience must have been terrifying: dippers sometimes held bathers under the freezing water to the edge of drowning, before whisking them back into the relative safety of the bathing machine. The resulting shock, it was believed, would "revitalize the organism, sooth anxieties, help restore harmony between the body and soul, and revive vital energy."

After such an intense morning, the rest of the day at a seaside resort was dedicated mostly to leisure pursuits: socializing, promenading along the shore or on

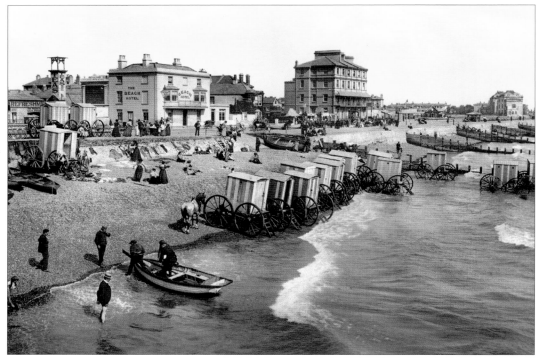

Bathing machines on the shore at Bognor Regis, England, between about 1890 and 1900.

newly constructed piers, and eating healthy meals. Evenings might be filled with dancing and, for the men, gambling. This schedule parallels the activities of a typical day at most European inland spas such as Bath, and eventually the practice of sea bathing, the saltwater version of the taking-the-waters ritual, made its way across the ocean to America.[2]

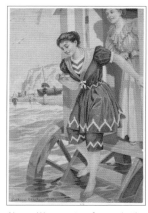

Above: Women step from a bathing machine. *Right:* Queen Victoria's bathing machine on display at the Isle of Wight, 2018.

TRANSATLANTICISM: AT THE BEACH WITH QUEEN VICTORIA

I have both good and bad childhood memories of being at the beach in Florida. I remember being told by my aunt, who was a nurse, that the annoying outbreak of poison ivy on my arm would benefit from exposure to salt water at the beach. It did. I also recall as a young child dashing across burning white sand at full sprint, drawn by the mesmerizing surf, only to be knocked out cold when struck by a car driving on the beach. I was unharmed, but to this day I am extremely cautious approaching the water.

One time I waded out to a sandbar and lost track of time. I didn't know how to swim yet. When the tide rose, the water was too deep for me to wade back to shore. I woke up on the beach; I'm still not sure who pulled me ashore. But not all memories were dramatic: I remember driving to the beach in my parents' car immediately after I received my driver's license. It was a rite of passage for Gainesville teens as soon as they passed their driving test. The beach brings up a flood of memories for me, none of which, of course, includes a bathing machine. But I can understand how ancient cultures felt both awe *and* fear as they approached the surf.

When I was a small child my father would take me out to the surf and throw me up in the air just as a wave almost crashed on top of me. He would catch me safely on the other side of the wave; I remember feeling both exhilarated and frightened. Perhaps that's what the pioneering European bathers felt as they ventured into the surf, stepping out of their bathing machines into the cold Atlantic and being held under the water by the sturdy arms of attendants.

I have found no evidence that bathing machines were ever used in Florida, but they are part of a history we continue even as we leap into the surf today. So, to see one and learn more about them, I ventured to the Isle of Wight in southern England, where Queen Victoria's bathing machine is on display.

To get to the royal bathing machine requires a stroll of about a half a mile from Osborne House, Victoria and Albert's palatial getaway on the coast. Prince Albert believed the proximity to the sea water was good for one's health, and he and Victoria built this opulent summer home between 1845 and 1851 with funds from the sale of the Royal Pavilion in Brighton, another royal residence near the sea. After Albert's death the queen spent a great deal of time at Osborne, and it's easy to understand why. The closest Florida comparison is James Deering's Coconut Grove mansion, Vizcaya, on steroids—Osborne House is over the top in Italianate Gilded Age splendor.

Queen Victoria's bathing machine now rests on concrete rails facing the water. It is meticulously painted a dark forest green with four black spoked wheels and a massive awning supported by curlicue wrought-iron supports. It's an imposing piece of equipment, much sturdier than I imagined—but let's face it, so was its owner.

I wonder if the queen, who as a teenager became sovereign of the most powerful country in the world, had both frightening and exhilarating moments at this beach. Did she find healing in the salt water? Did she relish the freedom of bathing on her private beach away from the prying eyes of her empire?

Today the queen's private beach is a protected sanctuary; the fact that it was preserved by the royal family so long ago makes it an environmental treasure, home to many types of endangered indigenous sea life. Long after the era of Victoria and Albert, their beach is still restorative to visitors.

✺ SEASIDE RESORTS COME TO AMERICA

The English sea-bathing fad jumped "across the pond," and seaside resorts sprang up in the northeastern United States by the 1820s and '30s (and, before long, in Florida). During the Industrial Revolution, America's emerging wealthy class sought relief from the congestion and pollution of the cities, and resorts emerged at Cape May, New Jersey, a seaside retreat for Philadelphians, and Nahant, Massachusetts, an escape for Bostonians. Eventually popular ocean resorts such as Atlantic City, New Jersey, and Coney Island, New York, became refuges for the common man, while exclusive watering places—most notably Newport, Rhode Island—developed into enclaves for the wealthy. At these American seaside resorts the bathing routine was consistent with taking the waters in Europe, but use of bathing machines did not prove as popular in the United States, and American bathers typically entered the surf sans attendants.

Over time the recreational aspects of these booming resort destinations surpassed the health-seeking reasons for visiting, but they developed initially because of the notion that salt water and sea air were excellent cures for a variety of ailments. Nineteenth-century doctors prescribed a trip to the sea for nervous disorders, respiratory ailments such as asthma, and a variety of complaints involving the "abdominal, excretory, and reproductive" organs, according to Lencek and Bosker's history of the beach. "Invalids and hypochondriacs were steered to a full regimen of bathing options," featuring sun, cold water, hot salt water, and sand, as "practiced in the spas of Europe."

In the United States the practice of not only bathing in the sea but swimming in it began to develop after about 1850. During the Middle Ages swimming, like sea bathing, was seen as unnatural, but by the 1500s some in the European upper classes began to see it as acceptable, and at the height of the sea-bathing era in Europe, swimming was seen as the "crown jewel" of cold-water therapy, Lencek and Bosker write. As the nineteenth century progressed and taking the waters became more fashionable in American society and exercise came to be perceived as healthy, swimming became popular with all classes of Americans.[3]

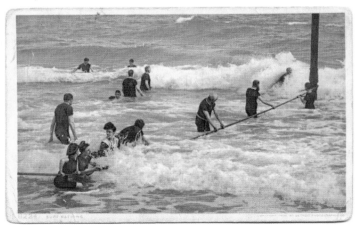

Bathers wade into the surf
using a safety line.

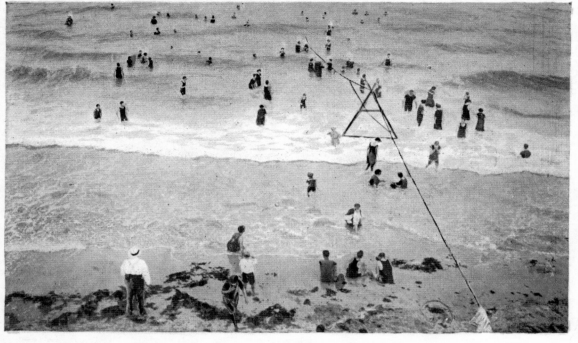

MID-WINTER OCEAN BATHING, FLORIDA

Like resorts near springs, seaside properties appealed to a clientele from the North, who were attracted by warm water in winter.

THE RISE OF THE BEACH IN FLORIDA

In Florida by the late 1830s, sea bathing was seen as "infinitely more beneficial" for health-seeking visitors "than medicine of any kind," John Lee Williams wrote in an advice-for-immigrants section of his guide to the territory. "Sea bathing is as regular a habit in Pensacola, among the old inhabitants, as supper in the evening," Williams wrote; "in East Florida it is not so common, but equally beneficial to health."

But early writings about the Florida coast weren't always positive. Shipwrecked on the Atlantic Coast in 1696, Englishman Jonathan Dickinson survived encounters with potentially hostile Indians and wrote an account of his adventure that was anything but laudatory about the beauty of the beach. "The wilderness country looked very dismal," he noted, describing "sandhills covered with shrubby palmetto, the stalks of which were prickly."

By the late nineteenth century the number of shipwrecked victims on Florida's "dismal" east coast was so great and the beach still so primitive that in 1874 the federal government erected five "Houses of Refuge" between Cape Canaveral and Cape Florida. These two-story structures were staffed by keepers whose job was to patrol the beach for shipwreck survivors after storms; each shelter was stocked to accommodate up to twenty-five survivors for as long as ten days.

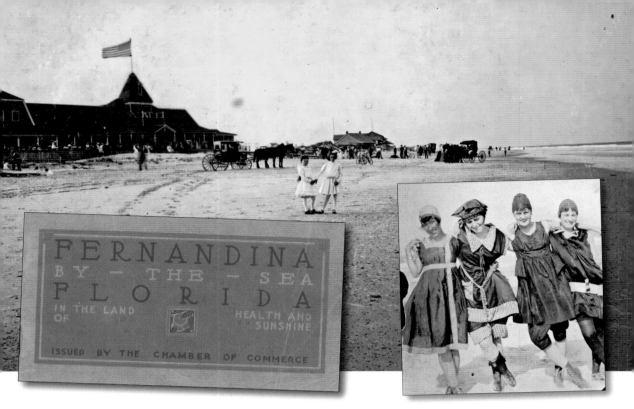

Images from Fernandina Beach include the casino at the Strathmore Hotel (*top left*), a 1913 Chamber of Commerce pamphlet extolling health and sunshine, and four women showing off the latest in early twentieth-century bathing apparel.

Despite dangers such as storms and outbreaks of yellow fever, Florida's promoters managed to lure northern visitors southward with reports of the salubrious climate, healthful air, and beneficial waters. By 1877 William Dudley Chipley proclaimed Pensacola the "Naples of America," extolling the virtues of its healthful climate, declaring that the thermometer rarely fell below 32 degrees, and concluding that his Panhandle city was fit to be used as a "grand sanitarium for the whole country." "The surf bathing is as fine as any in the world," boasted Charles Bliss in 1897; it would only take "a little encouragement" to make Pensacola a "water place equal to the most noted." In summer, hundreds "take a dip in the surf on a snow white sandy beach and then return home refreshed and invigorated with new life," Bliss declared.

Miles from the Panhandle on Florida's northeast coast, the vision of an American Italy of seaside resorts for the pursuit of health and leisure was manifested at what is now marketed as Florida's First Coast. The town of Fernandina on Amelia Island proclaimed itself the "Newport of the South," as luxury hotels such as the Egmont and the beachfront Strathmore attracted well-heeled northern visitors via steamboat. Union troops occupied Fernandina during the Civil War, and many returned after the war to invest in the community's future.

A typical advertisement of the period targeted three audiences—tourists, settlers, and capitalists—and proclaimed that Fernandina offered the "finest sea-beach in the country" and the "most enjoyable surf-bathing." Surrounded almost entirely by

water, Fernandina was one of the "most healthy and pleasant locations in Florida," another publication noted. In 1898 a hurricane demolished the Strathmore Hotel, but a beachfront casino and bathing pavilion were built for beachgoers who traveled via trolley from Fernandina's downtown on the opposite side of Amelia Island.

South of Fernandina the Fort George Island Company promoted a hotel and potential development near the site of the former Kingsley plantation, with claims of healthful salt water that absorbed "all poisonous gases and impurities." An 1887 brochure touted year-round bathing in the sea, which possessed a life-giving, health-restoring power not found on land, and the air at Fort George offered an "invigorating tonic of the ocean mingled with the healing odors of the tropical forest," full of wonderful medicinal properties. However, the hopes of investors behind the resort, including Harriet Beecher Stowe and General William Tecumseh Sherman, came crashing to earth after a yellow fever epidemic swept through northeastern Florida and the hotel was destroyed by fire in 1888.

Nearby Jacksonville had enjoyed a reputation as a "health resort for the nervous and consumptive" long before the Civil War. Despite devastating outbreaks of yellow fever in 1888 and 1889, General Francis E. Spinner, treasurer of the United States from 1861 to 1875, testified in 1895 to the healthfulness of Jacksonville's beaches, claiming that his stays in nearby Pablo Beach made his health "better than anywhere else" and that the ocean breezes, combined with the sulfur water from the artesian wells, kept his system "in perfect order." Spinner, a well-known sportsman, had retired in 1884 to Pablo Beach, where he lived in a large tent.

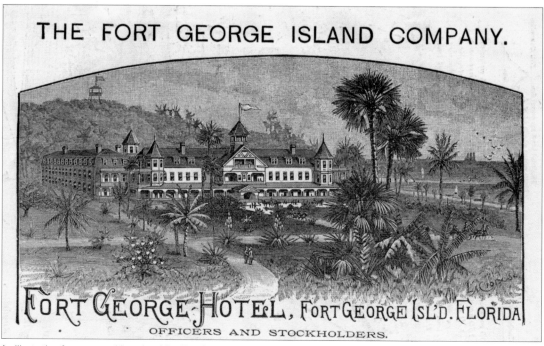

An illustration from a pamphlet advertising Fort George Island, published by the Fort George Island Company, 1888.

Two years later, in 1886, the magnificent Murray Hall Hotel opened on Pablo Beach—a three-story seaside resort, perfectly symmetrical with a six-story central tower topped by a waving flag. This imposing edifice accommodated 350 guests, generated its own power, and was one of the finest seaside resorts of its time. It drew sulfur water for a spa from an artesian well but emphasized the value of salt water. A testimonial in the 1886–87 season brochure endorsed the great value of "sea-bathing in winter, which, on the Florida coast, is not only possible but agreeable." Sadly, like the hotel on Fort George Island, the grand Murray Hall burned down in 1890, only four years after opening. Eventually Pablo Beach was absorbed into the town of Jacksonville Beach. As late as the 1930s, however, Eartha M. M. White, the pioneering philanthropist who built the bathing pool at Moncrief Springs, brought eighty-six "tuberculosis-suspect" children to a Jacksonville Beach in search of healing.

South of Jacksonville, the historic city of St. Augustine had yellow fever outbreaks as early as the 1820s but saw population growth during the Seminole Wars thanks to the security provided by a large military presence there. By the time Florida

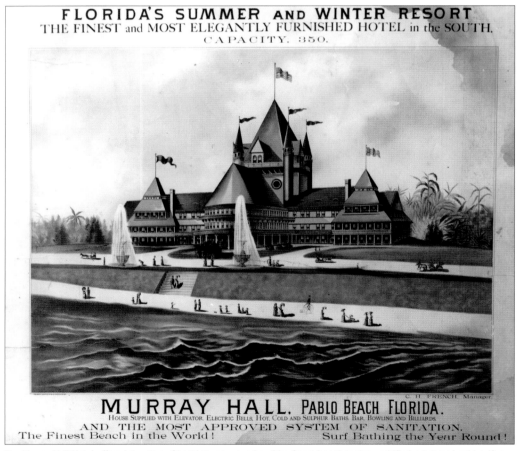

The Murray Hall Hotel offered guests surf bathing year-round on "the finest beach in the world," plus hot and cold sulfur baths.

The Capo Bath House was connected to the St. Augustine sea wall, where Victorian visitors often promenaded.

became a state in 1845, St. Augustine had become a "resort for people suffering from pulmonary and bronchial ailments"; promoters boasted that its climate "compared favorably with that of the best resorts in Europe and other countries." The entire town was to some degree "one large sanitarium," historian Thomas Graham has noted, quoting the late nineteenth-century writer Sylvia Sunshine's analysis of powerful chemical ingredients that exist at the ocean and act as a "neutralizer" to disease.

In 1890 railroad service was inaugurated from the inland resorts of St. Augustine to North Beach (near present-day Vilano Beach), and soon the emerging seaside community boasted of having "the Best Beach and Bathing on the South Atlantic Coast." Previously visitors to St. Augustine who wished to bathe in the ocean had to take a boat across the bay, then a ride in an open tram across Anastasia Island. One alternative was the Capo Bath House on a pier in Matanzas Bay, connected to the seawall, a gathering place for members of Victorian society who took healthful strolls along the promenade. At the bathhouse patrons could take hot or cold seawater baths or even take a take a dip in sulfur water. Like so many of Florida's Gilded Age resort structures, Capo Bath House burned down, this one in 1914.

Perhaps the most important development in the use of Florida's beaches for sea bathing began with the opening of Henry Flagler's Hotel Ponce De Leon in St. Augustine in early 1888. This magnificent inland hotel was the first in a string of modern beach resorts created by Flagler that ultimately stretched from Atlantic Beach in the north to Key West in the south.[4]

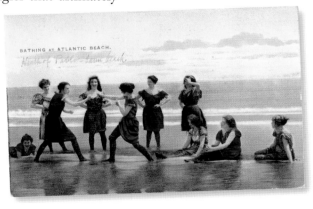

Colorfully clad women appear to engage in pugilistic activities in this postcard for Atlantic Beach.

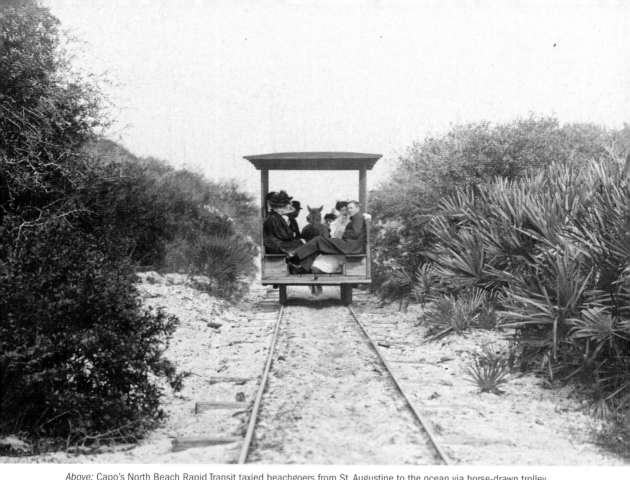

Above: Capo's North Beach Rapid Transit taxied beachgoers from St. Augustine to the ocean via horse-drawn trolley.
Below: Bathing hour on Daytona Beach in 1904 shows an array of horse-drawn carriages, bicycles, and even an early automobile.

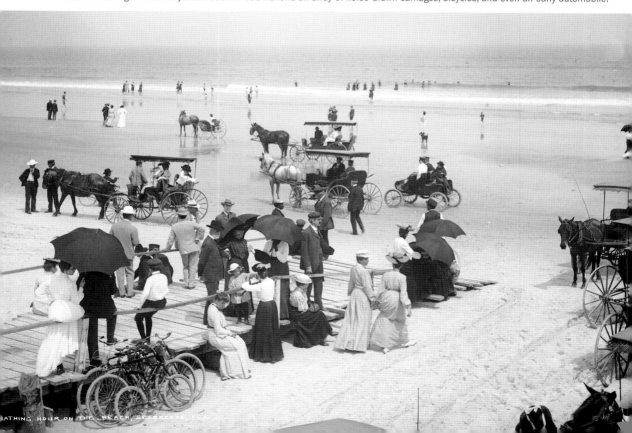

ATHING HOUR ON THE BEACH, SEABREEZE, FL

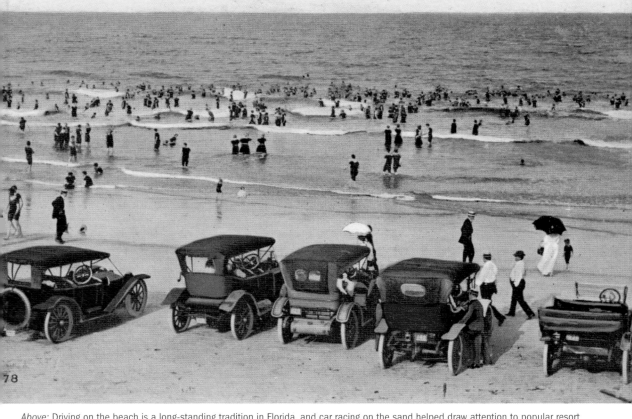

rf Bathing and Automobiling at Atlantic Beach, Fla.

78

Above: Driving on the beach is a long-standing tradition in Florida, and car racing on the sand helped draw attention to popular resort areas. *Below:* Eventually Victorian bathing apparel became less restrictive as it became more acceptable to show some skin in public.

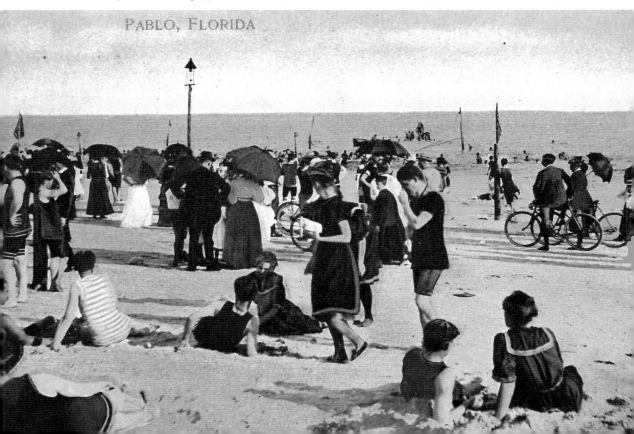

PABLO, FLORIDA

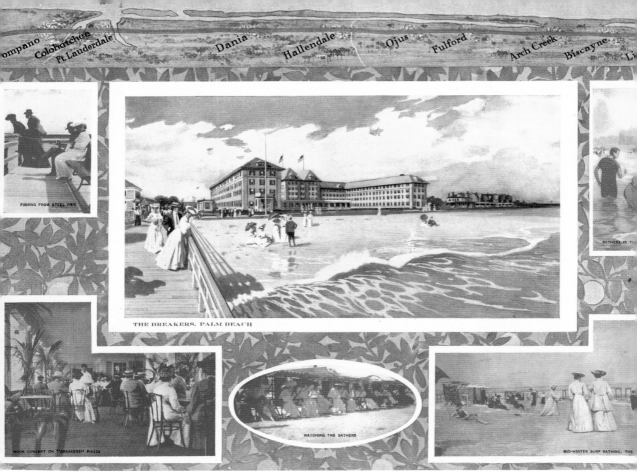

This page from a brochure promoting Henry Flagler's Palm Beach resort, the Breakers, includes multiple images of sea bathers.

❧ FLAGLER INVENTS THE FLORIDA RESORT

It would be inaccurate to refer to Henry Morrison Flagler's Florida resorts as health spas or to the wealthy patrons who frequented his resorts as invalids. "The long days of sitting on the veranda and coughing into a handkerchief were a thing of the past," observes historian Tracy Revels. What the Standard Oil and railroad tycoon achieved was the creation of an American version of Europe's upper-class watering places. In doing so Flagler opened up entire undeveloped portions of the state on the east coast, and the marketing for his empire created an image of Florida that remains with us today. The idea of the state as a restorative destination with sunny beaches and turquoise waters can be traced to the slick marketing of Flagler's East Coast Railway. Central to that advertising to northerners was the appeal of swimming, sea bathing, and other water therapies in the middle of winter.

Flagler, who was John D. Rockefeller's partner in Standard Oil, had been unimpressed with Florida during his first visit in 1878, when he brought his invalid wife Mary Harkness Flagler to Jacksonville and slipped down to St. Augustine to see the

old city for himself. Mary Flagler died in 1881, and in 1883 Flagler married a younger woman, Ida Alice Shourds. In December of the same year the Rockefellers and the newly married Flaglers ventured to Florida, arriving in Jacksonville, stopping at Green Cove Springs, and wintering in St. Augustine.

Flagler returned to the ancient city the following winter and stayed at Isaac Cruft's newly constructed San Marco Hotel. He was impressed with the hotel and its cultured guests, noting that it was filled "not with consumptives" but with the "class of society one meets at the great watering places of Europe." Later he would hire the hotel's builders, Joseph McDonald and James McGuire, to create his resorts; he also hired the hotel's manager, O. D. Seavey, to run his first large

Flagler's Hotel Ponce de Leon (*left*) was the first of his Florida resorts; his nearby Hotel Alcazar (*right*) featured an indoor pool.

St. Augustine hotel. Seavey was splitting his time between the San Marco and the Magnolia Springs Hotel, both of which he managed.

Flagler's first two Florida hotels were not beachfront resorts but rather exotic Gilded Age palaces in the heart of St. Augustine, with fantastic architecture loosely influenced by the city's Spanish heritage. Ironically, Flagler went to great lengths to remove the sulfur taste from the drinking water at his Hotel Ponce de Leon, actually drilling a well almost fifteen hundred feet deep in an effort to find water free of minerals. But the water still had a residual sulfur smell, even after being aerated and filtered. Across the street at Flagler's Moorish-inspired Hotel Alcazar, amenities included a complete spa and an enormous indoor swimming pool filled with water from an artesian well, built on the scale of "ancient Roman baths," according to historian Thomas Graham.

Flagler got closer to the beach when he purchased the Hotel Ormond, a failing property on the Halifax River fifty miles

Henry Morrison Flagler.

south of St. Augustine. It had originally opened in 1888. His 1889 purchase of the existing railroad from East Palatka to nearby Daytona Beach was his first foray into the area; he bought the hotel outright in 1891 and immediately set about expanding it. By 1905 the Ormond had grown from seventy-five rooms to more than four hundred, plus a saltwater swimming pool and a movie theater.

Flagler's touch helped lure the wealthy and powerful to stay in his new resort, and the fame of the nearby beach grew too. Sea bathing was not the source of its renown, but rather the hard-packed sands at Ormond Beach that turned out to be perfect for auto racing. A Flagler Hotel brochure from 1900 did make much of the surf-bathing opportunities though, noting that the "gentle slope" of the beach made taking a dip in the ocean "all that could be desired"—even by the "most delicate"— all through the winter months, while the wide beach was perfect for driving and bicycle riding.

As Flagler's empire moved south down Florida's peninsula, he purchased existing railroads, consolidating and improving a complicated network, and at the same time expanding opportunities for growth in every town where he built a depot. In 1892 he constructed his first segment of new railroad line, laying 15 miles of track between Daytona Beach and New Smyrna Beach. The state sweetened the deal, offering railroad builders like Flagler 12.5 square miles of land for every mile of track laid. Flagler's trains, which would eventually reach as far south as Key West in 1912, transported visitors south and fresh produce north, stimulating agriculture as well as tourism.

Perhaps the epitome of America's winter seaside-resort culture was on display at the site of Flagler's next large-scale development, Palm Beach. Building first the monumental Royal Poinciana Hotel on Lake Worth and later the Breakers on the Atlantic, Flagler created an exotic tropical paradise with all the Victorian-era conveniences his affluent clientele desired. The entire area was originally named Lake Worth after a general in the Second Seminole War, but after early settlers planted coconut palms scavenged from a Spanish shipwreck in 1878, Palm Beach was born.

Flagler's enormous Royal Poinciana opened in February 1894, a month before the railroad arrived in West Palm Beach—Flagler's company town on the opposite side of Lake Worth from the resort. Until a railroad bridge was built across the lake, guests traveled to the hotel by ferry. To get to the beach, almost a half mile away, they could stroll down carefully landscaped paths surrounded by colorful tropical plants, then ride in a trolley pulled by a mule or horse or be transported by a contraption that combined a wicker wheelchair and a bicycle, usually propelled by an African American worker.

Flagler employed African Americans in different capacities throughout his resorts—as construction workers and as waiters and porters inside the hotels. The images of African Americans used in marketing the resorts depicted them in roles

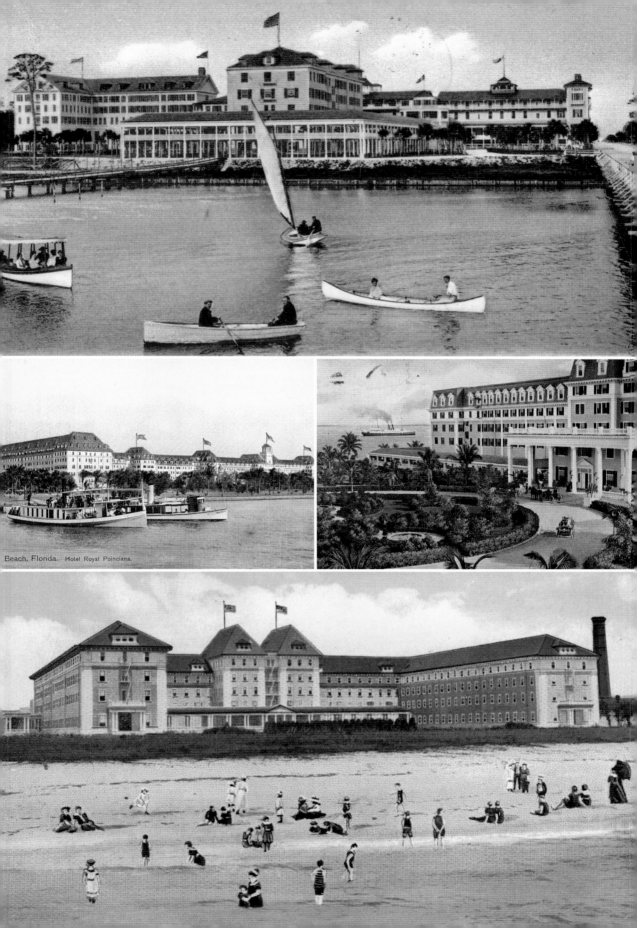

Beach, Florida. Hotel Royal Poinciana.

from "noble savage to childlike denizen of the tropical landscape," as Susan Braden notes in her book *The Architecture of Leisure*. Careful depictions of people of color as "happy, industrious, subservient" workers were created to appear non-threatening to the hotels'

Black hotel workers powered the wheeled wicker chairs used to transport hotel patrons.

upper-class white clientele. "Florida was sold to tourists as an American state that satisfied colonialist appetites for tropical pleasure and racial dominance," asserts scholar Henry Knight.

In 1900 a saltwater pool was added to Flagler's Royal Poinciana Hotel so that guests could bathe without making the trek to the ocean. Eventually this wildly successful resort was eclipsed in popularity by the Breakers, Flagler's beachfront property farther east. Originally called the Palm Beach Inn, the Breakers was built with a large saltwater swimming pool to accommodate bathers and swimmers from both hotels. Four years after the hotel's initial construction in 1896, its name was changed to the Breakers after an expansion, but this version of the hotel burned down in 1903. A new wooden hotel was built in 1904, but it too burned down, in 1925. Its 1926 replacement, built after Flagler's death in 1913, was heavily influenced by the Mediterranean Revival architecture of the Florida land boom and was designed in an Italian Renaissance style. It is one of the few Flagler-system properties that remains true to its original function, serving as a luxury hotel to this day.

Workers breaking ground for Flagler's Hotel Royal Palm in Miami.

Flagler's resorts were seasonal, attracting the northern elite primarily from February through April, the lone exception being the Hotel Continental on Atlantic Beach, constructed in 1901 for summer tourists from the South. Most of the guests had previously summered at exclusive watering places such as Newport, Bar Harbor, or Saratoga Springs, so many of their

favorite summer pursuits from northern resorts, including yachting, gambling, and golf, were also practiced in Palm Beach. Outdoor activities were popular, especially long strolls through the salt air, which were thought to restore one's health and also served an important social role where one could see and be seen by other guests. Sea bathing was but one of the outdoor activities available to Flagler's guests, and its popularity can be traced in marketing and photographs of the era. "For bathing, the beach, all its advantages considered, has scarcely a rival," notes a 1905 Florida East Coast Railway brochure, and "the waters of this coast are celebrated for their tonic and health giving properties."

Images of the era often show beaches packed with well-dressed Victorians, sometimes sitting in deck chairs and other times perched on horse-drawn carriages on the beach. Female bathers wore modest outfits that resembled dresses with leggings, along with bonnets they wore even into the surf. Male bathing suits were a bit more revealing, exposing the legs below the knee. But men's chests were usually covered. Bathers tightly grasped safety lines that extended into the surf while they warily made their way into deeper water.

Some of Flagler's resorts included bathing casinos—structures that had nothing to do with gambling. The Alcazar—the St. Augustine hotel originally planned as a

Below: The scene at Palm Beach between 1900 and 1906. *Right:* A brochure for Flagler's East Coast Railroad for 1895–96.

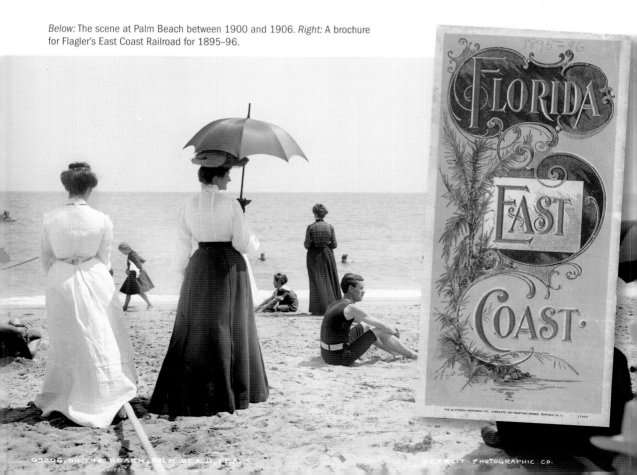

facility to house recreational amenities for the Hotel Ponce de Leon—had a casino that featured a huge indoor swimming pool, hydrotherapy facilities, bowling, billiards, and dancing. The casino at the Breakers in Palm Beach included a saltwater swimming pool, 150 feet by 50 feet, surrounded by a two-story gallery and private dressing rooms. Flagler's Hotel Royal Palm in Miami had a casino with a pool of similar proportions; the second floor had a music room, photography studio, and reception room, in addition to a gallery for gawkers. Hotel orchestras entertained guests at both the Palm Beach and Miami casinos. When Miami Beach was developed in the early twentieth century, it would support five bathing casinos, including one with an iconic windmill. These tourist facilities were more about recreation than restoration, but the activity of sea bathing for healthful purposes led to swimming at the beach purely for fun.[5]

Bathers and onlookers on Palm Beach, circa 1905.

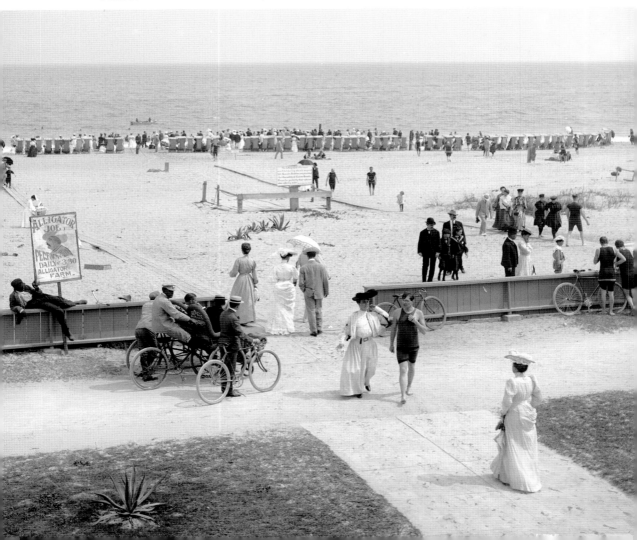

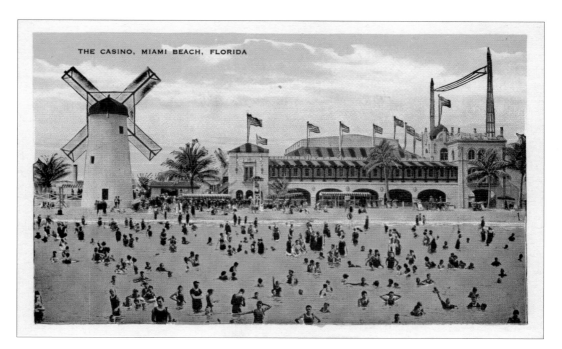

THE CASINO, MIAMI BEACH, FLORIDA

SAFETY FIRST
BATHE WITHIN
LIFE LINES

Top: A colorized postcard of the Casino on Miami Beach. *Above:* A sign stresses the importance of bathing within safety lines. *Right:* A 1902 Florida East Coast Railway and Hotels brochure lists bathing options, including pool bathing for those "too timid to tempt Old Neptune's grasp."

Florida East Coast
In General

Bathing.

SURF bathing is a popular and invigorating pastime for the visitors at Ormond, Palm Beach, and Nassau. The surf is enjoyable every day in the year at Palm Beach and Nassau, and there are only a few days at Ormond when the water is too cool for comfort.

Pool bathing at St. Augustine, Palm Beach, Miami, and Nassau is indulged in daily by those who are too timid to tempt Old Neptune's grasp, and the frequent water sports at the St. Augustine Casino are interesting to the onlookers.

Watching the Bathers.

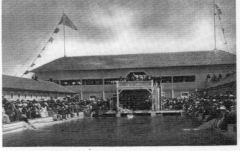

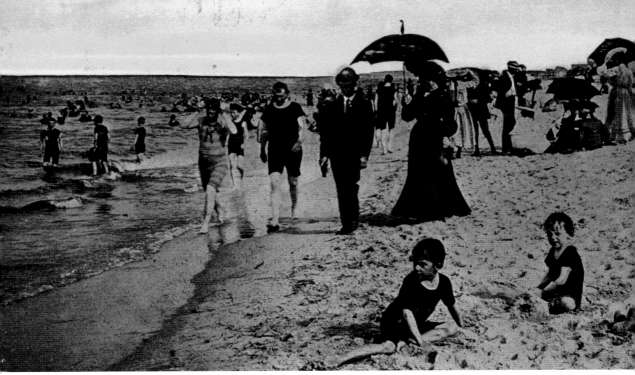

Bathing on Beach at Pass-a-Grille, Fla.

A colorized postcard shows bathers in the Gulf of Mexico at Pass-a-Grille on the southwestern tip of the Pinellas peninsula.

❧ SEA BATHING IN THE GULF OF MEXICO

While much of the credit for opening up the Atlantic coast of Florida is given to Henry Flagler's railroads and resorts, his friendly rival Henry Plant is often seen as an equivalent pioneer on Florida's Gulf coast. Plant's hotel system extended from Ocala to Fort Myers and eventually featured seven properties, including the magnificent Hotel Tampa Bay and the celebrated Hotel Belleview near Clearwater, both of which had bathing facilities. The Hotel Tampa Bay, located on the Hillsborough River, had hydrotherapy resources, while the Belleview had a pavilion for sea bathing and a springhouse where water from a submarine spring called Bellaire Spring was used to supply the hotel's drinking water.

Plant opened up much of the west coast of the state to the same upper-crust crowd to which the Flagler system catered, but his marketing materials didn't promote the sea bathing at his properties as vigorously as Flagler's. That did not mean there was no sea bathing on the Gulf Coast; vintage photographs and postcards show the practice was popular, especially on the Pinellas County peninsula. On the Gulf side of the peninsula, the small village of Pass-A-Grille developed into a tourist destination for vacationing northerners, with the construction of the first tourist

hotel around the turn of the century. Pass-A-Grille hotel properties were hard hit by a hurricane and fire in the early 1920s, but a beach casino with a bathhouse, guest rooms, and dance hall survived until the 1960s.

On the bay side of the Pinellas County peninsula, St. Petersburg residents bathed in Tampa Bay off long piers that stretched west, and a recreational facility named Spa Beach was developed along the waterfront. The 3,000-foot-long pier that marked the end of the Orange Belt Railroad was often used for recreational purposes, including bathing, and an 1896 pier designed as a commercial loading dock featured a bathing pavilion with thirty-four rooms. The facilities at Spa Beach near the city's famed Million Dollar Pier included a bathhouse, a natatorium (a building with an indoor swimming pool), a bathing beach, and a solarium for "bathing" in healthful sunshine. This collection of health-oriented resources reflects the changes in cultural norms related to bathing and health. Toward the beginning of the Victorian era, bathers entered the water tentatively, mostly covered from head to foot, a reflection of that period's modest values. By the 1920s, in contrast, bathers frolicked in the water, sunbathed, and exposed a good deal more skin.[6]

Postcards featured bathers at Pass-a-Grille in moonlight and sunlight.

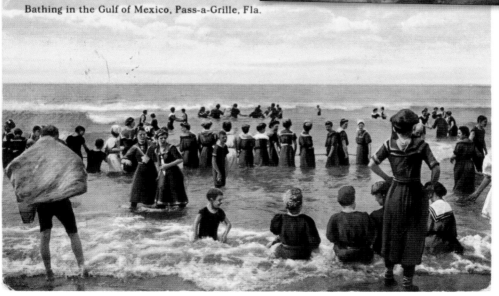

FINDING FLAGLER AND PLANT IN FLORIDA TODAY

The railroad and resort empires of the two Henrys, Flagler and Plant, opened up portions of the state to visitors drawn to Florida's comfortable winter climate and inviting waters. Both men operated railroad networks that made a trip to the Sunshine State easier than ever before. Flagler followed the Atlantic coastline all the way until he ran out of Florida at Key West; Plant followed the St. Johns River to Sanford and then headed toward the Gulf. All along the way they built spectacular Victorian structures so that their pampered northern guests would have all the comforts they expected. Sadly, most of their Gilded Age palaces have been lost, many to fire. But some of the best examples survive and are well worth a visit.

In St. Augustine Flagler's magnificent Hotel Ponce de Leon is now the heart of Flagler College, where one can tour many of the public areas, including the ornate lobby, the Women's Grand Parlor, and the opulent dining room

Flagler College, St. Augustine.

that houses a large collection of original Tiffany stained-glass windows. Across the street the former Hotel Alcazar is home to St. Augustine's City Hall, shops, and the intriguing Lightner Museum, where visitors can still see vestiges of the hydrotherapy facilities, including the needle shower and Russian baths, nicknamed the Senate because guests wrapped themselves in sheets like togas.

Flagler's spectacular Palm Beach home, Whitehall, is now open to the public as the Henry Morrison Flagler Museum. Located on Lake Worth, Whitehall was once a neighbor to Flagler's gigantic Royal Poinciana Hotel, which sadly was razed after its glory days ended. But the Flagler system's Breakers Hotel still welcomes guests and is a short walk from the museum.

The best surviving example of Plant's creations is the Moorish-inspired Tampa Bay Hotel, now home to the University of Tampa and the Henry B. Plant Museum. Three years after Plant's death in 1899 the city of Tampa purchased the property and ran it as a hotel until 1932. The museum and university took over the Gilded Age masterpiece in 1933. Today you can stroll the grounds on the banks of the Hillsborough River, marvel at original period furnishings, and see traveling exhibits related to the Victorian era.

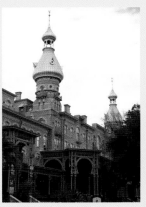

University of Tampa, Tampa.

You can also stay in a Plant hotel at the Belleview Inn, a newly renovated boutique hotel that consists of a section of Plant's original Belleview Biltmore near Clearwater. Nicknamed the "White Queen on the Gulf," the original wooden hotel ballooned to 820,000 square feet, allowing it to lay claim to the title of the largest occupied wooden structure in the world. Today only a portion of the original square footage remains, transformed into an elegant space that pays homage to the railroad baron who created it. Should you fancy a bit of sea bathing, it's a short drive to Clearwater Beach. If taking the waters is your pleasure, the spring-fed spa at Safety Harbor is nearby as well.[7]

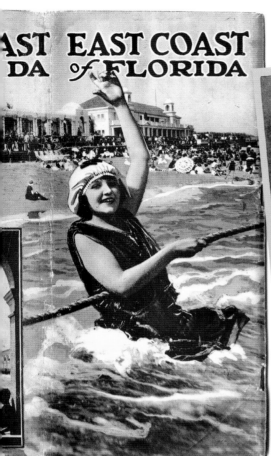

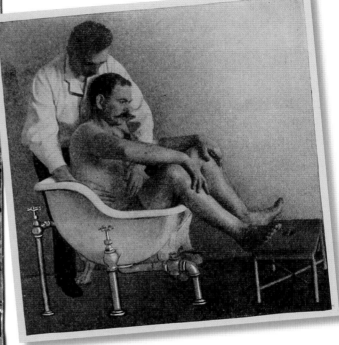

Left: A brochure cover shows a sea bather holding a safety line in front of a beach packed with people.

Above: An illustration from a 1910 publication titled *Hydrotherapy: A Work on Hydrotherapy in General, Its Application to Special Affections, the Technic or Processes Employed and the Use of Waters Internally* by Guy Hinsdale shows the application of a sitz bath with "abdominal friction."

FROM SEAWATER TO SITZ BATH

Throughout the state's development, Florida's less privileged classes visited its beaches for recreation and as a way to beat the heat, especially in summer. The notion of sea bathing in winter was dangled by Florida's early promoters as the ultimate balm for harmful northern winters. The state's salubrious surf was marketed as a healthful prescription at upscale coastal resorts, and sea bathing played a role in the state's rapid development after the Civil War. The roots of sea bathing—the hypothesis that immersion in cold water had therapeutic value—was also the source of inspiration for the emergence of the modality of hydrotherapy. Seen as a remedy for many ailments, including tuberculosis, hydrotherapy didn't require a nearby spring or beach, and "water cure" establishments and sanitariums were often precursors to modern hospitals. Throughout the state the popular practice of hydrotherapy spread from spas at posh resorts, to a branch of the famed Battle Creek Sanitarium in south Florida, to tuberculosis sanitariums across the state, becoming another manner in which Florida's water was used for healing purposes.

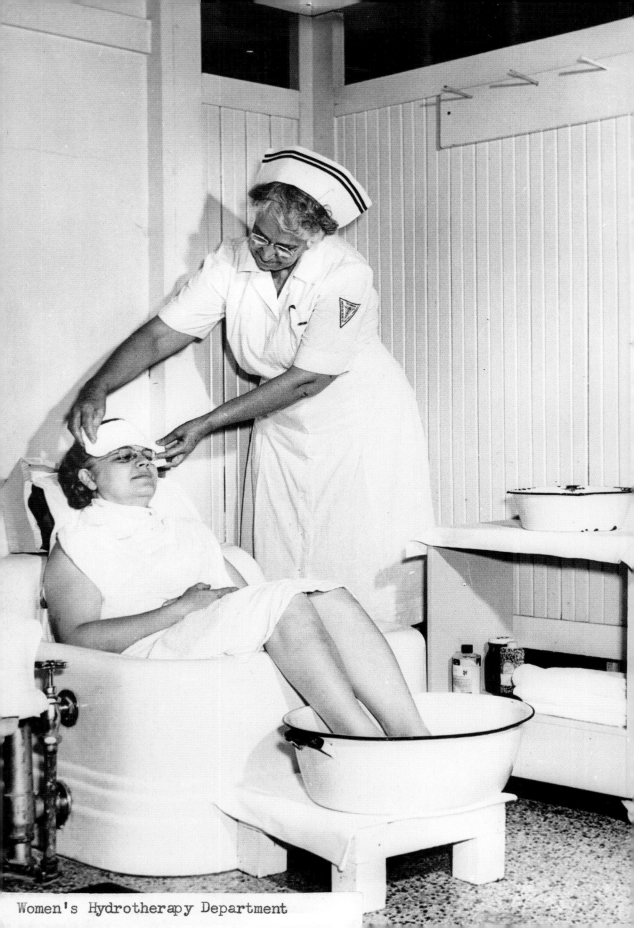

Women's Hydrotherapy Department

THE COLD-WATER CURE IN THE SUNSHINE STATE

Hydropathy in Florida

Indeed, after personally visiting and carefully studying most of the great health resorts of the world, and thoroughly informing myself concerning those which I have not visited, I feel no hesitation in saying that Florida's climate is unique and probably the finest in the world for promoting and prolonging life and health.

—Florida, Land of Health, *Dr. John Harvey Kellogg*

For health-seekers in the nineteenth century the waters of Florida were appealing for a number of reasons. Most important, the climate allowed a patient to be outside in winter, and in the Victorian era, spending time outdoors in fresh air was considered essential for good health. During the Industrial Revolution northern cities suffered from polluted air and water, and people with the means to do so fled to the mountains, beaches, and mineral springs to partake of the good, clean air. Until late in the century when germ theory was discovered, it was believed that the air itself could contain miasma—basically unhealthy particles that caused disease. Characterized by foul smells, miasma was seen as the source of plagues, cholera, and malaria, which literally translates to "bad air."

This concept goes back to the ancient Greeks, who associated a person's health and temperament with four "humors"—black bile, yellow bile, phlegm, and blood—that must be kept in balance. Many doctors thought that in order to keep the humors in the correct ratios, they should practice what has been dubbed "heroic medicine" and prescribe extreme treatments such as bloodletting and purging. According to this belief, popular with doctors throughout much of the 1800s, the discharge of harmful, putrid matter in the body through these methods, or through perspiration, urination, and other means, could bring relief from a variety of ailments and restore a patient's natural state of balance.

Some of the purgatives doctors prescribed included ingredients we know today to be toxic, including mercury. In the nineteenth century it was routinely prescribed as one of the ingredients of a compound called calomel, used to combat typhoid fever.

Opposite page: The Women's Hydrotherapy Department at the Florida Sanitarium in Orlando.

Patent-medicine advertising from the 1860s for Hoofland's Celebrated German Tonic claimed it would cure "dyspepsia, liver complaint, debility, indigestion, etc."

Louisa May Alcott, the author of *Little Women*, was among those who suffered from mercury poisoning, after she took the toxic substance to combat the typhoid fever she caught while nursing Civil War patients.

This was also the era of dubious patent medicine, when "snake oil" salesmen sold elixirs containing morphine, heroin, cocaine, and alcohol. Such bogus cures became fashionable in part as an alternative to noxious medicines such as calomel and a rejection of the doctors who prescribed them. The popularity of patent medicine soared after the Civil War, buoyed by persistent advertising and colorful packaging.[1]

THE BIRTH OF IRREGULAR MEDICINE

Sylvester Graham, 1880.

Heroic methods were slowly replaced in the nineteenth century, as alternative forms of healing became popular and patients had a wide choice of modalities as solutions to illness. Samuel Thompson, one of the first practitioners of "irregular" medicine to develop a following, was a self-proclaimed "botanic" physician who advocated using herbs and native plants such as lobelia and cayenne pepper instead of drugs. His acolytes, known as "Thompsonites," believed in taking the power away from conventional doctors and putting decisions about matters of health into the hands of the people. A similar movement, called Eclecticism, was built on Thompson's use of herbs but incorporated plants from Native American medicine.

While Thompsonism and Eclecticism both developed in North America, homeopathy has its roots in Europe with the work of Samuel Hahnemann, a German physician and pharmacist who took a novel, holistic approach to healing patients. Homeopathy was based on the idea that using small doses of substances that cause symptoms in a healthy person can be used to treat a sick person with the same symptoms. For instance, substances that can create fevers can be used as remedies for illnesses that produce fevers. Hahnemann's philosophies proved very popular in Europe and soon spread to the United States.

In the United States another health reformer, clergyman Sylvester Graham, stressed the value of fresh air and diet and promoted the importance of using whole

wheat flour in baking. Now considered the founder of the modern vegetarian movement, Graham developed a kind of unsifted wheat flour that led to what became known as the Graham cracker (although today's version is made with bleached white flour). Graham was also a proponent of spending time in sunlight, pursuing cardiovascular exercise, and practicing good hygiene, including frequent bathing.

Some of the theories advocated by these alternative-medicine movements of the nineteenth century, including an emphasis on a healthy diet and physical exercise, became part of the culture at Florida's mineral-spring spas and seaside resorts. They were also important aspects of what came to be known as the water cure, or hydropathy.[2]

An 1827 color lithograph depicts the application of leeches, another form of heroic medicine.

Following the publication of Sir John Floyer's history of cold-water bathing in 1701, plenty of popular writers promoted the efficacy of using cold water for healing. Belief in the power of warm mineral water and later cold seawater—attributed first to supernatural powers and later to beneficial minerals—was well established, but this new theory advanced the notion that any source of clean, cold water had healthful effects on the body, when applied correctly.

A poor Austrian farmer named Vincenz Priessnitz took these ideas from theory to popular practice. After an accident when he was a teenager left him with crushed ribs, conventional doctors told him he would never be able to work the farm again. Inspired by observations of the curative power of water in nature, Priessnitz resolved to heal himself and started a regimen of applying cold, wet bandages to the injured area and consuming copious amounts of fresh water. He proclaimed positive results, and soon others sought him out for assistance in overcoming their maladies.

In 1826 the farmer-turned-healer opened a center for healing at Grafenburg near his home in Silesia in the present-day Czech Republic. There Priessnitz developed a systematic approach to health known as hydropathy, which differed from previous water treatments in that the water he used had no perceptible mineral content. The regimens he taught required cold water, whereas at traditional spas such as Bath, the spring water was warm. Priessnitz's technique came to be known as the Grafenburg water cure.

None of the social activities of the privileged classes that defined nineteenth-century spa culture were permitted at Grafenburg; patients strictly adhered to a healthy lifestyle that included bland, fibrous foods, frequent exercise, and elaborate bathing rituals. In addition to cold-water baths and showers, patients were wrapped in wet sheets and told to drink a minimum of a dozen glasses of water every day. Priessnitz believed that the heroic methods prescribed by conventional doctors at the time actually harmed the body and that a combination of water, fresh air, exercise, and proper diet were the means necessary for replacing the "bad humors" that caused disease. By 1840 Priessnitz's Grafenburg facility was serving as many as seventeen hundred patients a year.

Like the earlier spa culture at mineral springs and seaside resorts, hydropathy made its way from Europe to the United States. In the mid-1840s two water cures had opened in New York City. (The term "water cure" was used in the names of establishments as well as for the methodology practices.) Disciples of Priessnitz taught versions of his system, and some of the prominent social reformers and religious leaders of the day adopted hydropathy as part of their health philosophies. Two early proponents, Joel Shew and Russell Trall, were conventional medical doctors who became hydropathy converts. Shew spent time in Grafenburg learning Priessnitz's system and used what he learned in opening a water cure in New York in 1844. Two years later he launched a publication called the *Water-Cure Journal.*

Masthead of the *Water-Cure Journal,* August 1854.

In 1849 Trall assumed the role of editor, and a year later the circulation reached fifty thousand. Trall's work helped form hydropathy into a philosophy of healing in which he integrated contemporary theories of medicine and what he described as the laws of nature.[3]

🎗 YUNGBORN: A RETURN TO NATURE

In a speech in 1901 Mark Twain joked that when he was a child, his mother had volunteered him as a test subject for the water cure. She poured a bucket of ice water over his head to "note the effect," Twain claimed. Then he was "rubbed down with flannels, a sheet was dipped in the water," and he was put to bed. Twain quipped that he perspired so much that his mother put a life preserver in bed with him (perspiration was thought to release toxins from the body, one of the perceived benefits of hydropathy). The iconic American writer gave credit for "filling the world with the wonder of water cure" to Sebastian Kneipp, a German monk who tailored many of Priessnitz's techniques into a more structured approach that formed the basis for contemporary hydrotherapy practices.

One of Kneipp's disciples was a young German who immigrated to the United States in 1892 and became progressively more ill with tuberculosis. Arriving in America with an empty wallet, Benedict Lust (pronounced "Loost") sustained himself by working as a waiter in restaurants at high-end hotels. But as his health began to fail, he returned to Europe in 1894 and found Kneipp. In his autobiography, Lust describes receiving hydropathic treatments of "ablutions, short hip baths, and lower leg gushes." Ablutions were vigorous rubbings with a wet cloth, which created friction that was believed to stimulate the skin and "draw blood from the congested organs to the surface of the body."

Beyond the numerous methods in which cold water was directly applied to different body parts, Kneipp employed methods for "hardening and bracing the system," including walking barefoot on wet grass, wet stones, freshly fallen snow, or in cold water, which he described in an 1890 treatise titled *My Water-Cure.* Guests at Kneipp's clinic at Wörishofen in Bavaria wore loose-fitting linen clothing, because one of the most important elements of a stay at a water cure was abandoning

restrictive Victorian apparel. This was particularly liberating for female patients in the era of tight-fitting corsets. The clinic also served Kneipp's prescription for a healthy diet—what Lust called "peasant fare," consisting of whole grains, hearty soups, vegetables, and potatoes. Guests were prescribed large doses of fresh air and sunshine. The entire philosophy was based on the concept that there is a healthy order in nature, and practitioners adopted a holistic approach to create a lifestyle more in alignment with that natural order.

After four months at Wörishofen, Lust reported feeling like a "new person," and Kneipp encouraged Lust to learn his system so that he could teach others. At Kneipp's urging, Lust returned to America to spread the gospel of healthy living according to the Kneipp system. After a brief stint working in Saratoga Springs, Lust opened what may have been the nation's first health-food store in 1896. He published a newspaper in English and German that included testimonials, techniques, and lists of supplies necessary for the Kneipp water cure.

Lust would continue to publish periodicals throughout his career, but much of his attention soon turned to teaching, and he eventually created a school to instruct naturopaths. He purchased the rights for the term "naturopathy" from another holistic healer to incorporate a wide variety of natural cures in addition to Kneipp's water therapies. Kneipp's system, as described by present-day naturopath Dr. Jared Zeff, employed the "beneficent agency of nature's forces, water, air, sunlight, earth, electricity, magnetism, exercises, rest, proper diet," and other treatments and philosophies.

As the popularity of alternative natural treatments grew in response to the increasingly mechanistic society of the Industrial Revolution and the horrors of heroic medicine that often made patients more ill, the conventional medical establishment felt threatened, and Lust was widely persecuted. During his career, Lust would find himself jailed fourteen times, and other naturopaths associated with him were brought to trial for practicing medicine without a license.

Lust consulted with many early naturopaths, including a fellow German, Louise Stroebel, who operated a "health home" in Butler, New Jersey. Lust and Stroebel ultimately married and pursued their dream of opening a larger institution in Butler, called "Yungborn," or "born young again," a nod to a similar facility in Germany named "Jungborn." Designed to be an improved version of Kneipp's Wörishofen facility, Lust's Yungborn was situated on sixty lush acres just an hour's train ride from New York City. Patients were charged $2.50 a day to receive treatments at the "Recreation Resort" promoted as a "Natural Health and Rational Cure Health Home for Dietetic-Physical-Atmospheric Regeneration Treatment." Soon Lust began a search for a winter location, so he turned to Florida, following in the footsteps of health-seekers who had been trekking to the healing powers of the Sunshine State for decades.[4]

KNEIPP CURE.

Fig.1. The Knee-jet. Fig.2. The Head-affusion.

Fig. 3. Walking barefoot in wet grass.

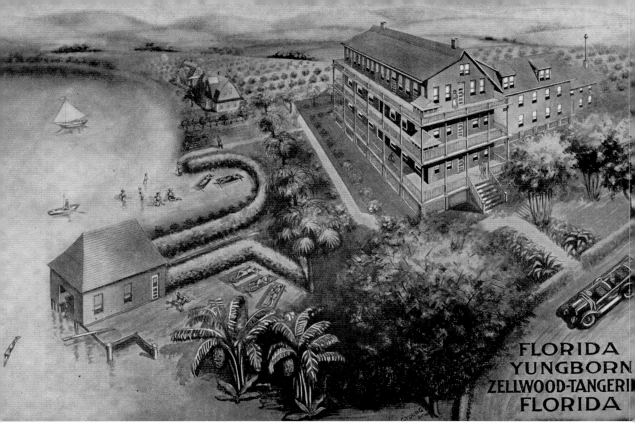

Dr. Lust's Florida Yungborn was considered the winter branch of his sanatorium. It specialized in "rational up-to-date drugless hygienic methods" for the "physically and spiritually weakened, for those overworked, and for the convalescent."

QUI-SI-SANA: THE WINTER YUNGBORN IN TANGERINE

Lust chose to situate his sanitarium in tiny Tangerine, Florida, in west Orange County, because he claimed it had an "ideal climate." In 1913 he bought a hotel called the Wachusett House and dubbed it Qui-Si-Sana ("place where you get health" or "here is health"). It's unclear if he had knowledge of the Qui-Si-Sana hotel in Green Cove Springs, but it is likely Lust knew of famed resorts of the same name in Baden-Baden, Germany, and Capri in Italy.

"In the vicinity of the most beautiful lakes in Florida, and country town of Mount Dora," begins a Yungborn promotional brochure, "there spreads, in incomparably ideal beauty, surrounded by majestic parks . . . the Health Resort of *Yungborn*." The long list of naturopathic treatments available included "packings, bandaging, baths and gushes of various descriptions," along with barefoot walks, steam and sun baths, massage, and "Osteopathy, Chiropractic, Mechanotherapy, Neuropathy, etc." The brochure provided directions for reaching the sanitarium by train to Mount Dora (Atlantic Coastline Railroad), steamboat (Clyde Line to Sanford), or automobile. The exotic location was described as ideal for healing: "The orange and grape-fruit groves, the strange vegetation, the brilliant sunshine and medium temperature, the

abounding foliage and flowers, the sun baths and swimming in the lake" all worked in concert to "restore perfect health."

At the Florida Yungborn, Lust encouraged guests to sunbathe in two solaria located on the lake—wooden structures that separated the genders for privacy. Sunbathers were advised to get "fully charged" with sunlight and then plunge into the chilly waters of the lake, thus creating a strong reaction from the cool bath and the healthful "solar beams." Diet was strictly regulated. Hydropathic treatments included hot saline baths, Nauheim baths (a bath with carbon dioxide bubbles added), and tepid and cool douches (water jets aimed at the body, designed to condition the skin to help "establish immunity"). Lust's wife, Louisa, also considered a pioneer in naturopathy, was a full partner in creating and running both Yungborn locations until she died in 1925.

Lust's advertisements claimed that the Yungborn building in Tangerine was the "most pretentious house in the village," and contemporary accounts refer to the sanitarium as a focal point of the Tangerine community. A tragic event occurred early in the morning of February 21, 1943, when a fire broke out in the kitchen of the health resort and rapidly spread throughout the three-story building. Lust and his staff evacuated the guests, but there were several serious injuries and two casualties. Among the injured was Lust, who was burned trying to help his patients escape the blaze and was treated with the drug sulfa by doctors on the scene. After the fire, Lust's health declined steadily, and he died on September 5, 1945. His naturopath peers, who rejected the use of drugs in any form, blamed the sulfa treatments for contributing to his demise. Today Lust's sanitarium in Tangerine, once dubbed "the most healthy spot in the state" where "Nature's forces" formed a "veritable Elixir of Life," survives only as an obscure footnote in history. Lust's legacy as the father of the naturopathic movement lives on, however, and naturopathic practice continues into the twenty-first century.[5]

The Wachusett House in Tangerine was rebuilt by Charles Bennett after a fire in 1899 before being sold to Dr. Benedict Lust in 1913.

The popularity of the alternative therapies practiced at Lust's Yungborn sanitariums resulted in part from the atmosphere of both cultural and spiritual reform that began in the United States in the 1830s and '40s and flourished again between the end of the Civil War and the start of World War I. Reformers looked at the revolutionary advancements brought on by an expanding and increasingly industrialized society and worked toward solutions to a wide array of issues caused by these changes. The temperance movement sought to ban the consumption of alcohol, abolitionists fought to end slavery, suffragists marched for women's right to vote, and health reformers such as Sylvester Graham worked to improve quality of life through diet and exercise.

Hydropathy, and the lifestyle it promoted, was a significant element in healthcare reforms of the nineteenth and early twentieth centuries, and activists from other movements sought out establishments that offered cold-water cures. Harriet Beecher Stowe stayed at the Brattleboro Water Cure institution for almost a year, receiving treatments, and her well-known husband, Calvin Stowe, surpassed her visit with a stay of fifteen months. Abolitionist and suffragist Julia Ward Howe stayed at Brattleboro too, and women's suffrage icon Susan B. Anthony visited multiple water cures. Red Cross founder Clara Barton stayed at the water cure facility called "Our Home on the Hillside," operated by reformer James Caleb Jackson in Dansville, New York.

Jackson's role in other American social movements helped to position his Dansville facility as a center of reform politics. Some of the most prominent reformers of the day spoke at "Our Home," including Anthony, Elizabeth Cady Stanton, Sojourner Truth, Frederick Douglass, and Bronson Alcott. Another prominent guest at "Our Home" was Ellen G. White, a Seventh-day Adventist who claimed that while visiting there, she had received a vision to create a similar facility in Battle Creek, Michigan.[6]

Ellen White, 1864.

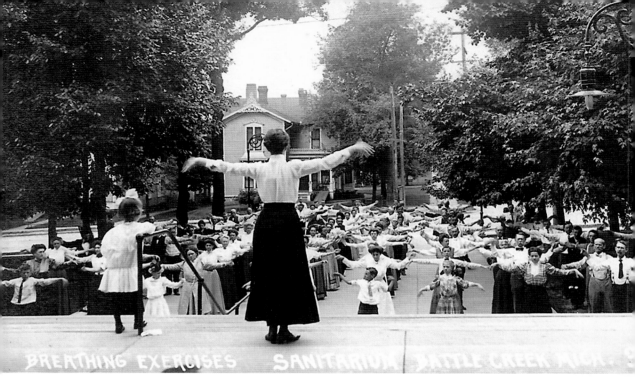

Breathing exercises at the Battle Creek Sanitarium, circa 1900. John Harvey Kellogg wrote that it was as much the duty of every person to "give thought to the air that he breathes, and to the manner of breathing, as to give attention to the food he eats."

✺ FROM THE SECOND COMING TO A BREAKFAST REVOLUTION

Historians call the period of religious fervor that birthed many of the nation's Protestant denominations the Second Great Awakening. Rejecting the Calvinist notion of original sin, members of these new groups focused on improving themselves by turning away from sin to prepare for salvation. This paradigm shift in spirituality contributed to the reform movements of the nineteenth century as well as spawning religious groups who believed that the Second Coming of Christ was growing near. William Miller, a farmer from Vermont, calculated it would take place in 1843, based on clues he found in the Bible. He attracted a large following, known as "Millerites," but after his predictions for the date of Christ's return passed uneventfully, he retired from preaching. His movement lived on, however, in a new denomination called the Seventh-day Adventist Church, the members of which believed that salvation required worshipping on Saturday.

James and Ellen White, early leaders of the Seventh-day Adventist movement, were attracted to the town of Battle Creek, Michigan, when a new convert, John Preston Kellogg, helped to raise money to lure Adventist printing operations to Michigan. Kellogg's son John Harvey was raised in an Adventist environment, and when he was older, he worked in the Adventist print shop and interacted with the Whites. At a revival in Otsego, Michigan, in 1863, Ellen White, considered a prophetess in the Adventist movement, had a vision that commanded Adventists to

Undated photo of John Harvey Kellogg and his cockatoo.

promote God's great medicine, "water, pure soft water," to combat illness and improve hygiene. Health reform became a central tenet of Seventh-day Adventism, and Ellen White wrote at length about the benefits of hydropathy. In 1865 she had her vision at the water cure at Dansville, and by 1866 the Adventists opened the Western Health Reform Institute in Battle Creek, Michigan. Soon it became apparent that the institute would need more trained physicians, so the Whites selected young John Harvey Kellogg to go to Russell Trall's Hygieo-Therapeutic College in New Jersey to learn hydropathy and other therapies. To increase his medical knowledge further, Kellogg also studied conventional medicine at the University of Michigan and Bellevue Hospital in New York.

Kellogg grew up in a household where both Grahamism and hydropathy were practiced—both he and his father suffered from tuberculosis. The Western Health Reform Institute operated much like a traditional water cure establishment when Kellogg started working there in 1875, so his experience with hydropathy was advantageous. A year later Kellogg was named superintendent of the institute, and one of his first acts was to rebrand the facility as the Battle Creek Sanitarium.

The word *sanitarium*, coined by Kellogg, differed from *sanatorium*. In his view, a sanitarium was a place where one went to learn to *stay* well, as opposed to just visiting to be healed. Sanatoriums specializing in treating tuberculosis patients with fresh air, rest, and hydrotherapy sprang up all across the nation after the success of Dr. Edward Trudeau's sanatorium in Saranac, New York. Kellogg's new term placed deliberate emphasis on the word "sanitary" and the importance of germ theory and hygiene, as he interpreted them. His goal was to expand the scope of his Battle Creek establishment far beyond that of a typical water cure, into an institution where patients would learn an entirely different lifestyle. Despite Kellogg's larger vision, his sanitarium offered two hundred different types of water treatments, from cold-water immersion to hot-air vapor baths—in short, hydropathic cures were an

essential aspect of every patient's health regimen. In 1876 Kellogg also published a book, *The Use of Water in Heath and Disease,* detailing these hydropathic methods.

Within two decades Kellogg achieved his goal of creating a university-like setting for the pursuit of health. According to Kellogg's biographer Brian C. Wilson, "thousands of Adventists and non-Adventists alike were convinced that a stay at the Battle Creek Sanitarium was just the cure for their harried lives." A new building was erected in 1878, and multiple additions and renovations were made throughout the remainder of the century in order to serve upward of seven hundred patients at one time.

To ensure fresh ingredients for the vegetarian fare consumed by guests, the church operated its own farms and dairies. But when visitors complained of broken teeth suffered from rock-hard Zwieback biscuits, Kellogg went to work trying to develop a more palatable alternative. The result was a baked product made of wheat, oats, and corn he called Granula. Unfortunately, Dr. James Jackson of the water cure facility in Dansville had already invented a product with that name, so Kellogg renamed his breakfast cereal Granola. Spurred by its success, Kellogg and his brother Will created the Battle Creek Sanitarium Health Food Company to market their culinary creations. Their most famous invention, dubbed Corn Flakes, was the foundation of a breakfast industry with which the Kellogg name is synonymous.[7]

In addition to hydrotherapy, exercise was important in the Battle Creek system, as seen here in this women's swimming pool.

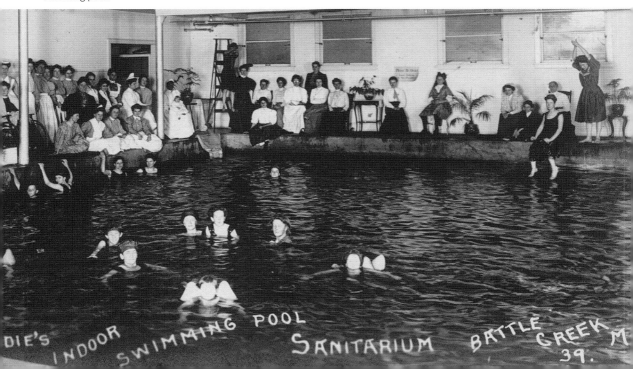

🌿 DR. KELLOGG BRINGS HIS SANITARIUM SOUTH

After a fire in 1902 Kellogg's sanitarium in Battle Creek was rebuilt again, and twenty-five years later a $3 million-dollar addition enlarged the campus even more. Kellogg ultimately became alienated from the leadership of the Seventh-day Adventist Church, and the sanitarium formally separated from the church in 1907. But the enormous institution largely stuck to Adventist principles.

In September 1930 the *Miami News* reported that Kellogg would open a second Battle Creek Sanitarium in Miami Springs, Florida, a city founded during Florida's 1920s land boom by aviation pioneer Glenn Curtiss and James Bright, Curtiss's partner in Florida development. Like Benedict Lust before him, Kellogg claimed to have searched for the perfect location, with the best climate for healing and restoration, and to have concluded that south Florida was ideal. Perhaps drawing on Florida's connection to the myth of the fountain of youth, Kellogg said his new project would feature research conducted by the "Florida Medical profession and leading insurance companies" for the purpose of prolonging human life. It would be housed at Curtiss and Bright's Hotel Country Club, built to help promote their Country Club Estates development in Miami Springs.

A promotional brochure for the Miami-Battle Creek Sanitarium, 1940.

Curtiss, who had completed the hotel just a few years prior, sold it to Kellogg for a single dollar, although legend has it Kellogg joked that a dollar was too little and gave Curtiss a ten-dollar bill. It's likely the deal with Kellogg gave Curtiss an opportunity to be free from the financial responsibility of operating the property in the midst of the Great Depression, as historian Seth Bramson has noted in his study of south Florida's Curtiss-Bright cities. The stuccoed resort was designed in a distinctive Pueblo Revival architectural style with southwestern décor throughout. A large thunderbird symbol prominently adorned the main building, in keeping with the theme Curtiss had envisioned for Miami Springs. During Florida's 1920s boom, fantasy architecture was a fad throughout the state, and Curtiss had designed buildings in his nearby city of Opa-locka with an Arabian Nights theme.

The Men's Gymnasium featured massage and sunbathing with care, as prescribed and supervised by experts in sun therapy.

Despite the hardships of the Great Depression, Kellogg's Miami Springs Sanitarium stayed full during the winter seasons. Like its Michigan predecessor, Kellogg's Florida property encouraged its visitors to adopt a new healthy regimen for living based on a strict diet, fresh air, exercise, and a plethora of hydropathic options. "Although at times almost monopolized by empirics and charlatans, today there is no therapeutic agent whose use rests on a more thoroughly rational and scientific basis than water," a marketing brochure stated.

Kellogg's Florida sanitarium also boasted that after seventy years of experience, his Battle Creek methods made hydrotherapy a "pleasurable experience" instead of the ordeal it once was. "Ideal" ocean bathing was only fifteen minutes away in the warm waters of Miami Beach, the brochure noted, alongside images of guests swimming at Coral Gables in the spring-fed waters of the Venetian Pool, an 820,000-gallon fantasy carved out of a rock quarry. The brochure lauded the healing powers of the sun, and one of the more interesting staged photographs shows a comparison of the sun tans of two men, both clad only in diapers, socks, and shoes.

Dressed in his iconic white three-piece suit, the diminutive Kellogg, with his signature snowy mustache and goatee, was an international celebrity who used his cachet in promoting his Florida venture as well as the state in which it was located. He made a big splash with celebrity visitors to Miami Springs, such as Dale Carnegie, Henry Ford, Thomas Edison, and George Bernard Shaw. His promotional writing was featured in newspapers and in publications of the Florida Department of Agriculture. In a tract titled *Florida, Land of Health*, Kellogg opined that with the proper effort, the entire population of the state could be the healthiest and "longest lived

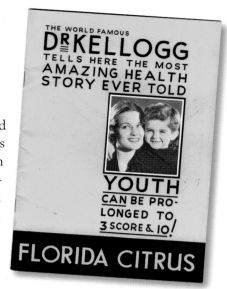

In this brochure issued by the Florida Citrus Commission, Kellogg stated that at Miami Springs patients drank citrus juice as freely as water.

people in the world." Youth could be prolonged to "3 score & 10" by including Florida citrus in one's diet, according to another brochure in which Kellogg claimed citrus had the remarkable power to prolong life, preserve youth, and prevent divorce and premature senility, while at the same time preventing disease and tooth decay.

Kellogg spent a great deal of time in Miami Springs in his later years, where, according to the City of Miami Springs website, "he treated patients, developed new soy-based food products, wrote and raised his large adoptive family." His Michigan sanitarium was embroiled in financial woes, and Kellogg seemed to relish having a tabula rasa in Florida where he could "get everything done as he would have it done," as Richard W. Schwarz notes in his biography of Kellogg. A 1936 newspaper article reported that Kellogg claimed to be far too busy to celebrate his eighty-sixth birthday. He died five years later in Michigan, where the enormous sanitarium building in Battle Creek is now home to federal government offices. The southwestern-style hotel that Kellogg's Miami Springs sanitarium occupied until 1959 is now a retirement home.[8]

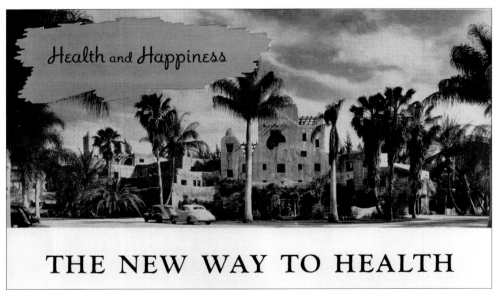

"The goal is, of course, superhealth," reads the sanitarium advertising. "It is every person's right to have abounding vitality."

LOOKING FOR DR. CORNFLAKE

John Harvey Kellogg is one of the most fascinating characters in American medical history. He was far ahead of his time in advocating for a healthy lifestyle consisting of ample amounts of exercise and a plant-based diet. He had legendary skills as a surgeon and was a prolific author who lived into his early nineties, despite fighting tuberculosis at a young age. But he also became controversial for his crusades against masturbation and sexual activity, was obsessed with frequent enemas, and started the Race Betterment Foundation, apparently in the belief that the human race was threatened by "racial mixing and mental defectives."[9]

To get a better understanding of the complicated man who was credited for inventing eighty different forms of water treatment, I traveled to the Dr. John Harvey Kellogg Discovery Center in Battle Creek, Michigan, and the Fair Havens Center in Miami Springs, Florida—the former site of Kellogg's world-famous Miami-Battle Creek Sanitarium.

In Michigan I found the Discovery Center housed in a nondescript building at the Adventist Heritage Village, which also contains many historic structures connected to the early days of the Seventh-day Adventist Church. The center is chock-full of bizarre contraptions from Kellogg's sanitarium, ranging from illuminated electric-light baths to mechanical "vibro-therapy" machines designed to improve circulation. Reproductions

Kellogg's wardrobe was an essential part of his brand.

of vintage photographs and advertising create context for understanding how things worked at the facility that treated thousands of patients from 1876 to 1942.

There's an interactive aspect, too: visitors can still operate some of the odd machines and pose for photos with a life-sized cutout figure of Kellogg in his famous white suit. Display cases show printed promotional pieces for Kellogg's sanitariums, as well as the china on which patients such as President William Howard Taft (touted as the hundred-thousandth patient) and Eleanor Roosevelt were served their vegetarian meals. The Discovery Center also sold reproductions of some of Kellogg's books, including *The Use of Water in Health and Disease* (1876), and offered a fascinating glimpse into life at a Kellogg sanitarium. From today's vantage point, the activities he promoted in Battle Creek seem eccentric and dated, although his idea of a healthy lifestyle has endured.

My visit to the Fair Havens Center in Miami Springs was more about appreciating the architecture than understanding the sanitarium lifestyle. Fair Havens is now an assisted living facility, and I was committed to respecting the privacy of the current occupants. So I limited my excursion to taking photographs of the exterior and lobby, which both still look largely unchanged from the building's origins as a Curtiss-Bright hotel from the 1920s.

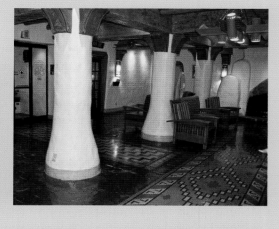

The former Miami Springs Sanitarium exterior and interior (2013).

The thunderbird motif still adorns the front of the building, which resembles a large pueblo of the kind one might see in New Mexico. The landscaping has matured since Kellogg ran the place, and much of the remarkable building is hidden behind tall palm trees, dense ferns, and large cacti. Inside, the lobby is quiet and dark. An adobe fireplace dominates the room, but other vintage details are much more subtle. A faux pitcher protrudes out of a stucco wall, hand-hewn wooden trim above the dining room entrance bears whimsical gold-leaf lettering, and thick, flared columns support large, rustic wooden beams—all vestiges of the romantic vision of aviator and developer Glen Curtiss. Curtiss and Kellogg are long gone, but the evidence of an era when fantastic architecture and innovative healing practices lured visitors to balmy south Florida lives on.

 ## THE ADVENTISTS' CENTRAL FLORIDA SANITARIUM

Although the Seventh-day Adventist Church and John Harvey Kellogg parted ways in 1907, the church remained involved in the sanitarium business. In fact, by 1908, Adventists had already established sanitariums in California (Loma Linda), Colorado (Boulder), Illinois (Hinsdale), and Florida (Orlando); the Florida Sanitarium began as a facility to treat tuberculosis and was owned by Dr. R. L. Harris, a doctor who was also the proud owner of the first automobile in Orlando.

Harris's sanitarium, located on seventy-two acres of land on Lake Estelle in Orlando in a community once known as Formosa, offered "fresh air, good food, and medicine" from a facility housed in an old farmhouse and a few cottages. When Harris decided to put his property up for sale, Mahlon Gore, a former Orlando mayor and newspaper editor, wrote to Kellogg suggesting that the Adventist Church might be a good candidate to purchase the property. Gore was a one-time resident of Battle Creek who had moved to Orlando to improve his health. Despite having only $4.53 in its bank account, the Florida Conference of Seventh-day Adventists offered $9,000 for the Orlando property. Ellen White gave her blessing; it was time for Florida to have a sanitarium, she said, so that the "light which our

sanitariums are established to reflect may shine forth to the people of Florida and to the many health seekers from the northern states."

In October 1908 the Adventists opened the Florida Sanitarium and Benevolent Association. The converted farmhouse held twenty beds as well as treatment and operating rooms. Despite its simplicity, this original structure also featured wrap-around porches, a parlor, dining room, and a "spacious front lobby," according to a history of the hospital published in 1998. When the sanitarium first opened, the small staff outnumbered the first four patients, but by 1912 a much-needed expansion was completed, adding a new building near Lake Estelle that could accommodate forty patients. In 1918, after only six years, that building was expanded again, doubling in length and bringing the capacity of the sanitarium to a hundred beds. Another expansion in 1925 had a wing with popular hydrotherapy facilities, including separate areas for men and women.

Orlando and the sanitarium flourished during the early 1920s, and the place residents came to call "Florida San" catered to patients who stayed the entire winter season. They enjoyed a wide variety of outdoor activities, including croquet, shuffleboard, tennis, and swimming in Lake Estelle. There was even an alligator pit where guests could feed table scraps to the cold-blooded reptiles. Many of the hydrotherapy treatments at the Orlando sanitarium were adopted from those Kellogg had developed at Battle Creek. They included steam baths in "sweat boxes"

The Seventh-day Adventist Church purchased the Dr. Harris Sanitarium and Hotel Company in 1908 and opened a twenty-bed hospital.

designed to remove toxic substances from the patient's body and a variety of hot- and cold-water treatments used to "stimulate circulation, reduce headaches, and treat arthritis." In 1970 the term "sanitarium" was officially dropped from its name. In 2019 the institution, long known as Florida Hospital, was officially rebranded as Advent Health, consolidating a system of hospitals that operates in nine states and bringing the institution's Adventist roots to the forefront. The popularity of hydrotherapy lasted at the Orlando facility through the 1950s and is still used on the campus for rehabilitation.[10]

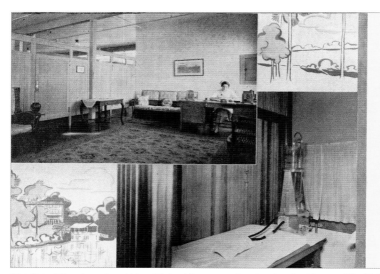

HYDROTHERAPY
MASSAGE

There are more than two hundred forms of hydriatic and massage procedures, hot and cold applications, sprays, douches, Swedish massages and colon irrigations—e a c h having a different effect. ● A well equipped department u n d e r competent medical supervision is provided, and forms a definite part in the treatment of disease.

"Heath and Happiness" could be obtained from more than two hundred forms of "hydriatic and massage procedures."

FROM SANITARIUM TO SPA

An October 1928 newspaper article noted that while "Mr. Kellogg of the Battle Creek Sanitarium was marking time" deciding about where to locate his Florida property, "Miami was working along other lines." The result, called the Miami Solarium, was "designed to take full advantage of the curative properties of Florida sunshine" as well as offering the ability to "treat cases by electricity and hydrotherapy." As at Kellogg's sanitarium in Battle Creek, "sun baths" were highlighted in the marketing, reflecting the shift away from the Victorian-era preference for pale skin to a tan complexion indicative of time spent outdoors. In 1932 marketing for the Miami Solarium shows a transformation into the Sun-Ray Sanitarium and then the Sun-Ray Hotel, rebranding itself as a resort with pools, a gymnasium, dancing, and outdoor entertainment as it strove to embody the "features of European and

American Spas." Hydrotherapy treatments were available for two dollars each, and the advertised list of "baths" included Turkish-Russian, needle showers, electric cabinet, reducing, and "salt glow" options as well as a warm exercise pool. But it's likely that by the 1930s the clientele had less appetite for indoor water treatments and a greater hunger to be outdoors. Nude sunbathing was high on the touted list of amenities.

The popularity of hydrotherapy in the nineteenth century, however, can be evidenced by facilities at two of Florida's premier resorts built by the railroad barons who made the Sunshine State a popular playground for the rich. The Hotel Alcazar in St. Augustine, built by Henry Flagler in 1888, advertised that it possessed the only baths in the world open from November to May. The Alcazar was the less expensive alternative to Flagler's grand Hotel Ponce de Leon across the street and was originally conceived simply to provide amenities like a gymnasium and swimming pool for the Ponce's guests. The Moorish-inspired design displays Spanish and Renaissance influences that complement yet are distinctly different from styling at the Ponce.

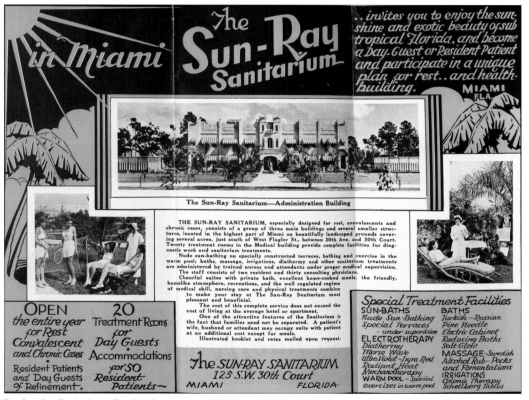

The Sun-Ray Sanitarium offered baths, massage, irrigations, and other sanitarium treatments administered by trained nurses.

.. Commutation Tickets sold for Turkish Baths ..

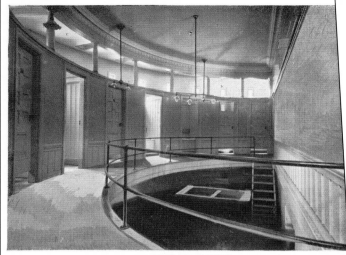

MEN'S DEPARTMENT.

.. Private Plunge and Hot and Cold Tub Baths for Men ..

Turkish and Russian Baths

· RATES ·

Single Bath	$ 1.50
Package Tickets (10 Baths)	10.00
Alcohol Rub	.25
Cologne "	.50
Salt "	.50
Packs, Hot or Cold	.50
Massage at Baths	1.00
" Outside	2.00

· GYMNASIUM ·

Use of Appliances	.25
Season Ticket (including Locker)	5.00
Exercise and Plunge	.50

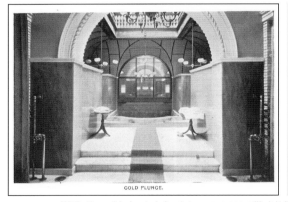

COLD PLUNGE.

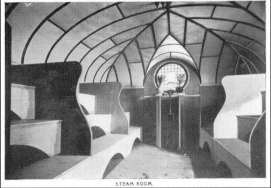

STEAM ROOM.

While the cold plunge is long gone, one can still visit (but not use) the steam room of the Alcazar Hotel at the Lightner Museum.

The Alcazar's hydrotherapy facilities included a Russian bath (steam room), Turkish bath (a dry-heat sauna), and a cold plunge located between the two. Between the cold plunge and the Russian bath was a room with a needle shower where seventeen separate shower heads could blast streams of water on a patient, a sitz bath in hot or cold water, and a "new Hydrotherapeutic Apparatus" with a variety of nozzles on top of a marble cabinet for spraying streams of water at different parts of a patient's body. Literature also advertised Nauheim Baths (water infused with carbon dioxide), cabinet baths, and a variety of "Electro-Therapy" devices said to be the "most modern appliances with which any electropathic institution in the country is supplied." The treatments were performed by "professional attendants" under

the "personal direction of Dr. Murray W. Seagears, a well-known surgeon employed by Flagler's Florida East Coast Railway. Today a portion of the baths are on display in the Lightner Museum that occupies the Alcazar building.

In addition to the "modern" hydrotherapy equipment, the Alcazar boasted an enormous indoor swimming pool advertised as being on the scale of the Roman baths. At the time it was built it was said to be the largest indoor swimming pool in the country. The pool was filled by sulfurous water supplied by an artesian well. In fact, the water in the fountains of the courtyards at the Alcazar today still smells strongly of sulfur and may in fact come from wells originally pumped by Flagler's crew.

Four stories up, a skylight covered the pool. A ballroom occupied the top floor, and dancers could view the pool below through graceful arches. Men's and women's dressing rooms occupied opposite ends of the enormous interior space, and each gender was allowed access to the pool at different times. According to an article in the *St. Augustine Record*, the facility had bathing suits for rent, because "a lot of people didn't own bathing suits" due to the novelty of swimming in the Victorian era.

Not to be outdone by Flagler, Henry Plant offered swimming and hydrotherapy facilities at his magnificent Tampa Bay Hotel. When the $2.5 million facility, with $500,000 worth of furnishings, opened in February 1891, it was every bit as glitzy as the Standard Oil tycoon's St. Augustine properties. Just eleven years earlier Tampa

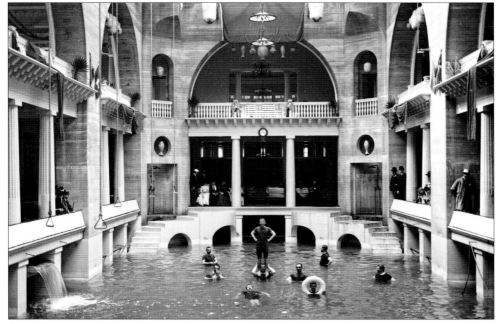

Bathers enjoy the Alcazar pool; amenities included dressing rooms for men and women and bathing suits for rent.

had had only 720 residents, but by the end of the century it was booming, thanks in part to Plant's investments and his railroads.

Guests at his Tampa Bay Hotel could choose from a plethora of outdoor leisure activities, including hunting, bicycling, boating, and fishing. Inside the hotel they could play billiards, try shuffleboard, and visit spa facilities that featured mineral-water baths, massages, and consultation from a staff physician. In 1896 Plant added a Colonial Revival–style casino building with an indoor heated swimming pool that could be covered to create a theater space large enough for an audience of two thousand. Sarah Bernhardt and John Philip Sousa both performed here. A promotional brochure touted a hydrotherapeutic apparatus in the casino building with a constant jet of water, claiming it was "one of only two such devices in the nation" and comparing the hotel's healing methods to those used by "famous professors" in Europe—capable of offering relief for a variety of ailments and maladies.

The casino building burned down in 1941, and little if any evidence remains of the hydrotherapy facilities at the Tampa Bay Hotel. But the fact that two of the most modern, well-appointed hotels of the age featured and promoted their water cure facilities shows the popularity of hydrotherapy during that period in Florida history.[11]

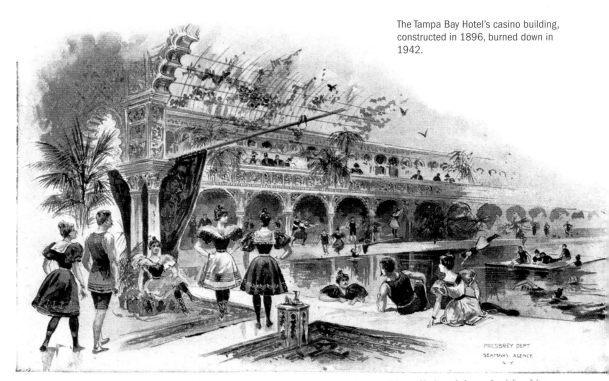

The Tampa Bay Hotel's casino building, constructed in 1896, burned down in 1942.

"The Swimming Pool in the Casino is 70 feet long by 50 wide, and is walled and floored with white tile and filled with crystal water."

HOT SPRINGS HYDROTHERAPY

When the attendant asked for my bed sheet, there was no turning back. I had stripped off my clothes, stuffed them into a locker, and entered the men's bathing area clad in only a thin cotton sheet.

The experience I was about to undergo included many of the same treatments practiced at a hydropathic or water cure facility a century ago, in Florida or elsewhere. This was not a cold-water cure, however—this was the torrid mineral water of Hot Springs, Arkansas, where many procedures have not changed since the mid-1800s.

Nine of the original bathhouses at Hot Springs form what is now a national park. Two of the buildings on Bathhouse Row still offer hydrotherapy treatments. Quapaw Baths and Spa specializes in a contemporary spa experience with facials, massage, and "Hot Stone Alignment." The Buckstaff Bathhouse, in operation since 1912, offers the ultimate "thermal mineral bathing experience"—a more authentic hydrotherapy treatment that included a whirlpool tub bath, sitz bath, vapor cabinet, needle shower, and hot-pack towel treatment. I chose the Buckstaff treatment so as to have a better idea what it might have been like for Victorian-era bathers.

The Buckstaff Baths, like those at spas and sanitariums in Florida, are still segregated by gender. I was the first visitor to the men's bath after the staff's lunch break, so it felt a bit odd as I began my bathing experience in a cavernous facility all by myself. In the center of the room were rows of vinyl-covered tables, much like those used by massage therapists. Along the walls were various marble stalls with various hydrotherapy devices; sitz baths to my right, enormous tubs on my left.

I didn't have time to take it all in as the attendant, dressed entirely in white (as is the tradition), led me to my mineral bath. He carefully

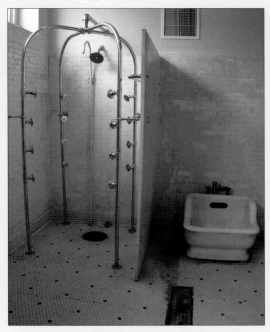

A needle shower and sitz bath at the Fordyce Bathhouse.

helped me climb over the steep sides of the tub inside a private stall. I was instructed to place my feet on the far end of the tub and lean back. The water felt too hot at first, but I got used to the temperature quickly. The temperature gauge by my right foot showed it was 104 degrees. The hot mineral water comes from 45 separate springs on the side of Hot Springs Mountain, and the average temperature of the water at its source is 143 degrees. The whirlpool was created by a vintage-looking device that resembled a cross between a kitchen mixer and outboard engine attached to the tub above my left foot. I relaxed into the warm flowing water, and by the time the attendant returned with a towel to take me to the sitz bath 20 minutes later, I was so comfortable in the tub that it took great effort on my part to get out.

Next was the low sitz bath, where I sat on a small wooden seat and allowed warm water to

Left: Antique plumbing and crackled porcelain on the tub in the 1915 Fordyce Bathhouse. *Right:* The Buckstaff Bathhouse opened in 1912.

cascade over my back while I faced out into the room. It felt heavenly, like taking a long warm shower but without privacy. After a few minutes, I was once again rousted from my relaxed state to cross the room for my vapor-cabinet experience. I'd seen many vintage photos of vapor cabinets that look like big boxes where the bather's head pops out from a hole in the top, and that was what I expected. But this was like a walk-in shower—a small closet-like space—and it felt claustrophobic at first. I found it hard to inhale through my nose, so I breathed through my mouth. The air had an interesting earthy, sweet taste. Soon it felt as though sweat was oozing out of every pore in my body. By the time the attendant came to get me, my anxiety had completely dissipated, and once more I didn't want to leave!

The attendant then asked if I'd like any area of my body to be "packed" with hot towels. Remembering how good it felt to have warm water pouring on my back in the sitz bath, I asked him to apply the warm, damp towels to my back, which he did after I lay face down on a table. Then I was wrapped up tightly in sheets like a human burrito. There is something primal and relaxing about being confined like this, and I've read that similar treatments were used in mental institutions to calm agitated patients. Ten minutes later the attendant returned to take me to the needle shower.

I'd seen vintage images of hydrotherapy treatments at Battle Creek where high-pressure hoses, looking very much like cruel torture devices, were pointed at the patient's back. Hence I was a bit nervous about something called a needle shower. I found it, however, to be quite relaxing—just like my other experiences—and ironically, I was slightly disappointed that the water pressure wasn't as epic as I had expected. When the attendant returned, the last step left in my hydrotherapy treatment was the cool-down room.

I was directed into a lounge full of massage tables where I was instructed to relax for about ten minutes. The space was simple and sterile looking—white subway tiles on the walls, ceiling fans overhead, and a television near the door. Despite the Spartan decor, I felt totally blissed out. After a few minutes I left, got dressed, and then went outside and plopped down in an Adirondack chair on the Buckstaff's front porch. While I chilled like a bowl full of Jell-O, tourists came by to pose for pictures in front of the bathhouse. One of them was smoking, and I felt like yelling at them to stop—how dare they burst my bubble of health and serenity? It felt as though every pore of my skin was open; every cell in my body in a tranquil state. When it was time to leave I almost couldn't get out of the chair. I was that relaxed.

MIND, BODY, AND SPIRIT: HYDROTHERAPY TODAY

At the beginning of the Victorian era, swimming and physical exercise were considered activities only for less cultured individuals of lower classes. But as the health reform movement became more popular, exercise was seen as important to a healthy lifestyle. Where bathers once timidly waded into the sea with the help of ropes, eventually seaside establishments hired swimming instructors to teach swimming in pools at their beachfront casinos. Physical activities were included in the amenities of resorts of the era, and the resorts increasingly served both social and wellness functions, much like a contemporary health spa. In today's Florida, both springs and sea are used primarily for recreational purposes, but the whole notion of recreational swimming can be traced to the health movements that started in the 1800s.

Hydropathy, or the "water cure" (today more commonly called hydrotherapy), is used now both for restorative purposes at contemporary health spas and for rehabilitation at hospitals and rehab facilities. Near the end of the nineteenth century hydrotherapy was also practiced on mental patients, as baths and wet packing were often used either to calm or to "shock" patients. The term "water cure" took on a new meaning after the Spanish American War, when American soldiers forced water down the throats of prisoners. This use of this definition of "water cure" still pops up in articles about water-based torture, such as waterboarding. It's ironic that the terms once used for treatments designed to improve health are today often associated with lunatics and torture. But the legacy of the movement continues in hospitals that originated as sanitariums, hydrotherapy treatments for rehabilitation, and health spas that cater to healing and restoration of the mind, body, and spirit.[12]

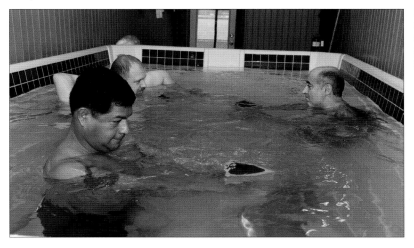

A pool used as a therapy tool designed to prevent and rehabilitate injuries for members of the U.S. Navy in Norfolk, Virginia, 2008.

CHAPTER 9 ❧

POPULATION BOOMS AND ALGAE BLOOMS

The Future of Florida's Healing Waters

From natural wonders to fantastical journeys of imagination, visitors to the Sunshine State will discover a long list of things to do in Florida. There's no U.S. state quite like Florida, where strawberries grow in winter and beaches beckon year-round.

—*Visit Florida website*

In the twenty-first century Florida's water is more valuable than ever—more than 21 million residents and tourists drink it, bathe in it, and play in it every year. And the number expands daily. The growth of the state has left many of its water resources depleted and polluted while Floridians' desires for water for recreation and well-being continue to swell. Fortunately, many of the state's most popular springs and beaches are part of its award-winning state park system that attracted more than 32 million visitors in 2016–17 and added $3 billion to the state's economy.

Despite the popularity of its parks, however, many Floridians seem to suffer a profound disconnect from the natural world. But this has not reduced the desire for water—it has only increased opportunities for manmade solutions to satisfy our urge to be near or in water. In both leisure and health, artificial alternatives have been invented as twenty-first-century options for taking the waters. This desire to be near water in human beings is innate, according to scientist Wallace J. Nichols, who coined the term "Blue Mind" to characterize the positive reaction to water we have on both a physiological and psychological level.[1]

Opposite page: A water-aerobics class at Warm Mineral Springs, 2012. *Above:* Silver Glen Springs, 2015.

Algae tickle the feet of tubers on the Ichetucknee River.

HISTORICAL WATERS AILING TODAY

In the nineteenth century and the early twentieth, Florida's artesian springs and salubrious climate were the essential ingredients in promoting the state as a paradise for sickly northerners tired of wicked winters. Steamboat travel made springs accessible, and when natural springs weren't available, artesian wells were often drilled to access the mineral-laced water. As Victorians shifted their focus to beachfront resorts and the popularity of the water cure led to inland sanitariums featuring hydrotherapy, springs were increasingly seen as recreational resources rather than health facilities. A number of them became roadside attractions. A few, such as Silver Springs and Rainbow Springs, became early theme parks offering rides and exotic animal attractions. They thrived if they were accessible by such roads as the Dixie Highway, Tamiami Trail, or Orange Blossom Trail.

Later in the twentieth century, when the interstate highway system rerouted automobile traffic and then Walt Disney World ushered in the era of corporate theme parks in 1971, attendance at these springs-based attractions suffered. Today Silver and Rainbow Springs, Weeki Wachee, and Homosassa Springs are all state parks popular with visitors seeking recreation and with eco-tourists. Other springs are located on private property, and some springs have even been capped, but many remain accessible to the public and often overflow with swimmers, snorkelers, and tubers. A dip in the springs is still one of Floridians' favorite ways to beat the heat.

But early in the twenty-first century it became apparent that these "bowls of liquid light" faced a dark future due to over-tapping of the aquifer and increasing pollution. Evidence has shown that in areas pumping significant amounts of groundwater, spring flow has declined, and some springs have simply stopped flowing. Nitrogen from fertilizer seeps into the aquifer from both agricultural and residential

sources and often pollutes the spring water. As a result, the Florida mineral water that was once bottled and shipped across the country because it was believed to be efficacious in the healing of disease could now include high enough nitrogen levels to cause illness. In 2018 Dr. Robert Knight of the Florida Springs Institute reported that in several areas, water sampled from the aquifer had nitrate concentrations "many times higher" than the drinking water standard of 10 parts per million. The water crisis in Flint, Michigan, since 2014 has demonstrated how quickly the contamination of drinking water can lead to a public-health crisis.

The crystal-clear waters that Florida's early promoters used to lure visitors from the North are now often green and gunky; ironically, this is in part because the state's marketers have been so successful in bringing people to the land of perpetual health and restoration, creating greater stress on natural systems. Springs advocates and environmentalists have raised awareness greatly about the degradation of these blue wonders, but awareness is only the first step toward safeguarding them. While it is possible to restore the flow of our waters and eliminate the sources of pollution, it is unlikely that the springs will ever return to a "pristine" ecological state, according to Dr. Knight.

The freshwater aquifer below Florida is also threatened by saltwater intrusion. Sea-level rise, combined with the overuse of the groundwater supply, has made the risk of saltwater intrusion in freshwater wells an increasing threat. Climate change and pressures created by the state's rapid growth rate have made potable water an increasingly valuable commodity.[2]

Menacing aquatic growth lurks just beneath the surface at Manatee Springs in Chiefland.

ADVOCACY THROUGH ART

In the eighteenth and nineteenth centuries William Bartram, Harriet Beecher Stowe, and Sidney Lanier were among the writers who successfully used their talents to promote Florida. They helped to create a ripple that has today grown into a tsunami, as hordes of new residents and visitors descend upon the state on a daily basis. To counter the effects of this sea of humanity and its demands on the state's water resources, a group of modern writers and artists use their talents to protect, preserve, and document the condition of Florida's waters, in particular its springs.

Margaret Ross Tolbert, for example, is a Gainesville-based artist who paints enormous canvases of Florida springs that seem to capture their vital essence. Both complex and simple, abstract yet rich and colorful, Tolbert's paintings are as close as you can get to immersion in a spring while on dry land. Her paintings grace both public and private spaces around the world, and her engulfing installations have awed audiences at museums. Her 2010 book *Aquiferious* combines Tolbert's art, poetry, and prose with contributions from other writers. She also created a Facebook group of the same name that for me was a portal into the world of springs advocacy.

Many talented artists, advocates, and environmental groups contribute to creating more awareness of the tenuous condition of our springs, including the Springs Eternal Project, a series of creative partnerships led by artist and educator Lesley Gamble and photographer John Moran. My association with the project began in 2012 at a serendipitous meeting with Gamble and Moran during a cleanup of Gainesville's Glen Springs. Gamble's projects include a video, "Swimming through Air," the debut of which took place during a performance of the Gainesville Orchestra; the Urban Aquifer project, which wrapped Gainesville buses in photographs of springs; and the Springs Ambassadors Camp, in which sixteen middle-school students spent six days learning more about Florida's springs in 2016.

John Moran's photographs are well known throughout the state, and over time he has created an inventory of springs images that document the springs in their decline. Juxtaposed with contemporary photos of the same springs, Moran's older photos provide powerful visual evidence of the degradation documented by springs science. These then-and-now diptychs formed the foundation of two Springs Eternal exhibits that have traveled the state and been reproduced as a catalogue mailed to Florida lawmakers.

Manatee Springs by Margaret Ross Tolbert, oil on canvas, 84×60 inches, 2008.

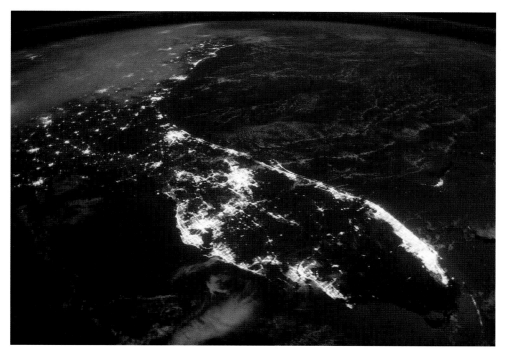

The lights along the coast in this 2014 photo from the International Space Station show our propensity to live near water.

❧ THE CRITICAL CONDITION OF FLORIDA'S COASTS

Florida's coasts have experienced more development than any other geographic region of the state. Although the state's early settlers avoided coastal zones because of the near impossibility of growing crops in sandy soil and salty air, Florida's beaches soon became a symbol of the state once they were "discovered" by visitors arriving via the railroads of Henry Flagler and Henry Plant. Developers such as automotive pioneer Carl Fisher carved out tropical wonderlands like Miami Beach from mangrove swamps, and in the 1920s Florida boomed as Sunshine State real estate became accessible to more than just the wealthy. To create more beachfront real estate, dredge-and-fill projects destroyed natural ecosystems, creating miles and miles of frontage on canals.

Thanks to devastating hurricanes, the Great Depression started early in Florida, but during the Second World War a whole new generation fell in love with the state and its beautiful white sand beaches when large numbers of soldiers were stationed in Florida, some housed at Gilded Age beachfront hotels. The Don Cesar and Vinoy hotels in St. Petersburg, the Biltmore Hotel in Coral Gables, and Henry Flagler's Breakers in Palm Beach and Hotel Ponce de Leon in St. Augustine were all used by the government for the war effort. After the war the development of the

beach in Florida was "relentless and omnipresent" with the "force of a hurricane," leaving in its wake "high-rise condominiums, time-share resorts, and luxury vacation homes," writes historian Gary Mormino.

Sea bathing for health purposes transitioned into recreational swimming at Florida beaches as access to coasts became easier and modern medical practices replaced alternative cures. But the notion of the beach as a healthful place persists. The state's Visit Florida website brags that "the Sunshine State draws a diverse array of visitors from all over the world, eager to experience a spa-like experience in nature, with the soothing lullaby of waves, sea salt air, the soft song of seagulls and beautiful sunsets and sunrises casting beautiful colors against the sky."

In the summer of 2018, however, many of Florida's beaches were stained an ugly pea-green color from algae blooms, and the sand reeked with the smell of tons of dead marine life, killed by another kind of algae bloom called a red tide. The cause of the red tide was controversial, but it is likely fed by an excess of nutrients in the runoff from agricultural areas surrounding Lake Okeechobee, runoff that eventually flows into the sea. The evolution of agriculture in the region surrounding the huge lake can be traced back to Hamilton Disston, a northern industrialist who sought to drain the Everglades in the 1880s. He ultimately failed, but the Army Corps of Engineers eventually built a series of canals to make it possible for much of the land to be used for the production of sugar cane.

Experts say that as Florida starts to feel the effects of climate change, the likelihood of more intense hurricanes will increase, which in turn will spur more red tides. It is likely there will be more outbreaks of devastating algal blooms to come. Florida's pristine beaches are also vulnerable to sea-level rise, and south Florida is particularly susceptible, with many streets already flooded on a consistent basis by lunar high tides. The health of the salt water and the entrancing beaches that helped to create the popular image of Florida is very much at risk in the immediate future.[3]

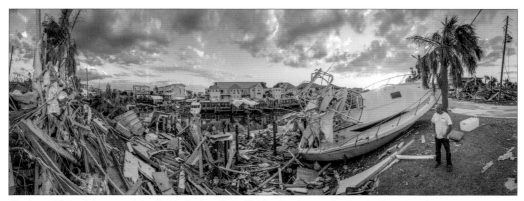

Hurricane Michael devastated the Florida Panhandle in 2018; scientists predict that the intensity of storms is increasing.

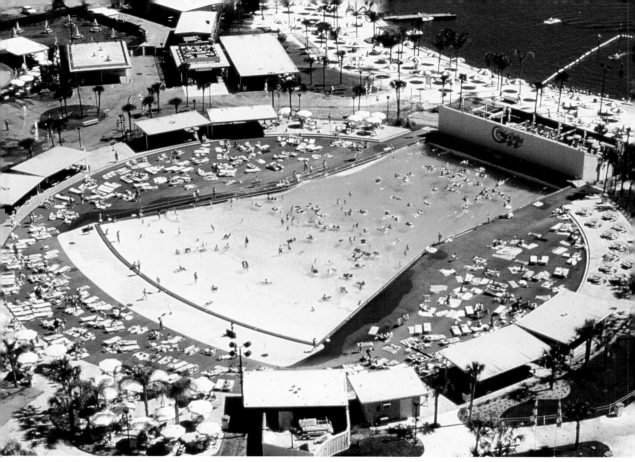

An aerial view shows the wave pool at the Wet 'n Wild water park in Orlando.

WATER PARKS AND MANMADE LAGOONS: SANITIZING NATURE

Florida captured the imagination of readers across the nation in mesmerizing accounts from famous writers. Some described the Land of Flowers as an earthly paradise, in perfect balance with nature. Others saw an unformed world just waiting to be shaped by human hands. Florida was the last state in the East to be developed, and opportunity seemed to abound for all Americans, from homesteaders to freshly minted millionaires. The narrative of Florida as an earthly paradise was exploited by businessmen, who bottled Florida spring water and sent it north, and by railroad barons, who created a system to bring tourists south. Promoters used the natural resources of the state to create a brand—what historian Ray Arsenault has dubbed the Florida Dream: "the centuries-old promise of perpetual warmth, health, comfort, and leisure."

Arsenault expanded his definition to include a Florida dreamscape, which he describes as a "cultural backdrop capable of inspiring a wide variety of dreamlike images and expectations." That description can fit the current brand of Florida, which still includes cerulean water and white sand beaches but is now synonymous

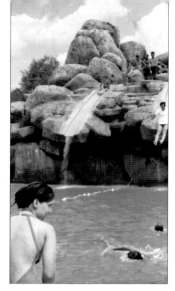

Visitors using water slides at the River Country water park at Walt Disney World, 1977.

with the fantasy and nostalgia offered at theme parks such as Walt Disney World and Universal Studios.

A recent trend focusing on the absurd and horrific in Florida, however, has resulted in the state becoming a national punch line, and stories of alligator attacks and python hunts compete with the ubiquitous "Florida Man" meme for attention. Devastating hurricanes, disease-carrying mosquitoes, and reports of shark attacks also influence the modern-day media consumer's perception of natural Florida. But people flock to the state anyway, at the rate of almost a thousand each day. Today's visitors don't need to venture into the natural world to have an exotic Florida experience, though—they can find one in air-conditioned comfort and in purified chlorinated water. Water parks simulate many of the same experiences that attracted nineteenth-century travelers. Wave pools have replaced sea bathing, and concrete "lazy rivers" offer a more sterile alternative to tubing down spring runs.

In 1977 the Wet 'n Wild water park opened in Orlando, capitalizing on the influx of travelers to central Florida lured by Walt Disney World's opening in 1971. The water park's founder, George Millay, wanted to create a "cleaner" alternative to Disney's River Country, which had opened a year earlier and used "fresh water in an effort to mimic Florida's natural springs," according to a history of Wet 'n Wild. Millay's water park would use chlorinated water, just like in swimming pools. A decade later, Wet 'n Wild was so popular that it was often packed, and Millay created similar water parks all over the country. In 1999 he sold his pioneering Orlando water park to a group that included Universal Studios. At the end of 2016 Universal closed Wet 'n Wild and a year later opened the massive Volcano Bay water park to compete with the themed water parks at Walt Disney World, such as Typhoon Lagoon and Blizzard Beach.

Today's entrepreneurs have found different ways to tap into the desire to be in, on, or near water, much as the state's early promoters used springs and sea to lure tourists. In late 2018 a new housing development north of Tampa called Epperson opened a 7.5-acre manmade lagoon for residents, complete with white sand beaches, tidal pools, and crystal-clear water, emulating a pristine Florida beach. The company that created the pool, Crystal Lagoons, has plans to develop similar complexes throughout the state, including an enormous fifteen-acre project at Lake Nona near Orlando. The company's website proclaims that their vision is to establish "an environment fostering innovation, sustainability, wellbeing and an active lifestyle." While Florida's natural resources are more and more at risk, business interests have created opportunities for Floridians and tourists to experience water in artificial environments.[4]

"THE SOURCE OF INSPIRATION": PRESENT-DAY LINKS TO THE PAST

Modern theme parks often mimic the past, choosing historical themes that have positive associations for visitors. Reproductions of nineteenth-century architecture are scattered throughout Walt Disney World's properties—some with direct connections to Florida history. Disney's Grand Floridian Resort and Spa, which opened in 1988, pays homage to the expansive wooden hotels built in Florida a century earlier—hotels such as the Hotel Ormond in Ormond Beach and the Belleview Biltmore in Bellair. Architects designed the Grand Floridian as a tribute to the "era of the railroad magnates who built new rail routes to Florida," and the monorail leading to the property has been described as a modern version of the railroads that delivered visitors to hotels in Victorian times. This elaborate hotel may be the closest representation still in existence of the scale and grandeur of Florida's Gilded Age resorts and spas.

Elsewhere on Disney property, the towns that sprang to life around spring-based spas such as Green Cove Springs and White Springs in north Florida inspired the basis for the fictitious creation story of Disney Springs, a shopping, dining, and entertainment complex in central Florida that opened in 2015. Expanding upon the shopping complex that was once called Downtown Disney and later a nightclub complex known as Pleasure Island, Disney Springs is centered around an artificial spring run that looks remarkably like the real thing. A bridge traverses the run above the spot where water bubbles up from a manmade, karstlike cave in a

Recent images of the Belleview Inn near Clearwater, the Cafe Alcazar in the former pool of St. Augustine's Hotel Alcazar, and the spring and renovated pool facilities at Green Cove Springs.

basin surrounded by manmade cypress knees and native plants. The planners behind Disney Springs were committed to delivering something as authentic looking as possible after visiting a number of Florida springs, according to Disney Imagineer Theron Skees in a 2017 article: "The idea of a Florida spring represents not only the power and beauty of nature, but optimism and possibilities." The concept of the fictitious town's watery origins can be seen in the enormous letters spelling out "Springs Bottling Co." at the top of a restaurant and on a hand-painted mural touting clear and refreshing "Springs brand mineral waters." Even the seal of the imaginary town of Disney Springs shows the swirl of a spring boil, along with the motto, "the Source of Inspiration."[5]

But throughout the state, vestiges of the golden age of bathing still exist, from the pool at Hampton Springs in the back of a remote county park to the opulent Breakers Hotel in Palm Beach, still an upscale destination, that began as part of Henry Flagler's empire. Some of these places, such as the crumbling cabins at Suwannee Springs, are ephemeral relics that won't be around much longer. Others, such as the restored Belleview Inn near Clearwater, are the result of a conscious effort to preserve our past for future generations to enjoy.

Photographers John Moran and David Moynahan created this image of the pool at Hampton Springs illuminated at night in 2014.

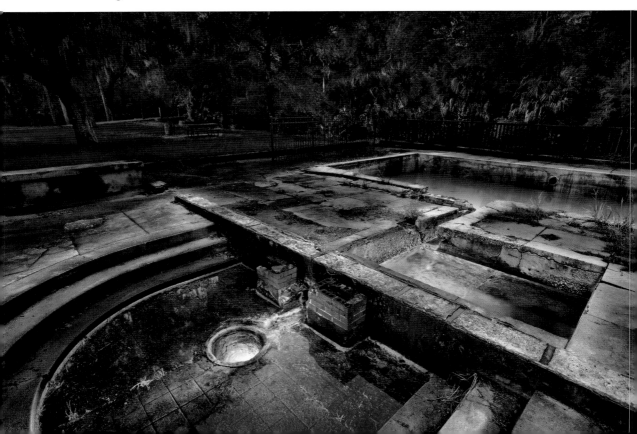

According to the promoters of Indigo Float Orlando, floating in one of their floatSPA pods delivers a long list of physical, emotional, and cognitive benefits.

🌀 HARNESSING WATER'S HEALING POWERS TODAY

Well-being and wellness are the terms often associated with modern-day equivalents of hydropathy, and a day at a contemporary spa has become the most common modern version of a stay at a Victorian-era water cure or sanitarium. The modalities have changed with the times, of course: one treatment that seems to be booming is a sensory-deprivation chamber known as a "floatSPA pod." The water in these pods is loaded with Epsom salt (magnesium sulfate), a compound originally discovered in seventeenth-century Epsom, England, which subsequently became one of Britain's premier spa towns. The list of benefits achieved from soaking in these isolation tanks is really not all that different from those promoted at nineteenth-century Florida spas—the experience reportedly can help with muscular pain, rheumatism, fatigue, headaches, injury, and stress-related illnesses.

A more rapid delivery system for fluids and minerals is available at spas that administer vitamins and minerals intravenously for "performance, recovery, and wellness needs." One such spa in Jacksonville Beach offers a "Fountain of Youth" treatment said to offer hydration, promote healthier skin, reduce inflammation, and assist in detoxification. Float baths and intravenous infusions are modern modalities

that capitalize on the healing qualities of water and minerals and are part of the continuum of medical history utilizing water that goes back thousands of years.

While these therapies may seem alternative, Orlando journalist Kayla O'Brien suggests that they are becoming more mainstream, as self-care is now considered a desirable option to use, either alongside or instead of doctors and "big pharma." Irregular medicine thrived in this country during an era of democratization spurred by the election of Andrew Jackson in the first half of the nineteenth century. Reform movements and a "proliferation of medical systems and alternative routes to wellness" promised a "clear path to health and wellness." A similar atmosphere exists today as spiraling costs of health care have opened the door for more unconventional medical treatments and philosophies related to water in the pursuit of wellness.

The medical field is united in acknowledging the importance of drinking enough water to ensure that one's body functions properly—water acts as a lubricant for bones and tissues, assists with digestion, and boosts energy and brain function. Familiar rehabilitative practices used by athletes, such as hot footbaths or ice baths, are vestiges of water therapies first developed in Europe. Along with such relatively commonplace practices, alternative perspectives about the fundamental nature of water have reconnected people to the sense of mystery and awe with which ancient people regarded this magical liquid. In the mid-twentieth century Theodor Schwenk, a German-born engineer, created an institute to study the "life-giving forces of water and its movement" and re-examine water's "spiritual nature." The work of Masaru Emoto, a Japanese doctor of alternative medicine, gained popularity in 2004 when he proposed that ice-crystal formation could be manipulated by forces outside the water. The acceptance of alternative ideas related to water confirms that in the minds of many people, medical science has not removed all the magic from water.[6]

RECREATING A WATERY PARADISE

In 1791 William Bartram wrote that no other place on earth "affords a greater plenty of pure, salubrious waters" than Florida. Over the next two centuries, millions of people of European descent followed in his footsteps, attracted by the very waters he described. In 1929, less than 150 years after Bartram's enticing description, a naturalist named John Kunkel Small observed the rampant development of the place Bartram had extolled. Small's book, *From Eden to Sahara: Florida's Tragedy,* predicted dire consequences if the state's groundwater continued to be exploited.

Because the belief that development can "improve" Florida has been the dominant narrative throughout the state's history, the perspective that the state is an earthly paradise has often been overpowered, reduced to a marginalized voice in the

wilderness. Important Florida environmentalists such as Marjory Stoneman Douglas and Marjorie Harris Carr have had victories—creating Everglades National Park and stopping the Cross Florida Barge Canal, for example. But developers still have carte blanche most of the time, and the state's waters are often seen only as resources for agriculture, recreation, and industry or as an amenity for further development. "Water, in Western cultural theory, is a resource," argues anthropologist David Groenfeldt, "like coal or oil or phosphate or gold." In the indigenous tradition, in contrast, water is viewed as an important element of life—water *is* life for many indigenous people—and it is viewed through a spiritual rather than an economic lens. Florida's earliest inhabitants surely viewed water as sacred.

If Florida's healing waters are to be healed, a paradigm shift needs to occur in the very way water is perceived. If more Floridians can return to the viewpoint of ancient cultures who saw themselves as connected to water and the environment, rather than seeing themselves as separate from the natural world, there is an opportunity to preserve our water resources. Environmental journalist Cynthia Barnett writes of creating a "water ethic," a consciousness-shifting reconnection to water, akin to the anti-litter efforts of the 1970s that successfully helped the nation "Keep America Beautiful." This "mental shift" requires what Barnett calls a Blue Revolution, resulting in infrastructure changes and correcting the way we build on the land to make it more water-friendly. "Water is the defining element—the essential elixir—of the good life here in Florida," Barnett writes—"it's what brought us here and what keeps us here."

We can glean much from the stories of Florida's healing waters—perhaps even a prescription for healing them in the future. These stories of sacred waters reveal a pattern of use and abuse that cannot continue without detrimental effects. In the twenty-first century, if we want to preserve this paradise known as Florida, our charge is to become stewards of our water-rich Shangri-La.[7]

According to a Slovakian proverb, pure water is the world's first and foremost medicine. Photo of Gilchrist Blue Springs.

ACKNOWLEDGMENTS

Thanks first to my wife, Julie, my willing adventure partner who accompanied me on research trips from Panacea Springs in the Florida Panhandle to Queen Victoria's beach in Britain. I am extremely grateful for her support and good company.

Thanks, too, to Joy Wallace Dickinson for her mentorship and editorial prowess and to photographer John Moran, who has been incredibly generous in allowing me to use his remarkable photos. John also introduced me to Meredith Babb and the University Press of Florida, for which I am eternally grateful. Author and photographer Gary Monroe put in a good word for me as well. Thank you to Meredith and to the UPF staff for working with me and adding so many important Florida history titles to their catalogue every year. And thanks to Lesley Gamble, Ph.D., for allowing me to contribute to the Springs Eternal Project and its work promoting awareness of our state's springs.

I am constantly inspired by many of the springs advocates who reside in north Florida, including artist Margaret Ross Tolbert, writer Lu Merritt, the Sierra Club's Merrillee Malwitz-Jipson, and the omnipresent Karen Chadwick. Kudos also to writer Cynthia Barnett and Dr. Robert Knight for all they do to raise awareness and propose solutions for Florida's water issues.

Much of the research for the book was undertaken as I prepared talks that expanded on my earlier book, *Finding the Fountain of Youth: Ponce de León and Florida's Magical Waters,* also published by the University Press of Florida. I acquired a better understanding of the sacred origins of water because of the "Myth and Magic" talks I gave at the Center for Earth Jurisprudence in Orlando, and much of the health content in this book sprang from research for a talk at the Matheson History Museum in Gainesville. Thanks to Jane Durocher, most recently of the St. Johns Riverkeeper, and to Peggy Macdonald, formerly of the Matheson History Museum, for setting up those talks. Matheson staff have been very generous with permission to use images from the museum's extensive collection of postcards, stereographs, and print ephemera.

The Clay County Archives in Green Cove Springs serves as a key resource for the stories of both Green Cove and Magnolia Springs, and Archives Specialist Vishi Garig was extremely helpful in my work there. Christopher Mark Esing also graciously shared his knowledge and images. Thanks, too, to the Orange County Regional History Center for its support, to the archives at the St. Petersburg Museum of History and the Pinellas County Heritage Village, and to Jean Barraclough for sharing her extensive knowledge of Safety Harbor history. In Florida we are fortunate to have two incredible resources that were most helpful as well: the Florida Memory program of the State Library and Archives in Tallahassee and the P. K. Yonge Library of Florida History at the University of Florida in Gainesville.

Finally, thanks to my family, friends, and clients who made this book possible.

NOTES

Chapter 1. The Healing Power of Water: Connections to Ancient Sacred Tradition

1. Sacred Origins: Milanich, *Florida's Indians*, 4–5; Wentz and Gifford, "Florida's Deep Past: The Bioarchaeology of Little Salt Spring"; O'Donoughue, *Water from Stone*, 12, 129, 137; Vanderhill, "Historic Spas of Florida"; Rambler [pseudonym], *Guide to Florida* (New York: American News Company, 1875).

2. Old World Water Worship: Buxton, *Imaginary Greece*, 110; Croutier, *Taking the Waters*, 18; Aldrete, *Daily Life in the Roman City*, 110.

3. Aquae Sulis: "The Essential Roman Baths" (promotional booklet), 32.

4. Sacred Water Around the World: Foglino and Troeller, *Spa Journeys*, 93; Croutier, *Taking the Waters*, 90. "Water and Hinduism," *All You Need to Know about Hinduism* (blog), June 2010, http://history-of-hinduism.blogspot.com/.

5. From Myth and Magic: Croutier, *Taking the Waters*, 115.

6. Spa Culture in the New World: Joki, *Saratoga Lost*, 1.

7. From Subterranean Caves: Knight, *Silenced Springs*, 19, 24.

Chapter 2. Promoting Paradise: Natural Features Give Rise to Medical Tourism

1. Introduction: O'Sullivan and Lane, *Florida Reader*, 12; Nester, "Healers and Dealers," 90–102.

2. British Promote Settlement: O'Sullivan and Lane, *Florida Reader*, 50; Nelson, *General James Grant*; Tebeau and Marina, *History of Florida*, 66; Fabel, "British Rule," 136, 141; O'Connor and Monroe, *Florida's American Heritage River*, 75.

3. The Bartram Effect: Fabel, "British Rule," 136–37; O'Connor and Monroe, *Florida's American Heritage River*, 54, 97; "John Bartram's Travels on the St. Johns River, 1765–1766," Florida History Online, https://www.unf.edu/floridahistoryonline; Bartram, *Travels*, 159–60; Schafer, *Bartram and the Ghost Plantations*, 26, 128; Derr, *Paradise*, 254.

4. Florida's Territorial Period: Gannon, *New History of Florida*, 108, 207; Gannon, *History of*

Florida in 40 Minutes, 17; Tebeau and Marina, *History of Florida*, 79.

5. Nineteenth-Century Travel: Grunwald, *The Swamp*, 31; O'Sullivan and Lane, *Florida Reader*, 82; Sears, *Sacred Places*, 3; "Timeline," *TBAlert: For a Future Without Tuberculosis* (blog), https://www.tbalert.org/; Barrett, "The Romance of Tuberculosis."

6. Steamboat Travel: Derr, *Paradise*, 68; McIntyre, *Souvenirs of the Old South*, 15; "The Steamships of Jacksonville," July 2, 2012, https://www.metrojacksonville.com/; Bass, *When Steamboats Reigned*, 3, 8, 9, 11; Jim Robison, "Business Ventures Lend City Name, Life," *Orlando Sentinel*, March 29, 1992; Walters, *Story of Thornby*, 15; Belleville, *River of Lakes*, 61.

7. Letters from the Frontier, Emerson: Williams, *Territory of Florida*, 16, 17, 148; O'Sullivan and Lane, *Florida Reader*, 76; Griffin, "Emerson in St. Augustine."

8. Promoting America's Italy: Tebeau and Marina, *History of Florida*, 183, 246; Revels, *Sunshine Paradise*, 6; Kelley, *Old South and the New*, 17; Derr, *Paradise*, 310; Stronge, *Sunshine Economy*, 78, 132, 173.

9. The Yankee Proselytizer and the Consumptive Confederate: Foster and Foster, *Calling Yankees to Florida*, 12; "Florida Fables and Harriet Beecher Stowe," *Jacksonville Historical Society* (blog), November 15, 2011, https://jaxhistory.wordpress.com/; "Uncle Tom's Cabin: A 19th-Century Bestseller," *Publishers' Bindings Online, 1815–1930: The Art of Books*, http://bindings.lib.ua.edu/gallery/uncletom.html/; Bass, *When Steamboats Reigned*, 55.

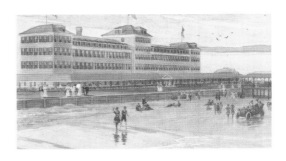

10. Spa Society Comes to Florida: "Gate City" Route, South Florida Railroad brochure; "Fountain of Youth," *Pensacolian,* June 2, 1888, 1.

Chapter 3. Restorative Springs near the St. Johns: Healing Waters along Florida's Heritage River

1. VisitJacksonville.com/media/fast-facts/; Knight, *Tropic of Hopes,* 49.

2. On Magnolia Springs: Hooper, *Clay County;* http://archives.clayclerk.com/magnolia-springs/; "War-Time Letters from Seth Rogers, M.D.," Florida History Online, unf.edu/; promotional brochure for Magnolia Springs, 1890, Clay County Archives, Green Cove Springs, FL; E. H. Sellards and Herman Gunter, 1912 Florida Geological Survey; Rosenau et al., *Springs of Florida,* 97; Vanderhill, "Historic Spas of Florida."

3. Green Cove Springs: Bill, *A Winter in Florida;* "Fragrant Florida," *Courier-Journal* (Louisville, KY), April 16, 1882; Blakey and Deaton, *Parade of Memories,* 155; Heather Hause, "Fountains of Youth: Medical Tourism in Green Cove Springs, Florida, 1845–1900," manuscript, Clay County Archives, Green Cove Springs, FL, 23; Revels, *Sunshine Paradise,* 18; Hooper, *Green Cove Springs,* 64–65; "Pocket Directory of Green Cove Springs, 1889, University of Florida Digital Collections, http://ufdc.ufl.edu/.

4. Wadesboro Spring: Hooper, *Clay County;* "Orange Park, Florida," 1879 monograph, University of North Florida, Florida Heritage Collections, PALMM Digital Collections, https://palmm.digital.flvc.org/; Mary Jo McTammany, handout on Wadesboro history (at The Springs development); *Troy Messenger* (Troy, AL), April 11, 1878; Jeffrey Dalton Cummings, "Living at the Springs: A Historical Journey," accessed through The Springs website; Blakey and Deaton, *Parade of Memories,* 149; Dr. W. Gano, "Florida, the healthiest state in the union. Orange Park, near Jacksonville, one of its greatest attractions," https://lccn.loc.gov/tmp96008653.

5. Moncrief Springs: Vishi R. Garig, "Leonidas E. Wade 1858–1938: A Clay County Lawyer," in "This Month in Clay County History," www.bluetoad.com; Blakey and Deaton, *Parade of Memories,* 149; Cowart, *Crackers and Carpetbaggers;* "The Lost Story of Jacksonville's Moncrief Park," December 30, 2015, https://www.

metrojacksonville.com/; Tim Gilmore, "Moncrief Springs: Three Corinthian Columns," *Jax Psycho Geo* (blog), June 16, 2012, https://jaxpsychogeo.com/.

6. Welaka Springs: O'Sullivan and Zhang, *A Trip to Florida;* Michaels, *The River Flows North;* "Lodge Demolished," *Tampa Tribune,* March 19, 1978; Ormund Powers, "In Times of War and Peace, Welaka Has Had a Colorful History," *Orlando Sentinel,* May 27, 1998; Alvers, *Welaka.*

7. Orange Spring: National Register of Historic Places Registration Form, Orange Springs Methodist Episcopal Church and Cemetery (npgallery.nps.gov, accessed April 1, 2018); *Lancaster News* (Lancaster, SC), June 6, 1855; *Fayetteville Observer* (Fayetteville, NC), April 9, 1855; Hubbard Hart, findagrave.com; National Register of Historic Places Registration Form, James W. Townsend House, Lake Butler, FL (npgallery.nps.gov, accessed April 4, 2018); *Ocala Evening Star,* August 27, 1915.

8. Ponce De Leon Springs: Brian L. Polk, "De Leon Springs State Park: Its Many Layers of History from 6,000 Years Ago to 1982," Florida Department of Environmental Protection; Francke et al., *Volusia;* Robert Sitler, "Immersed in the Millennial History of DeLeon Springs," *Journal of Florida Studies* 1, no. 6 (2017); Phil Gotschall and Fred Allen, "Healing Waters: A History of DeLeon Springs," 2nd ed. (2005), pamphlet in author's collection; "Historic De Leon Springs Threatened by High-Rises," *Orlando Sentinel,* November 9, 1973.

9. On the springs at Enterprise: Speir, *Going South,* 197; O'Sullivan and Zhang, *A Trip to Florida;* Thomas W. Fryer Jr., "The Story of Enterprise," research project, Daytona Beach Junior College, May 1960; Francke et al., *Volusia;* "History of Benson Springs Is Related," *Orlando Evening Star,* March 23, 1927.

10. Wekiwa Springs: Robison and Belleville, *Along the Wekiva River; Orlando Evening Star,* May 1, 1884; Jim Robison, "Steamboats on Wekiva Helped Build Community," *Orlando Sentinel,* December 15, 1991; "The Orange Land," *Atlanta Constitution,* September 14, 1875; *Orlando Sentinel,* October 1, 1925.

11. Altamonte Springs: Jim Robison, "Early Travel Writers Waxed Poetic about Florida's Rivers," *Orlando Sentinel,* July 12, 1992. Shofner, *History of Altamonte Springs,* 52, 56, 199; Sherman Adams, ed., *Orangeland: A Description of the Topography, Climate, Soil, Productions, Resources, Advantages, Opportunities, Prospects, and General Characteristics of Orange County, Florida* (Orlando, FL, 1883–84).

Chapter 4. The Healing Spas of North Florida: Health Resorts from the Big Bend to the Suwannee Valley

1. Introduction: Webber, *Eden of the South.*

2. White Springs: Vanderhill, "Historic Spas of Florida," 61–62; "History of the Town of White Springs," whitesprings.org/; Rosenau et al., *Springs of Florida,* 137; Petty, *Hamilton County,* 106–7; White Springs brochure, collection of Christopher Mark Esing; White Sulphur Springs Water brochure, author's collection.

3. Suwannee Springs: Vanderhill, "Historic Spas of Florida," 62–63; "A Magnificent Hotel," *Atlanta Constitution,* June 24, 1883, 9; Steven Cohen, "Suwannee Springs Dreamland Now Just Faded Memories," *Suwannee Democrat,* August 12, 1980; Tami Stevenson, "Forgotten Suwannee Springs Once Drew Thousands—Now in Danger of Disappearing," *Suwannee Valley Times,* December 2011, http://www.suwanneevalley-times.com/; "A Florida Hotel Burned," *New York Times,* January 17, 1884; Allen Candler and Clement Evans, eds., *Georgia* (Atlanta, GA: State Historical Association, 1906), https://archive.org; Suwannee Springs promotional brochure, Florida Ephemera Collection, Yonge Library, University of Florida, Gainesville; *Montgomery Advertiser* (Montgomery AL), June 15, 1902, 14.

4. Hampton Springs: "Hampton Springs: Florida's Most Beautiful Year 'Round Retreat," brochure, Florida Ephemera Collection, Yonge Library; "Once-Famed Health Resort on Comeback Trail in Taylor," *Tallahassee Democrat,* May 26, 1946, 20; Donald R. Hensley Jr., "The South Georgia Railroad," *Taplines: Shortline and Industrial Railroading in the South* (blog), n.d., http://www.taplines.net/; Hampton Springs ad, *Chicago Tribune,* January 26, 1926, 22; Hotel Hampton ad, *Montgomery Advertiser,* June 9, 1912; "Acquire Hampton Springs Property," *Tallahassee Democrat,* August 17, 1927, 1.

5. Worthington Springs: Vanderhill, "History Spas of Florida," 67; Mrs. Albert Miller, "Worthington Springs History," *History of Union County, Florida, 1921–1971* (Lake Butler Woman's Club, 1971), Orlando Public Library; "Worthington Springs," in "Alachua County History & Nearby Communities," ChazzCreations Limited—40 Years (blog), n.d., http://www.chazzcreations.com/; "Masons Celebrate with Great Picnic," *Tampa Bay Tribune,* June 27, 1910, 8; "Concert Enjoyed by Hotel Guests," *Weekly Tribune* (Tampa), August 4, 1910, 5.

6. Dowling Park: Gary Kirkland, "Magic of the Springs," *Gainesville Sun,* June 10, 2004, http://www.gainesville.com/; Eric Musgrove, "Thomas Dowling: Suwannee County Biography," *Suwannee County Democrat,* October 25, 2013, http://www.fl-genweb.org/; *Live Oak Daily Democrat,* September 21, 1906, 5; "Dowling Park: Florida's First Retirement Community," The Florida Memory Blog, June 9, 2013, https://www.floridamemory.com/; "Dowling Park," *Desolation Florida* (blog), January 30, 2016, http://www.desolationflorida.com/

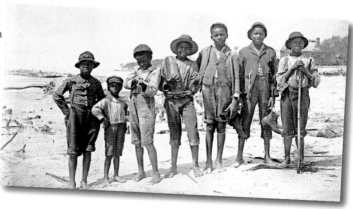

Chapter 5. Mineral Springs near the Gulf: Spring-Based Spas near America's Sea

1. Introduction: Davis, *The Gulf*, 7.

2. Newport Springs: Davis, *The Gulf*; Vanderhill, "Historic Spas of Florida"; "Daniel Ladd and the Hamlins of Frontiers Florida," *Ladd Family* (blog), http://www.laddfamily.com; *Weekly Advertiser* (Montgomery, AL), December 5, 1889, 5; "Wakulla Is Ready for Homecoming," *Tallahassee Democrat*, March 12, 1930, 1.

3. Panacea Springs: "Panacea's Past Is Remembered," *Tallahassee Democrat*, July 8, 1962, 16; Vanderhill, "Historic Spas of Florida," 69.

4. Lanark Springs: http://www.floridamemory.com/blog/2015/01/09/lanark-by-the-sea/; Lynette Norris, "History of Lanark Village," July 9, 2015, *ECB Publishing: Home of the Monticello News and Jefferson Journal* (blog), http://www.ecbpublishing.com.

5. Espiritu Santo Springs: Firschein and Kepner, *Brief History of Safety Harbor*; "Green Springs a Tented City," *Tampa Bay Times*, September 15, 1904; "The History of Natural Mineral Springs," Safety Harbor Resort and Spa; "Espiritu Santo: Springs of the Holy Spirit," *Weekly Tribune* (Tampa), August 15, 1907, 6; Espiritu Santo Springs promotional booklet created by Capt. Tucker, 1910, in author's collection.

6. Wall Springs: Richard Danielson, "Wall Springs: Old Place, New Face," *Tampa Bay Times*, Seminole Times edition, April 16, 2001, 1; "Wall Springs," *Tampa Tribune*, August 28, 1907, 3.

7. Sulphur Springs: Walter C. Williams, ed., *Rinaldi's Guide Book to the City of Tampa* (Tampa: Rinaldi Printing Company, 1915), 42; "Yes It's True," *Weekly Tribune* (Tampa), August 17, 1899, 3; https://www.tampapix.com/watertower.htm; Craig Pittman, "Tampa's Sulphur Springs Too Far Gone, Experts Say," *Tampa Bay Times*, November 3, 2012.

8. Manatee Mineral Spring: Canter Brown Jr., quoted in Isaac Eger, "Angola's Ashes: A Newly Excavated Settlement Highlights Florida's History as a Haven for Escaped Slaves," *Sarasota Magazine* (July 2018). See Manatee County Public Library System for Carl D. King, "A Tour of The Historic Old Manatee Village," 1976; Robert E. King, "Medicine in Manatee County," May 21, 1980; and "Manatee County Historical

Interview with John Crews Pelot and Mrs. John Crews Pelot," January 10, 1973. See also Jim Gallery, "The Spring That Was a Prescription," *Palm Beach Post*, June 26, 1960.

9. Warm Mineral Springs: "Historic and Architectural Evaluation Report for the City of North Port Prepared by DMK Associates," May 20, 2016, 24; *Tampa Tribune*, August 15, 1924, 9; Bill Blalock, "Balloonist Disappears in Florida Mystery Pool," *Tampa Tribune*, December 18, 1938, 52.

10. "Have you heard of Milwaukee Springs?" Florida Memory Blog, June 16, 2014, https://www.floridamemory.com/.

Chapter 6. Drinking Florida Mineral Water: Liquid Cure-Alls from the Aquifer

1. St. Petersburg's Fountain of Youth: Arsenault, *St. Petersburg and the Florida Dream*; Will Michaels, *The Making of St. Petersburg* (Charleston: History Press, 2012); "How Waterfront Spring Won Name Fountain of Youth," *Tampa Bay Times*, January 7, 1923; "Huge Shark Is Captured," *Tampa Tribune*, April 4, 1909; Will Michaels, "Babe Left Mark Here," *Tampa Bay Times*, February 26, 2014; "Comes Here on Crutches but Now He Is Walking," *St. Petersburg Daily Times*, April 27, 1919; "Woman Inquires Carload Rates on 'Youth' Water," *St. Petersburg Times*, January 22, 1925, 1; Art Levy, "Cashing in on the Fountain of Youth: 'Magical' Waters Tied to Ponce de Leon Can Be Found Throughout Florida," August 27, 1985, *Florida Trend*, https://www.floridatrend.com.

2. Punta Gorda's Radioactive Artesian Well: Jackie Snow, "Florida's Radioactive Fountain of Youth May Prolong Life," July 25, 2013, *National Geographic*, https://news.nationalgeographic.com; Mary Hickert, "Taylor Street Well Has High Radium Count," *Charlotte News Press* (Ft. Myers), June 30, 1983, B1; Peter Gallagher, "Millions Follow Ponce de Leon's Tracks," *Tampa Bay Times*, April 13, 1983, D1.

3. Award-Winning Orange City Mineral Water: Peter Gallagher, "Thirsty? Head to Orange City," *Orlando Sentinel*, February 21, 2001; "Orange City Town History," http://www.ourorangecity.com; *New Smyrna Daily News*,

December 5, 1919; https://www.ourorangecity.com/departments/utilities/.

4. Magnesia Springs: Mary Ann Sebrey, "Magnesia Springs: 82 Years in One Family," *Gainesville Sun*, July 20, 1975; Moore, *Magnesia Springs;* "Death of a Good Man," *Gainesville Daily Sun*, December 19, 1906, 3.

5. Other Florida Mineral Waters: Ad in *DeLand News*, March 6, 1903; "The Plan to Save the Fenholloway," *Tallahassee Democrat*, March 12, 2006, 1; "Splendid Mineral Water," *Tampa Tribune*, October 28, 1909; "Beautiful Chumuckla Springs Where Nature's Magic Touch Brings Healing," *Pensacola News Journal*, June 7, 1914, 9; "Healing Powers of Heilbron [sic] Water Discovered by Accident by Early Settlers," *Bradford County Telegraph*, n.d., 1989, Union County Historical Society, Lake Butler, FL.

Chapter 7. Sea Bathing in Florida: Discovering the Healing Power of Salt Water

1. Chapter introduction: Mormino, *Land of Sunshine*, 303; Lencek and Bosker, *The Beach*, 76.

2. From Hot Springs to the Cold Sea: [Smithsonian Institution], *Journey: An Illustrated History of Travel*, 204; Wittie, *Scarbrough Spaw;* Jack Binns, "Dr. Robert Wittie," *Scarborough News* (North Yorkshire, UK), June 3, 2001; "Floyer and the Medical Importance of Bathing," www.revolutionaryplayers.org.uk; Floyer and Baynard, *Psychrolousia;* Gilbert, *Brighton*, 16; on belief in the revitalizing shock: Lencek and Bosker, *The Beach*, 71.

3. Seaside Resorts Come to America: Lencek and Bosker, *The Beach*, 154; Wiltse, *Contested Waters*, 15.

4. The Rise of the Beach in Florida: Frisbie, *Florida's Fabled Inns*, 151; Chipley, *Pensacola*, 9; Bliss, *Pensacola of To-day;* advertisement, brochure, Amelia Island Museum of History, Fernandina Beach, FL; Hicks, *Amelia Island*, 46–48; Fort George Island Company, *A Winter at Fort George, Florida* (Boston, MA: W. G. Crawford, 1886); Brown, *Book of Jacksonville*, 120, 144 (Pablo Beach); "A Pictorial Review of Activities Conducted Under Auspices of the Clara White Mission," https://digitalcommons.unf.edu/eartha_books/1 (Eartha White); Martin, *Florida During the Territorial Days*, 185; Graham, *Mr.*

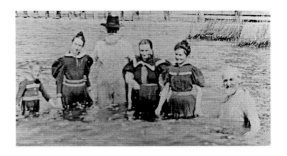

Flagler's St. Augustine, 12; "Pacetty & Monson," *56 Marine* (blog), https://56marine.weebly.com/.

5. Flagler Invents the Florida Resort: Revels, *Sunshine Paradise*, 43; Graham, *Mr. Flagler's St. Augustine*, 44, 192; "Ormond Hotel," http://www.historic-structures.com/; Stronge, *Sunshine Economy*, 50; "Florida East Coast Illustrated," brochure, http://palmm.digital.flvc.org; Braden, *Architecture of Leisure*, 130, 219–20, 235; Rinhart and Rinhart, *Victorian Florida*, 164.

6. Sea Bathing in the Gulf of Mexico: "Pass-a-Grille Historic Sites Survey"; Arsenault, *St. Petersburg and the Florida Dream*, 80.

7. Finding Flagler and Plant in Florida Today: "The Hotel Belleview: The Gilded Age's White Queen on the Gulf," in "The Belleview Inn Story," https://www.thebelleviewinn.com/.

Chapter 8. The Cold-Water Cure in the Sunshine State: Hydropathy in Florida

1. Chapter introduction: Cayleff, *Wash and Be Healed*, 7; Janik, *Marketplace of the Marvelous*, 6.

2. The Birth of Irregular Medicine: Cayleff, *Wash and Be Healed*, 12; "The Origin of Graham Crackers," https://www.snopes.com/.

3. Origins of the Cold-Water Cure: Cayleff, *Wash and Be Healed*, 21; Schwarz, *John Harvey Kellogg*, 23; Cayleff, *Wash and Be Healed*, 25.

4. Yungborn: A Return to Nature: Twain, "Osteopathy," *Mark Twain's Speeches*, February 27, 1901; Lust, *Collected Works of Dr. Benedict Lust*, ix; Kneipp, *My Water-Cure*, 19; Kirchfeld and Boyle, *Nature Doctors*.

5. Qui-Si-Sana: The Winter Yungborn: Kirchfeld and Boyle, *Nature Doctors;* "Cold Douche," http://www.traditionalhydrotherapy.com/; Shofner, *History of Apopka*, 158.

6. The Water Cure Reform Movement: Cayleff, *Wash and Be Healed*, 94.

7. From the Second Coming to a Breakfast Revolution: Wilson, *Dr. John Harvey Kellogg*, 6, 38; Andress, *Adventist Heritage*, 67.

8. Dr. Kellogg Brings His Sanitarium South: "The Battle Creek Idea," http://www.heritage-battlecreek.org/; *Miami News*, September 22, 1930, 1; Bramson, *Curtiss-Bright Cities*, 82; "The World Famous Dr. Kellogg Tells Here the Most Amazing Health Story Ever Told," brochure for the Florida Citrus Commission, 1936, author's collection; "Hotel Country Club (Fairhavens)," http://www.miamisprings-fl.gov/; Schwarz, *John Harvey Kellogg*, 81.

9. Looking for Dr. Cornflake: "John Harvey Kellogg," http://eugenicsarchive.ca/.

10. The Adventists' Central Florida Sanitarium: Eve Bacon, *Orlando: A Centennial History* (Chuluota, FL: Mickler House, 1975), vol. 1, 239; *Florida Hospital Through the Years*, privately published by the hospital, 8.

11. From Sanitarium to Spa: *Orlando Sentinel*, October 9, 1928, 4; "Sun-Ray Park Hotel to Open Tomorrow," *Pittsburgh Press*, December 31, 1933, 9; Braden, *Architecture of Leisure*, 178, 276; "Alcazar baths" brochure, Florida Historical Society Archives, Cocoa; Graham, *Mr. Flagler's St. Augustine*, 192; "Lightner Swimming in History," *St. Augustine Record*, November 16, 2010, https://www.staugustine.com; Braden, *Architecture of Leisure*, 276; Tampa Bay Hotel brochure, Florida Ephemera Collection, Yonge Library.

12. Mind, Body, and Spirit: Carla Joinson, "Water Therapy," *Indians, Insanity, and American History Blog*, http://cantonasylumforinsaneindians.com/.

Chapter 9. Population Booms and Algae Blooms: The Future of Florida's Healing Waters

1. Chapter introduction: "Florida Park Service Economic Impact Assessment, 2016–2017," https://floridadep.gov/sites/; Nichols, *Blue Mind*.

2. Historical Waters Ailing Today: Knight, *Silenced Springs*, 53; Bob Knight, "Too Polluted to Drink," *Gainesville Sun*, November 7, 2008, http://www.gainesville.com.

3. The Critical Condition of Florida's Coasts: Jon Wilson, "Famous Florida Resorts Served Soldiers in Time of War," https://www.visitflorida.com; Mormino, *Land of Sunshine*, 323; "Florida Beaches," https://www.visitflorida.com/en-us/florida-beaches.html; Maya Wei-Haas, "Red Tide Is Devastating Florida's Beaches. Are Humans to Blame?" August 8, 2018, *National Geographic*, http://www.nationalgeographic.com.

4. Waterparks and Manmade Lagoons: Hardin and Monroe, *Imagining Florida*, 10; Amanda Kondolojy, "After Forty Years, Universal Is Shutting Down the World's First Modern Water Park. Here's Why," *Theme Park Tourist*, June 3, 2016, https://www.themeparktourist.com; "Crystal Lagoons' Project in Orlando Will Have the Largest Crystal Clear Lagoon in the US," http://www.crystal-lagoons.com.

5. "The Source of Inspiration": Chuck Mirachi, "The History of Disney's Grand Floridian Resort," *Huffington Post*, July 18, 2017, https://www.huffpost.com; Jim Korkis, "Walt Disney World Chronicles: Disney Springs Backstory," *All Ears*, December 5, 2017, http://allears.net.

6. Harnessing Water's Healing Powers Today: https://purehydrationspa.com/about/faqs/; Kayla O'Brien interview via Facebook Messenger, January 5, 2019; Janik, *Marketplace of the Marvelous*, 13; Schwenk and Schwenk, *Water: The Element of Life*.

7. Recreating a Watery Paradise: Bartram, *Travels*, 194; Groenfeldt, "Water Development and Spiritual Values," 6; Cynthia Barnett, "Our Water. Our Florida," Collins Center for Public Policy brochure, and Barnett, *Blue Revolution*.

SELECTED BIBLIOGRAPHY

Aldrete, Gregory S. *Daily Life in the Roman City: Rome, Pompeii, and Ostia.* Norman: University of Oklahoma Press, 2009.

Altman, Nathaniel. *Healing Springs: The Ultimate Guide to Taking the Waters.* Rochester, VT: Healing Arts Press, 2000.

Alvers, Nancy Cooley. *Welaka at the Turn of the Century.* Welaka, FL: Welaka Inc., 1987.

Ammidown, Margot. "Edens, Underworlds, and Shrines: Florida's Small Tourist Attractions." *Journal of Decorative and Propaganda Arts* 23 (1998): 238–60.

Andress, William C. *Adventist Heritage of Health, Hope, and Healing.* Fort Oglethorpe, GA: TEACH Services Inc., 2013.

Arsenault, Raymond. *St. Petersburg and the Florida Dream, 1888–1950.* 1988; 2nd ed. Gainesville: University Press of Florida, 2018.

Barnett, Cynthia. *Blue Revolution: Making America's Water Crisis.* Boston: Beacon Press, 2011.

Barrett, Michael. "The Romance of Tuberculosis," *Aeon,* May 13, 2017, https://theweek.com/.

Bartram, William. *Travels and Other Writings,* edited by Thomas P. Slaughter. New York: Library of America, 1996.

Bass, Bob. *When Steamboats Reigned in Florida.* Gainesville: University Press of Florida, 2008.

Belleville, Bill. *River of Lakes: A Journey on Florida's St. Johns River.* 2nd ed. Athens: University of Georgia Press, 2018.

Bill, Ledyard. *A Winter in Florida; or, Observations on the Soil, Climate, and Products of our Semi-Tropical State.* New York: Wood and Holbrook, 1869.

Blakey, Arch Fredric, and Bonita Thomas Deaton. *Parade of Memories: A History of Clay County, Florida.* 1976; 2nd ed. Green Cove Springs, FL: Clay County Sesquicentennial Steering Committee, 1995.

Bliss, Charles. *Pensacola of To-day (Bliss' Quarterly),* 1897. Florida Heritage Collection. Publication of Archival Library and Museum Materials project, https://palmm.digital.flvc.org/.

Braden, Susan R. *The Architecture of Leisure: The Florida Resort Hotels of Henry Flagler and Henry Plant.* Gainesville: University Press of Florida, 2002.

Bramson, Seth H. *The Curtiss-Bright Cities: Hialeah, Miami Springs, and Opa Locka.* Charleston, SC: History Press, 2008.

Broadaway, Whitney. "Making Waves at Wet 'N Wild." *Reflections from Central Florida,* Summer 2017. Historical Society of Central Florida, Inc., Orlando.

Brown, S. Paul. *The Book of Jacksonville: A History.* Poughkeepsie, NY: A. V. Haight, 1895. https://archive.org.

Buxton, Richard. *Imaginary Greece: The Contexts of Mythology.* Cambridge, UK: Cambridge University Press, 1994.

Cayleff, Susan E. *Wash and Be Healed: The Water-Cure Movement and Woman's Health.* Philadelphia, PA: Temple University Press, 1987.

Chipley, William Dudley. *Pensacola (the Naples of America) and Its Surroundings, Illustrated: Sept. 1877.* Reprint ed., New Delhi, India: Sagwan Press, 2015.

Cowart, John W. *Crackers and Carpetbaggers: Moments in the History of Jacksonville, Florida.* Jacksonville: Bluefish Books, 2005.

Croutier, Alev Lytle. *Taking the Waters: Spirit, Art, Sensuality.* New York: Abbeville Press, 1992.

Davis, Jack E. *The Gulf: The Making of an American Sea.* New York: Liveright, 2017.

Derr, Mark. *Some Kind of Paradise: A Chronicle of Man and the Land in Florida.* Gainesville: University Press of Florida, 1998.

Fabel, Robin F. A. "British Rule in the Floridas." In *The New History of Florida,* edited by Michael Gannon, 134–49. Gainesville: University Press of Florida, 1996.

Firschein, Warren, and Laura Kepner. *A Brief History of Safety Harbor.* Charleston, SC: History Press, 2013.

Florida Ephemera Collection, P. K. Yonge Library of Florida History, George A. Smathers Libraries, University of Florida, Gainesville. http://www.uflib.ufl.edu/spec/pkyonge/.

Floyer, Sir John, and Dr. Edward Baynard. *Psychrolousia: or, the History of Cold-Bathing, Both Ancient and Modern.* 1702; reprint ed., Gale ECCO online database, 2010.

Foglino, Annette, and Linda Troeller. *Spa Journeys.* New York: PowerHouse Books, 2004.

Foster, John T. Jr., and Sarah Whitmer Foster. *Calling Yankees to Florida: Harriet Beecher Stowe's Forgotten Tourist Articles.* Cocoa: Florida Historical Society Press, 2012.

Francke, Arthur E., Alyce Hockaday Gillingham, and Maxine Turner Carey. *Volusia: The West Side.* DeLand, FL: West Volusia Historical Society, 1986.

Frisbie, Louise K. *Florida's Fabled Inns.* Bartow, FL: Imperial Publishing Company, 1980.

Gannon, Michael, ed. *New History of Florida.* Gainesville: University Press of Florida, 1996.

———. *History of Florida in 40 Minutes.* Gainesville: University Press of Florida, 2007.

Gilbert, Edmund W. *Brighton: Old Ocean's Bauble.* York, England: Methuen and Company, 1954.

Graham, Thomas. *Mr. Flagler's St. Augustine.* Gainesville: University Press of Florida, 2014.

Griffin, Patricia C. "Ralph Waldo Emerson in St. Augustine." St. Augustine: St. Augustine Historical Society and Museum of Arts and Sciences, St. Augustine Historic Museum Center, 1995.

Groenfeldt, David. "Water Development and Spiritual Values in Western and Indigenous Societies." In *Water and Cultural Values,* edited by R. Bolens, M. Chiba, and D. Nakashima, 108–15. Paris: UNESCO, 2006.

Grunwald, Michael. *The Swamp: The Everglades, Florida, and the Politics of Paradise.* New York: Simon and Schuster, 2006.

Hardin, Jennifer, and Gary Monroe. *Imagining Florida: History and Myth in the Sunshine State.* Boca Raton, FL: Boca Raton Museum of Art, 2018.

Hause, Heather. "Fountains of Youth: Medical Tourism in Green Cove Springs, Florida, 1845–1900." *Journal of Tourism History* 8, no. 3 (October 2016): 239–59.

Hicks, Rob, and Amelia Island Museum of History. *Amelia Island.* Charleston, SC: Arcadia Publishing, 2007.

Hooper, Kevin S. *Clay County.* Charleston, SC: Arcadia Publishing, 2004.

———. *Green Cove Springs.* Charleston, SC: Arcadia Publishing, 2010.

Janik, Erika. *Marketplace of the Marvelous: The Strange Origins of Modern Medicine.* Boston: Beacon Press, 2014.

Joki, Robert. *Saratoga Lost.* Images of Victorian America. Hensonville, NY: Black Dome Press, 1998.

Kelley, William Darrah. *The Old South and the New: A Series of Letters.* 1887; reprint ed., Palala Press, 2012.

Kirchfeld, Friedhelm, and Wade Boyle. *Nature Doctors: Pioneers in Naturopathic Medicine.* 2nd ed. Portland, OR: NCNM Press, 1994.

Kneipp, Sebastian. *My Water-Cure: Tested for More Than 35 Years and Published for the Cure of Diseases and the Preservation of Health.* 1890; reprint ed., Andesite Press, 2015.

Knight, Henry. *Tropic of Hopes: California, Florida, and the Selling of American Paradise, 1869–1926.* Gainesville: University Press of Florida, 2013.

Knight, Robert L. *Silenced Springs: Moving from Tragedy to Hope.* High Springs, FL: Howard T. Odom Florida Springs Institute, 2015.

Lencek, Lena, and Gideon Bosker. *The Beach: The History of Paradise on Earth.* New York: Viking, 1998.

Lust, Benedict. *Collected Works of Dr. Benedict Lust: Founder of Naturopathic Medicine.* East Wenatchee, WA: Healing Mountain Publishing, 2006.

Martin, Sidney Walter. *Florida During the Territorial Days.* Athens: University of Georgia Press, 1944; reprint ed., 1974.

McIntyre, Rebecca Cawood. *Souvenirs of the Old South: Northern Tourism and Southern Mythol-*

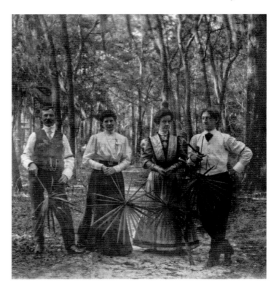

ogy. Gainesville: University Press of Florida, 2016.

Michaels, Brian E. *The River Flows North: A History of Putnam County.* Dallas, TX: Taylor Publishing Company, 1986.

Milanich, Jerald T. *Florida's Indians from Ancient Times to the Present.* Gainesville: University Press of Florida, 1998.

Moore, Robert F. *Magnesia Springs in Alachua County, Florida: Then and Now.* CreateSpace Independent Publishing Platform, 2016.

Mormino, Gary. *Land of Sunshine, State of Dreams: A Social History of Modern Florida.* Gainesville: University Press of Florida, 2005.

Nelson, Paul David. *General James Grant: Scottish Soldier and Royal Governor of East Florida.* Gainesville: University Press of Florida, 1993.

Nester, Deborah Craig. "Healers and Dealers: Florida Travel Narratives and the Colonizing of Eden, 1850–1900." In *Florida Studies,* edited by Steve Glassman, 90–102. Newcastle, UK: Cambridge Scholars Press, 2006.

Nichols, Wallace J. *Blue Mind.* Boston: Little, Brown and Company, 2014.

O'Connor, Mallory, and Gary Monroe. *Florida's American Heritage River: Images from the St. Johns Region.* Gainesville: University Press of Florida, 2009.

O'Donoughue, Jason. *Water from Stone: Archaeology and Conservation at Florida's Springs.* Gainesville: University Press of Florida, 2017.

O'Sullivan, Maurice, and Jack C. Lane, eds. *The Florida Reader: Visions of Paradise from 1530 to the Present.* Sarasota, FL: Pineapple Press, 1991.

O'Sullivan, Maurice, and Wenxian Zhang, eds. *A Trip to Florida for Health and Sport: The Lost Novel of Cyrus Parkhurst Condit.* Cocoa, FL: Florida Historical Society Press, 2009.

Petty, Marsanne. *Hamilton County.* Charleston, SC: Arcadia Publishing, 2009.

Revels, Tracy J. *Sunshine Paradise: A History of Florida Tourism.* Gainesville: University Press of Florida, 2011.

Rinhart, Floyd, and Marion Rinhart. *Victorian Florida: America's Last Frontier.* Atlanta, GA: Peachtree Publishers, 1986.

Robison, Jim, and Bill Belleville, *Along the Wekiva River.* Charleston, SC: Arcadia Publishing, 2009.

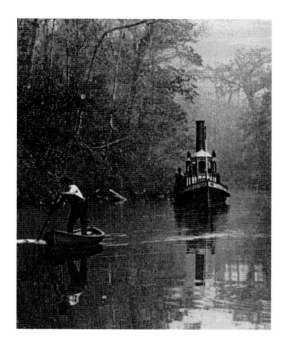

Rosenau, Jack C., Glen L. Faulkner, Charles W. Hendry Jr., and Robert W. Hull. *The Springs of Florida.* Geological Bulletin 31, Florida Geological Survey. [Tallahassee]: State Board of Conservation, Geological Department, 1977.

Salzman, James. *Drinking Water: A History.* Rev. ed. New York: Harry N. Abrams, 2017.

Schafer, Daniel L. *William Bartram and the Ghost Plantations of East Florida.* Gainesville: University Press of Florida, 2010.

Schwarz, Richard C. *John Harvey Kellogg: Pioneering Health Reformer.* Hagerstown, MD: Review and Herald Publishing, 2006.

Schwenk, Theodor, and Wolfram Schwenk. *Water: The Element of Life.* Great Barrington, MA: Steiner Books, 2000.

Sears, John F. *Sacred Places: American Tourist Attractions in the Nineteenth Century.* New York: Oxford University Press, 1989.

Shofner, Jerrell H. *A History of Altamonte Springs, Florida.* Mineral, VA: Tabby House Books, 1995.

———. *History of Apopka and Northwest Orange County, Florida.* Apopka, FL: Apopka Historical Society, 1982.

Small, John Kunkel. *From Eden to Sahara: Florida's Tragedy.* 1929; reprint ed., Sanford,

FL: Seminole Soil and Water Conservation District, 2004.

Smithsonian Institution. *Journey: An Illustrated History of Travel.* London: DK, 2019.

Speir, Robert F., M.D. *Going South for the Winter: With Hints for Consumptives.* 1873; reprint ed., Charleston, SC: Nabu Press, 2010.

Stamm, Greg. *The Springs of Florida.* Sarasota, FL: Pineapple Press, 1994.

Stronge, William B. *Sunshine Economy: An Economic History of Florida Since the Civil War.* Gainesville: University Press of Florida, 2008.

Tebeau, Charlton W., and William Marina. *A History of Florida.* 3rd ed. Miami: University of Miami Press, 1999.

Townshend, Frederick Trench. *Wild Life in Florida, With a Visit to Cuba.* London: Hurst and Blakett, 1875.

Thulesius, Olav. *Harriet Beecher Stowe in Florida, 1867 to 1884.* Orange Park, FL: Sigma Press, 2001.

Tolbert, Margaret Ross. *Aquiferious.* Orlando, FL: Fidelity Press, 2010.

Twain, Mark [Samuel Clemens]. "Osteopathy," February 27, 1901. *Mark Twain's Speeches.* Project Gutenberg, 2006. https://www.gutenberg.org/.

Vanderhill, Burke G. "The Historic Spas of Florida." In *Geographic Perspectives on Southern Development,* Studies in the Social Sciences, vol. 12, 59–77. Carrollton: West Georgia College, 1973.

Walters, Sandra. *The Story of Thornby: How Ordinary People Took on Government.* Louisville, KY: BlackWyrm Publishing, 2011.

Webber, Carl. *The Eden of the South.* New York: Leve and Alden, 1883.

Wentz, Rachel K., and John A. Gifford. "Florida's Deep Past: The Bioarchaeology of Little Salt Spring (8So18) and Its Place Among Mortuary Ponds of the Archaic." *Southeastern Archaeology* (Winter 2007): 330–37.

Williams, John Lee. *The Territory of Florida.* 1837; reprint ed., London: Forgotten Books, 2017.

Wilson, Brian C. *Dr. John Harvey Kellogg and the Religion of Biologic Living.* Bloomington: Indiana University Press, 2014.

Wiltse, Jeff. *Contested Waters: A Social History of Swimming Pools in America.* Chapel Hill: University of North Carolina Press, 2007.

Wittie, Robert. *Scarbrough Spaw, or, A Description of the Nature and Vertues of the Spaw at Scarbrough in Yorkshire.* York, England, 1660; reprint ed., Early English Books Online Text Creation Partnership, 2013.

PHOTO CREDITS

All images in this book are from the author's personal collection or in the public domain except for the following, which are used with the generous permission of those credited below.

Adventist Digital Library: 176
AdventHealth: 164, 183
Amelia Island Museum of History: 146
Beaches Museum, Jacksonville Beach, FL: 148
City of Indian Rocks Beach, FL: 3
Clay County Archives, Green Cove Springs, FL: 15, 46 (*all*), 47 (*all*), 48, 50 (*top*), 51, 52, 53, 55, 209
Rebecca Bryan Dreisbach: 66 (*bottom left*)
Dr. Christopher Mark Esing (PhD): 81, 82 (*top*), 83 (*top*), 183, 184
Florida Historical Society, Library of Florida History, Cocoa, FL: 151 (*bottom*), 152, 157 (*right*), 178, 180, 184, 186, 210
Heritage Village Archives & Library, Largo, FL: vi (*top*), 14, 107, 108 (*top*), 108 (*bottom*), 114 (*top*), 129, 213
Hunter Library, Western Carolina University, Cullowhee, NC: 96
Indigo Float, Orlando, FL: 203
Kilby Photo, LLC, Melbourne, FL: 206 (*top left*), 206 (*third row from top, left*), 206 (*bottom right*)
Gregory Komara, Department of Anthropology, Florida State University, Tallahassee: 2
Library of Congress Prints and Photographs Division, Washington, DC: 5, 10, 24, 25, 27, 31 (*bottom*), 35 (*bottom*), 78, 142 (*top*), 149 (*top*), 150 (*bottom*), 157 (*bottom*), 158, 166 (*top*), 166 (*bottom*), 187
Matheson History Museum, Gainesville, FL: i, ii, viii, x, xii, 18, 28, 30, 32, 33, 36, 37, 38, 39, 41, 42, 45, 52, 58, 61 (*top*), 64 (*bottom*), 67, 74, 76 (*left*), 77, 79, 80 (*bottom left*), 88, 92, 94, 95, 99, 113, 150 (*top*), 151 (*top*), 153 (*top*), 155 (*all*), 156 (*top*), 156 (*bottom*), 159 (*top*), 160, 214, 216, 217
John Moran: vi (*bottom*), xii, 13, 66 (*bottom right*), 80 (*right*), 116 (*top right*), 192, 193, 194, 195, 198, 202, 205, 206 (*top right*), 206 (*second row from top, both*), 206 (*third row from top, right*), 206 (*bottom left*), 208
New York Public Library: 26 (*bottom*), 141, 142 (*bottom left*)
Orange County Regional History Center, Orlando, FL: 1, 69, 70, 71, 172
Ephemera Collection, P. K. Yonge Library of Florida History, Department of Special and Area Studies Collections, George A. Smathers Libraries, University of Florida, Gainesville: 76 (*right*), 82 (*bottom*), 88, 110 (*right*), 163 (*left*), 185
Robert F. Moore: 133
Dan Smith: 61 (*bottom*)

Special Collections & Archives, Florida State University Libraries, Tallahassee: 102 (*top*), 159 (*right*)
Special Collections and University Archives, University of North Florida, Jacksonville: 149 (*bottom*)
Special Collections, University of South Florida Tampa Library:188
State Archives of Florida, Tallahassee, Florida Memory: v, 19, 20, 21, 23, 41, 49, 56, 60, 72, 73, 84, 85, 86 (*top*), 100 (*top*), 102 (*top*), 102 (*bottom left and right*), 105 (*top*), 105 (*bottom*), 106 (*bottom*), 117, 123, 127, 147, 153, (*bottom*), 159 (*left*), 173, 199, 200, 211
Stetson University Library Archives, DeLand, FL: 63
St. Petersburg Museum of History Archives: 131
Carol Stricklin: 100 (*bottom*)
Tampa-Hillsborough County Public Library System, Tampa, FL: 137 (*top*)
Thermae Bath Spa, Bath, United Kingdom: 6, 7 (*top*)
Margaret Ross Tolbert: 196
Union County Historical Museum, Lake Butler, FL: 40, 91, 93
West Volusia Historical Society, DeLand, FL: 65 (*top*), 66 (*top*), 68 (*left*), 132, 137 (*bottom left*)
Wellcome Collection, London, United Kingdom: 10, 167
Wikimedia Commons: 35 (*top*), 167, 169, 174, 175, 191, 197

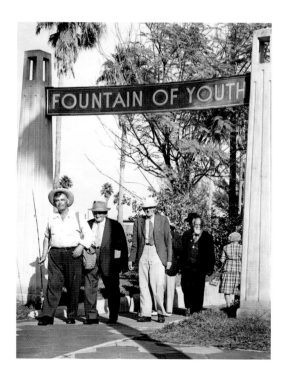

INDEX

Note: Unless otherwise indicated, all place names refer to locations in Florida.

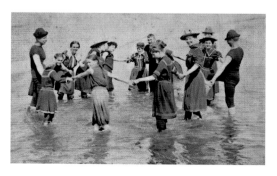

Rick Kilby is an author and graphic designer with a passion for Florida history and culture. He has designed *Reflections from Central Florida,* the magazine of the Historical Society of Central Florida, for over seventeen years, and currently acts as the magazine's managing editor. His book *Finding the Fountain of Youth: Ponce de León and Florida's Magical Waters* received the bronze medal at the 2014 Florida Book Awards.